VEERAPPAN

Simply written, the author easily manages to take you along on his journey...how it began, the struggles and finally accomplishment. An honest account with the right amount of detailing makes *Veerappan: Chasing the Brigand* a gripping read.

—*Akshay Kumar*

True stories have rarely been this exciting. This book is a scintillating read!

—*Amish Tripathi*

A meticulously researched non-fiction that hooks you like a compelling thriller.

—*Ashwin Sanghi*

A fascinating, absorbing account of how one extraordinary man could challenge the might of two states, and another even more inspirational man could oppose and bring about his end by employing matching but superior leadership and tactical skills. [On] Reading his book, we come to understand why Vijay Kumar, a legend in his own right, opted to stay on in the police when he had been selected for the Indian Administrative Service.

—*J.F. Ribeiro, Former DG, Punjab, and the author of Bullet for Bullet*

A gripping tale, amazingly well-told. While being racy and riveting, the narrative is of immense interest to the professional as well, chronicling as it does aspects of operational planning, intelligence generation, focused training and excellent teamwork capped by leadership of the highest order, that led to success in a historic encounter of epic significance.

—*P.K. Hormis Tharakan,*
former chief of Research & Analysis Wing (RAW), 2005-2007

VEERAPPAN
CHASING THE BRIGAND

K. VIJAY KUMAR

RUPA

Published by
Rupa Publications India Pvt. Ltd 2017
7/16, Ansari Road, Daryaganj
New Delhi 110002

Sales Centres:

Allahabad Bengaluru Chennai
Hyderabad Jaipur Kathmandu
Kolkata Mumbai

Copyright © K. Vijay Kumar 2017

ISBN: 978-81-291-4535-2

Fifth impression 2017

10 9 8 7 6 5

The moral right of the author has been asserted.

Printed at Parksons Graphics Pvt. Ltd, Mumbai

Dedicated to late Selvi J. Jayalalithaa
and to all search teams

Contents

Introduction

'*Nine out of ten times between hiding and searching teams, the hiding teams succeed.*'

—RICHARD CLARKE

Finding and bringing Veerappan to justice was an onerous task that took many years and claimed several lives in the process. It was a combination of experience, stratagem, meticulous planning and, to an extent, luck that finally helped us succeed.

Many brave policemen, officers and courageous civilians took enormous risks and made huge personal sacrifices in an attempt to bring Veerappan to justice. I am entirely to blame for this book's bias towards the Tamil Nadu Special Task Force (STF). Further, space constraints have led to the omission of and, at times, mere reference to several heroic episodes. But that should in no way detract from their contribution.

I have made all efforts to present the events to the best of my knowledge and as truthfully as possible. But several episodes described in this book are based on secondary reports gained from a multiplicity of sources. As such, I often had to deal with wildly contradictory versions of the same event.

Wherever I encountered differing versions of the same event, I tried to reconcile them and provide the most logical, coherent and accurate account. But it is difficult to state with certainty that all events took place exactly the way they have been described in this book.

As in all such operations, we witnessed courage and nobility as well as the seamier side of individuals and organizations. Wherever I have pointed out the latter, my intent was not to defame anyone, but to recreate the events as truthfully as possible.

In some cases, I have deliberately blurred sequences, obscured details and scrambled timelines in order to preserve operational secrecy and protect the identities of people who were involved in sensitive missions. Some of them continue to put their lives on the line for the nation even today.

To sum up the experience, I will quote my colleague K.N. Mirji, 'It's like a football team. All eleven play, but one scores the goal.'

Springing the Trap

18 October 2004. Around 10 p.m.

No matter how often you set a trap, the last few minutes of waiting are excruciating. Time slows down and your thoughts speed up. Invariably, you start thinking of everything that can go wrong. Especially when you are engaged in a deadly game of double bluff with a quarry who has repeatedly proved to be dangerous and unpredictable, changing his plans in the blink of an eye.

'What if he does so again?' I wondered. However, along with the apprehension, I felt a rising sense of anticipation. This could be the night when we would finally capture our target, after months of planning and hard work. All that remained was to spring the trap. Would we succeed in doing something that had not been achieved in over two decades?

'It has to work. Please let it work,' I prayed.

As I walked around ensuring that everybody was primed and ready, I paused briefly to take stock of my body's reaction to the high stress levels. My pulse was normal, as was my heartbeat. No sweat either. The cool winter night probably helped. I hadn't got much sleep the previous night, often waking from a fitful slumber and forcing myself to stay in bed to get some rest. But I wasn't drowsy or tired. If anything, my senses seemed hyper-alert. Every little sound seemed magnified in the uncannily silent night. There wasn't even a stray dog barking.

My worries resurfaced. Only four people, apart from me, knew who the person was in the vehicle we were waiting to intercept—Koose Muniswamy Veerappan, dreaded forest brigand who had virtually held two states to ransom for many years. One of them, Superintendent

of Police N.K. Senthamaraikannan—affectionately called 'Kannan'—was standing next to me. A methodical planner and logistics wizard, Kannan had played a critical role in the operation thus far. The other was Kumaresan, an undercover Special Task Force (STF) constable, waiting midway to keep watch and alert us.

The remaining two men were in the vehicle itself, which had been disguised to look like an ambulance belonging to a hospital in Salem, Tamil Nadu. One of them, Saravanan, was driving the vehicle. He was a member of the elite STF that I was leading. The other undercover cop was Sub-Inspector Velladurai, known as Durai, a brave, devil-may-care Tamil Nadu Police officer. Durai's participation had been concealed even from other STF members. Only Kannan and I knew his exact role. Pretending to be a sympathizer of the Liberation Tigers of Tamil Eelam (LTTE), he had promised to help smuggle the target out of the country into the LTTE-held parts of Sri Lanka.

I had had my misgivings about Saravanan's ability to hold his nerve under pressure. In fact, I had ordered his removal from the mission. But he had persuaded me to change my mind, insisting that it was a matter of honour for him. I had relented. Had I made the right call?

Our target believed that he would use the ambulance to break out of the police cordon that encircled his old hunting grounds. What he didn't know was that it was a specially modified police vehicle. Unfortunately, our team had been working in a hurry, and while painting the words 'SKS Hospital Salem' on the side of the ambulance, they had misspelled Salem as Selam. We could only hope that the target and his trusted companions wouldn't notice this error.

The target had a sixth sense when it came to spotting danger. After all, he had managed to elude the police of three states over the years. What if it came to his rescue again?

Many policemen had already perished at the target's hands. What if our plan failed and two more names were added to the list? Yes, they had volunteered for the task. I had told them that they were free to act as they saw fit if they felt their lives were at risk, as long as no innocents were harmed. But somehow, I doubted that such rationalization would be any consolation if I was confronted with the cold, stark reality of their deaths.

I shook my head and tried to get rid of the negative thoughts. 'I believe in God. He will not let us fail,' I muttered.

I was reminded of the words of the astrologer Rethinam, who lived near Pollachi. Normally, I don't set much store by soothsayers and prophecies. But a few months ago, he had confidently told me that 18 October would be a special day.

Part 1

The Making of a Cop

Life as a Rookie

I took over as the head of the STF barely ten months before that fateful night in 2004, though I had served two short stints with it previously. A lifetime of experiences and influences have gone into shaping me and my decisions, leading to the successful manhunt of the bandit who had been a thorn in the sides of the Tamil Nadu and Karnataka STFs. This story would not be complete without a brief mention of them.

I'm often asked about when I first decided to join the police. Honestly, there was never a time when I thought of doing anything else. Though I was inspired by F.V. Arul and Rustomji, I didn't have to look too far for role models. My father, V. Krishnan Nair, was a police inspector. Like most young boys, I looked up to my father and was fascinated by the uniform. It was a lethal combination that pretty much sealed my fate. Besides, in those days, cops were still the heroes in movies!

When I appeared for the Civil Services examination, I was selected for the 1975 Indian Police Service (IPS) batch, but I narrowly missed out on the Indian Administrative Service (IAS). I had always wanted to be in the IPS, but an innate competitive streak in me didn't like the idea of having failed to achieve something. So I gave the exam again, even as I proceeded to the National Police Academy, Hyderabad.

Like every batch, we believed we were the best. I was having a great time at the academy. In fact, I was in Kolkata as part of our Bharat Darshan (all-India tour) watching Bruce Lee in *Enter the Dragon* along with some batchmates, when I learned that I had cleared the IAS examination, along with some ten others. The director of the academy, S.M. Diaz, congratulated us warmly but then said, 'I don't want the lot

of you to hang around here and spoil the discipline of the other trainees. Proceed on leave immediately.'

By then, the time I had spent at the academy had deepened my conviction that I was meant to be a police officer. Still, a spot of leave was always welcome. Besides, I was still recovering from a bout of chicken pox that I had contracted a few days before the results were declared, so I decided to take a much-needed break.

After a fortnight, I wrote to the director that I wished to continue in the police and requested his permission to return. He not only welcomed me back, but took great delight in showing me off to other trainees as someone who had opted for the IPS despite getting into the IAS. Besides enjoying my brief leave, I also got to bask in his approval.

The first few years of service went by in a blur as I learned the ropes. It was during this stint that I first served under the legendary Walter Davaram, who later became the first head of the Tamil Nadu STF.

Walter was a tough, adventurous officer who believed in leading from the front—the more dangerous the situation, the better. He was an interesting combination of brains and brawn. As a student, he had spent most of his time playing various sports. He also had a photographic memory that had helped him top the history course at Madras Christian College and Annamalai University. Walter was an ace shooter, and is the person responsible for triggering a passion for shooting in me. My scores in shooting at the academy were nothing much to write home about, but Walter inspired me to practise relentlessly. It soon turned into a virtuous cycle. The more I shot, the better I got, and the better I got, the more enthusiastically I practised.

My preferred firearm was the Browning 9mm handgun. It would never leave my side—it would either be in my drawer or under my pillow. I got good enough with it to compete in the fiercely contested Inter Police Championship in Jodhpur in 1984. At one of the events, I was tied with a constable from the Indo-Tibetan Border Police for the gold. His team raised a protest on technical grounds, but I immediately said, 'Give him the gold.'

'Are you sure?' asked some of my teammates.

I nodded. 'It will mean a promotion for him. Besides, I'm an SP. It

seems petty for a senior officer to squabble with a constable over a medal.'

My competitive shooting days didn't last long after that, but I did become an instructor. I continued target practice whenever I got an opportunity, though I found out the hard way that there's a huge difference between firing at a stationary target at a practice range and trying to hit a live person in a combat situation.

While I was still at the academy, when I went home on a break, I was told by my parents that it was time to get married. My sister Dr Uma Malini and brother-in-law Dr Gangadharan acted as matchmakers and brought a proposal for a doctor's daughter.

'We would like you and the girl to see each other,' my father told me. I nodded meekly, feeling a bit like a lamb being led to the slaughter.

The meeting took place on 14 July 1976. A tiny girl with big eyes entered the room. She was dressed simply and kept blinking. I learned later that she had had a huge row with her mother because she flatly refused to get decked up to meet us. Thankfully, she didn't sulk about it during our brief interaction. I also found out that Meena had been terrified by the rather luxuriant moustache I used to sport those days—which would have rivalled Veerappan's.

We were served a fabulous lunch of ghee-rice and mutton curry, followed by the famed palada kheer of Kerala for dessert. Conscious of all the eyes scrutinizing my every move, I didn't think I would have had much of an appetite, but the food was so delicious that I found myself tucking in. 'Well, she can certainly cook,' I thought.

As it turned out, the meal had actually been prepared by the other ladies of the family—which I found out much later. Fortunately for me, Meena was—and continues to be—a wonderful cook. One of her passions is preparing homemade chocolates, which get distributed among friends and relatives who eagerly look forward to these treats. She has often been urged to sell her creations, but is happy to make them as an act of love without any monetary returns.

The wedding at Guruvayur on 22 April 1977 had a full horde from her *Vattekad taravaad* and my *Kumaranchat taravaad* (joint families) in noisy attendance.

I didn't really have to make much of an adjustment to married life.

Meena went about setting up our house, stoically putting up with my irregular hours and frequent transfers. On our first Diwali as a couple, I was out all night raiding illegal gambling and hooch dens. I returned home the next morning to find her waiting patiently in the balcony. She served me breakfast and went about her activities without any fuss.

Meena's father was a prosperous doctor. Suddenly, she had to run a household on a government officer's salary. The arrival of our son Arjun in 1978 and daughter Ashwini in 1982 stretched the already thin budget. But she always seemed to manage. Many years later, I learned that she had once quietly exchanged some jewellery to help meet the needs of our family.

I had hardly ever bought her gifts. So once, while posted in Kashmir with the Border Security Force (BSF), I purchased a pendant. I arranged for a shikara ride and as she gazed upon the beauty of the Dal Lake, I pulled out the gift rather dramatically and handed it over to her.

I was a largely absentee father, often rushing off on challenging assignments and missing my children's important milestones. Meena did her best to make up for my absences. We tried to insulate our children from my job as much as possible, though once, I breached the line.

While serving as the Superintendent of Police (SP) of Salem district, I was taking the family to see a James Bond movie. I was driving my private car, a beat-up Ambassador that we probably pushed as much as we travelled in. My elderly driver was sitting beside me in the front; Meena and the kids were in the back.

Just then, I noticed a local goon harassing some citizens. The sight infuriated me. I pulled over and leapt out of the car. The rowdy turned towards me menacingly. He was a big fellow, clearly looking for trouble. But he slowed down when he saw my pistol.

I picked up a branch lying on the road, grabbed him by the collar and pushed him to the floor of the car, next to the front seat. Then, I thrashed him with the branch all the way to the nearest police station. The children, who were excited at the prospect of seeing some action on-screen, found the real-life version quite scary. They ducked, whimpered and burst into tears. Meena was livid. After the goon was handed over to the cops, she let me know, in no uncertain terms, that such behaviour in front of the children was completely unacceptable. Needless to say, I

never repeated such an act before my family.

While in the same post, I was once asked to handle the security for an election rally by the then prime minister (PM), Rajiv Gandhi. The rally went off peacefully and I heaved a sigh of relief. A few days later, I got a call from the Director General of Police (DGP), Tamil Nadu, V.R. Lakshminarayanan. 'The "powers-that-be" were very impressed by the way you handled the PM's security at his rally. I believe Mr Arun Singh (then a minister of state) had a brief chat with you behind the dais. A new force has been set up to protect the PM and members of his immediate family. It's called the Special Protection Group (SPG). Would you like to apply for it?' he asked.

I was only too happy to do so and even more delighted when I was informed that I had cleared the SPG interview. I spent the next five years of my life—easily among the most exciting and demanding—in the SPG. Shortly after I joined the force, Rajiv Gandhi was shot at on 2 October 1986 at Rajghat, which led to the birth of the Close Protection Teams (CPT). Many heads of state and government, including Mikhail Gorbachev, offered us training and other support. I was chosen to join the CPT, which meant that I was part of the innermost ring, virtually serving as the PM's shadow.

For security reasons, I will not reveal details of the functioning of the CPT. Virtually every waking moment that wasn't spent guarding the PM was utilized in training. We spent hours honing our reflexes and our shooting skills, especially in simulated combat situations. My team ended up smashing several cars at a remote airstrip during defensive driving. The CPT received the first lot of Ambassadors fitted with Isuzu engines in India; we certainly put them to good use, even if they didn't enjoy a very long life.

All CPT members were given training in the basics of martial arts by a bunch of black belts from diverse disciplines—karate, judo, taekwondo, etc. We didn't specialize in any one form; instead, our instructors taught us some quick, dirty and very useful moves. For example, a mild jab with a finger at the right spot can send shockwaves, leaving the recipient shaken but not dead—an ideal tactic in a situation where someone seems suspicious, but use of lethal force may be an overreaction.

I wouldn't fancy my chances against Bruce Lee, but I learned enough to deal effectively with anybody who ventured too close to the PM. A gentle tap on any of the nerve centres would do the trick. 'Ouch' became a common word in the PM's immediate vicinity, but he was never told about the cause.

I had always believed that I was in pretty good shape, but a training stint in the Alps, along with some other members of the CPT, took me to a completely new level.

The course that we attended was called 'Deprivation & Desensitization Training', which gives a fair idea of what it comprises. We were deprived of sleep, dignity and just about everything that humans hold dear.

We were trained by a gentleman called Rossie, a plump, unsmiling individual. Despite his girth, he was amazingly fit and came with an impressive reputation. He had reportedly trained para-commandos, Carabinieri, Gaddafi's famous female bodyguards and some of the most expensive personal security personnel across the world. He always had a whistle strung around his neck. When he blew that whistle, you had to drop everything and scramble to him. He also had a habit of springing nasty surprises. Though doubts were raised about us being trained by a man who did not belong to the US, UK or the erstwhile USSR security, Rossie's choice was fully vindicated after our training was complete.

On the first day, we were treated to a sumptuous meal with superb wine. 'They have a strange definition of deprivation,' I thought, as I tucked into the food. Once we were stuffed and ready to go to bed, Rossie led us out in sub-zero temperature. After that cosy dinner, it was a brutal shock to the system.

In the moonlight, Mount Alps sparkled like cut glass washed in vinegar. There was a white car parked in the middle of a tarmac strip. 'Right, gentlemen,' he said, 'The person you're protecting is in that car. It has just been attacked. Commence drill.'

A lot of jumping, running and rolling followed. By the end of it, many of us had either heaved up most of the food we'd eaten with such delight, or had severe cramps. The icy peaks of the Alps now seemed cheerless.

The next day, the same fare was brought out. By now, we'd wised up, so we ate frugally. In fact, we were still hungry when we finished our

meal, but given what was coming next, we didn't mind too much. We waited smugly for Rossie to order another exercise.

A thin smile played across his lips as he said, 'Take a break for a couple of hours,' and marched out of the room, as we exchanged stunned looks and our stomachs rumbled in protest.

A couple of days later, after a long practice session of close-quarter manoeuvres, with Whitney Houston crooning in the background, he said, 'Would you like a toilet break?'

We nodded and raced to the loo. We had just about unzipped when we heard the whistle.

'You've got to be kidding me,' I groaned. But the whistle was shrill and insistent. Some of us forced ourselves to halt midstream and staggered back. In a couple of cases, a telltale patch appeared on the trousers. Others ignored the whistle and completed the task at hand, but then had to go through a gruelling round of exercises as punishment. It all seems very funny now, but it certainly didn't feel that way back then.

Rossie was liberal in doling out both verbal and physical punishment. One of his favourite tricks was to ask a candidate to undo his shoelaces and tie them again. If he bent to tie his shoelace, he promptly got a sharp rap on his head. If he glanced down, he got a cuff on the ear. It reminded me of the scene from *Enter the Dragon* where the novice gets a rap for looking down. Soon, all of us mastered the art of tying our shoelaces while standing on one leg and staring straight ahead. 'For a bullet-catcher, his eyes are his no. 1 weapon, followed by his hands and then his weapon itself,' Rossie would harangue, even as he rained blows like a furious drummer on the poor laggard's back.

On one occasion during dinner, a waiter came around with a tray. After he'd finished serving us, Rossie asked, 'How's the food, gentlemen?'

'Excellent, sir,' replied one of us.

'Really?' asked Rossie, his voice deceptively soft. A second later, the unfortunate trainee found himself staring down the barrel of a gun that the waiter had whipped out from under the tray. 'Bang, you're dead,' sneered Rossie. On closer inspection, it turned out to be a toy, but we got the message loud and clear: Stay alert at all times.

Midway through the training, we were ordered to go on a mountain

trek, carrying fully loaded backpacks, and given a short deadline to complete it. Rossie didn't accompany us. Instead, we were led by a licensed guide. Within a few minutes, it became painfully evident to me that I was holding up the group. I was prone to muscle cramps and sure enough, in the cold, my body began acting up.

My other teammates were all sub-inspectors, a lot younger and clearly more active than I was. As I struggled to keep up, one of them took some of the stuff from my backpack and put it into his. Others began to follow suit. I tried to protest, then reasoned with myself that there was no way we would finish the trek on time if I carried the full load. So I kept my mouth shut.

We managed to complete the trek within the stipulated time and heaved a huge sigh of relief. It had started to snow as we crossed the finish line. The cold and exhaustion combined had given me cramps in both legs. I was looking forward to a hot bath and a warm meal.

Then I noticed the guide and Rossie in conversation. Rossie's arms were crossed and he was looking at me. My heart sank. 'Uh-oh, here comes trouble,' I thought.

Rossie strode up and glared at me. 'Did you let your men share your load?'

I nodded, avoiding his eyes.

He turned to one of the men. 'Give him your backpack,' he ordered.

The man hesitated.

'Do what he says,' I told him.

I hefted the backpack on to my shoulders. It felt like a ton of bricks.

'Everybody else, into the bus,' said Rossie. Then he turned to me. 'We'll be somewhere along the highway. Find us. Or you can just drop down on the road.'

Then he got into the bus and it drove off.

The next couple of hours felt like the longest of my life. I was cold, lonely and exhausted. The light was fading. It was getting progressively darker and colder. I ached in every muscle and bone. On a bend, I saw a cupola with an icon of the Virgin Mary. Through chattering teeth, I prayed fervently to her. Not that I'm a Christian, but I had gleaned that Rossie was a devout Catholic, and right now I needed all the help

I could get.

After what seemed like eternity, I saw a little pub, barely a shack, on top of a slope. A man standing outside waved at me and went in. Rossie and the others emerged, glasses of liquor in hand. He beckoned me to come up.

The road to the top was little more than a dirt track, at an incline of about seventy degrees. I spent the last few metres on all fours as I scrambled up. Rossie kept the verbal barbs coming. 'Weak commander, weak commander,' he chanted.

I saw the faces of all my men. They were desperate to help me, but had orders not to do so. I could see the pain in their eyes. A few of them were actually in tears. It sent a wave of shame rushing through me. Never again, I vowed, would I be a weak commander.

When I finally reached the top, Rossie hauled me to my feet. 'You look like hell,' he said.

'That's exactly how I feel,' I thought, but wisely kept my mouth shut.

Rossie slapped me on my shoulders and handed me a drink. He didn't say anything after that. He had made his point, and I had learned a lesson that would stay with me for the rest of my life.

The training ended, and I went back to being the PM's shadow. Still, in the midst of my hectic schedule, I tried to stay up to date with events in my home state, Tamil Nadu. I began to hear a name with alarming regularity—Veerappan. He was a man who was turning into a scourge for the police as well as the administration.

The years from 1990–2001 were hectic and enriched me with the experience of handling two more districts—the CM's security, caste riots in south Tamil Nadu and militants in Jammu and Kashmir. I also served as Inspector General (IG), Anti-Dacoity and Piracy Cell, a post that was created especially for me, with just about half a dozen men. We soon realized that all the dacoits in that area were already dead. So the cell shifted its attention to anti-piracy operations and apprehended several fake music and movie tape makers. After my selection as IG, BSF, by its DG, E.N. Ram Mohan, in 1998, I turned my attention to militancy in Kashmir. By 2001, I had completed three years of my stipulated five-year tenure in the BSF.

The Call that Started It All

Room 119, Ministry of Home Affairs, North Block, New Delhi
June 2001, 11 a.m.

It was another hot, muggy day in the capital. A discreet knock was followed by a gentle cough as the door of my office swung open. A young BSF officer walked sheepishly but purposefully towards me. As IG (Operations), BSF, I was attending an important conference of senior officers of all the paramilitary forces at the home ministry. Sixteen BSF jawans had been butchered on the Bangladesh border a few weeks before this conference, so it was a sombre meeting.

Many heads swung around to look at me. My irritation must have been evident, because the officer half-smiled apologetically and thrust a slip of paper into my hand before beating a hasty retreat.

I glanced down. It said, 'Phone, most urgent.'

'What could be so urgent?' I muttered under my breath.

I made my excuses and left the conference room. As I stepped outside the air-conditioned hall, the June heat felt like a blow on the face.

'Yes?' I said into the mobile.

'Please hold the line. Amma will speak to you,' said the familiar voice of Joint Secretary Natarajan.

I stared at the mobile screen for a while. 'Amma' could mean only one person. Sure enough, within seconds, I heard the crisp voice of Selvi J. Jayalalithaa, the then newly re-elected chief minister (CM) of Tamil Nadu.

'Mr Vijay Kumar, how are you?'

'Good morning, ma'am. I'm very well, thank you. Please accept my heartiest congratulations on your grand return,' I replied.

'Thank you,' she said, and got straight to the point. 'I'm calling you over to head the Tamil Nadu STF, with Mr Walter Davaram as overall in-charge of both the Tamil Nadu and Karnataka forces. This sandalwood smuggler problem has gone on for too long.'

Throughout her stint in the Opposition, Jayalalithaa had charged the Dravida Munnetra Kazhagam (DMK) government with being soft on the famed brigand, Veerappan. She had vowed that if she returned to office, she would take a tough stand against him. Clearly, she was getting down to brass tacks and I couldn't help but smile.

By then, I had spent quite a few years away from the state, including long stints with the BSF in Kashmir and then in New Delhi. During that time, I had chafed whenever I heard about the numerous daring escapades of Veerappan. The sensational abduction of superstar Dr Rajkumar had made headlines around the globe. The police as well as the citizens of three states—Tamil Nadu, Karnataka and Kerala—would tremble in fear, wondering about his next strike. I knew many of the officers and policemen who pitted themselves against guns, mines and treacherous terrain in an attempt to capture him. They were good men, but the media portrayed them as bumbling buffoons. Every time I read those reports, I itched to be part of the STF, working shoulder to shoulder with them. It seemed that my wish had finally been granted.

'It will be an honour,' I told the CM.

'Good. You'll get your orders soon,' she said and hung up.

I was over the moon. I smiled at the BSF officer, who looked puzzled as he took back the mobile. This call from the CM was one of the best moments in my life. After all, it's not every day that you're invited to join a mission you have wanted to be a part of for the longest time.

When the Government of India sacks or dumps you, it happens instantly. But when your state asks for you to be sent back, it usually takes weeks. So it was with some amazement that I received my transfer orders the next day. 'The CM certainly means business,' I thought as I looked at the papers.

I hurriedly took leave of my colleagues. Come to think of it, I believe the BSF still owes me a farewell party!

A few days later, I found myself sitting in a bedroom of the newly built unoccupied constables' quarters, which doubled up as the STF headquarters at Sathyamangalam, or Sathy as we knew it. Deputy Inspector General (DIG) Tamil Selvan welcomed me warmly. As we chatted over tea and pakoras, I couldn't help glancing at the black leather glove that concealed three mangled fingers on his left hand. It was the souvenir of a daring firefight with Veerappan. Tamil Selvan could easily have used the injury as an excuse to be transferred from the STF to an easier, cushier job, but he had chosen to return to this assignment the moment the doctors declared him fit enough to resume duty.

Sensing my gaze, he glanced at me. I looked away, embarrassed. My eyes fell upon the Dhimbam Hills on the horizon. They represented the haystack. Concealed somewhere within them was the needle I had to find at all cost!

A little later, I stepped into a hall where senior STF officers and men had assembled to meet me. I looked at them. There were many familiar faces. I had seen them join the force as fresh-faced recruits. Now, they were middle-aged men, their youth lost somewhere in the mountains and hills through which they trudged, searching for their wily target.

'Let me start by saying that you all have done tremendous work in reducing a gang of 150 to single digits over the years,' I said. 'But I also have a question. Why haven't we been able to catch the leader?'

There was silence. Then, one of the men spoke up. 'Sir, it's not as if we haven't had our chances. There were many occasions when we came really close to nabbing him. But he got lucky each time.'

'We just have to get lucky once,' I thought, but said, 'We have to use his luck against him by plugging all the loopholes that have so far led to his escape. I want all of you to tell me about him. I want to read all the files on every operation ever conducted against him. I want to understand where we went wrong. Get me everything we have on him. You have forty-eight hours.'

Part 2

The Veerappan Files

Rise of a Brigand

July 2001

'Ayya (Sir), Veerappan has had quite an eventful career,' said the lean man standing in front of me, holy ash smeared prominently on his forehead.

I couldn't help but smile, both at the dry wit and the elegant colloquial Tamil of Inspector Karuppusamy, so typical of southernmost Tamil Nadu where he had spent his childhood.

More than twenty years after he had joined the police as a sub-inspector, his belt size was still 28 inches and his weight 60 kg, helped, no doubt, by his austere vegan diet. 'This man is truly a yogi in camouflage,' I thought.

Among the first volunteers to join the STF in 1993, he was determined to stay on till its mission concluded successfully.

Thanks to his long, uninterrupted stay with the force, Karuppusamy had become something of an encyclopaedia on not just the area's geography and local medicinal plants, but also on Veerappan, his operations and his legend. The STF's operations covered some 400 hamlets in Tamil Nadu and Karnataka; Karuppusamy had contacts in each one of them. He was loved by his men for his scrupulous honesty.

He was the best man for me to talk to, to get a sense of Veerappan, including the incidents that had shaped him. I gestured to Karuppusamy to take a seat and got straight to the point.

'Tell me what you know of Veerappan's life,' I said.

'Ayya, I'll share all I know about A-1 and the gang,' he replied. A-1 is a cop's shorthand for accused-1, as mentioned in the First Information

Report (FIR)—in this case, Veerappan. 'The gang' stood for Veerappan's gang.

He recounted a tale that had the makings of a fantastic Bollywood potboiler. As he proceeded, it was easy to see why Veerappan had captured the imagination of movie makers and the public alike, a fascination that continues till today.

In fact, so much mythology has sprung up around Koose Muniswamy Veerappan that it is practically impossible to weed out fact from fiction. Many differing dates, some almost a decade apart, are cited for his birthday. But his actual date of birth was 18 January 1952. The STF figured this out later, when it got hold of the brigand's horoscope.

Veerappan was the third of five children, raised in the village of Gopinatham on the fringes of a deciduous forest. Its inhabitants were quite comfortable spending long periods of time within the jungle.

Several villages in this region were submerged when the Stanley reservoir (popularly known as Mettur Dam) was built in the 1940s. The population was resettled. Later, when states were reorganized in 1956 on the basis of language, a substantial Tamil-speaking population in Kollegal taluk, in which Veerappan's village was situated, ended up in Karnataka from Coimbatore district in Tamil Nadu.

The area was rich in natural resources but was economically backward, and governance wasn't always visible or effective. It was equally difficult to make people understand the importance of conservation when pillaging the surrounding forest offered quick, easy money to supplement their uncertain and meagre incomes.

Like the Wild West, where guns and gods command equal reverence, every second family in the area possessed a crude firearm of some kind—typically unlicensed, homemade muzzle-loaders, mostly used for protection against wild boars and other forest animals, but sometimes employed for more sinister purposes.

Every once in a while, the police or forest department would raid the village. Some weapons would be confiscated; most would be quickly hidden. After the raid, the hidden cache of weapons would be surreptitiously retrieved and life would return to normal.

Having grown up with guns all around him, Veerappan soon made

a name for himself as an ace shot. Old-timers swear that they had seen him shoot monkeys in mid-air, as the unfortunate animals leapt from one tree to another. Given the limited capabilities of the muzzle-loaders that he was toting, that would indeed be marksmanship of the highest calibre.

Before too long, Veerappan's prowess with firearms began to get the wrong kind of attention. The first case against him was registered for hunting a wild boar. When a forest officer came looking for him, he fled into the woods. He was just a boy then. The rest, as they say, is history.

Veerappan wasn't alone for long in the forest. His alleged prowess caught the attention of a local poacher, Sevi Gounder, who, according to old-timers, had the backing of a local Tamil Nadu Member of Legislative Assembly (MLA). Very soon, Veerappan became a valued member of his gang. He is believed to have killed his first elephant as a juvenile and quickly went on to become a notorious poacher. His favoured technique was to shoot at the forehead of the elephant, killing it instantly. Even as the number of elephants killed by him piled up, he is said to have claimed that he was actually performing an act of charity by killing the tuskers, as millions of living beings, like birds and ants, could be sustained by feeding on a single elephant carcass.

I often wondered if all this was just part of his propaganda to portray himself as some sort of Robin Hood. No doubt Veerappan enjoyed a certain degree of popularity with the local populace. Petty authorities—whether police, forest or revenue—are not welcome figures in remote areas. They tend to be seen as something of a nuisance. Veerappan defied them and this endeared him to the locals.

Whenever any local had a grouse, Veerappan, who was one of them, was quick to exploit their resentment. This again generated a certain amount of popularity for him. Though only a few people actively helped him, it appeared that the entire population supported him. This led to strict action against the populace, which created resentment, which he further fanned. It became a vicious cycle.

Veerappan was not very charitable, but was a generous employer. The closure of granite mines in the area had rendered several people jobless. This gave him a large pool to recruit his gang from, as well as for peripheral members like couriers, guides, lookouts, etc. He also employed

several locals for sandalwood cutting and smuggling from villages on the Tamil Nadu-Karnataka border around the Palar River. His smuggling operation was quite large and he paid daily wages, which was the only source of livelihood for the poverty-stricken villagers. In fact, Veerappan ensured that they were able to pocket twenty-rupee notes for the first time in their lives.

Karuppusamy continued, 'Soon enough, Veerappan was heading his own motley band of poachers, one of the many in the region. A single act of audacious brutality catapulted him to undisputed number one. The local police active at that time found out later that Veerappan had invited members of the biggest rival gang over for a meal, ostensibly to carve up exclusive poaching areas within the forest for each gang. At some point during the meal, Veerappan served betel nuts to his rivals. That was a signal for some of his men, lying concealed in the forest, to open fire immediately, thus wiping out the competition.'

'It's certainly a fascinating coincidence,' I mused. 'You know, the ancient sect of Thuggees used to do something similar. They would befriend their intended victims and then strangle them after offering them betel nuts.'

'Maybe outlaw masterminds just think alike,' responded Karuppusamy, as he continued the tale.

By then, Veerappan headed the largest gang in the area. Others were quick to see the writing on the wall and either swore allegiance to him or quietly faded away.

Veerappan was regarded with fear and awe. He had a larger-than-life image, which he was conscious of and cultivated meticulously. He was ruthless with people whom he regarded—correctly or otherwise—as police informers. That ensured that he was rarely denied assistance if he ever asked for it.

Veerappan's poaching business flourished and he soon expanded into sandalwood smuggling, decimating large tracts of the forest. He ruthlessly killed any rivals—real or imagined—but largely stayed under the radar of the authorities, with one exception. On 27 August 1983, he allegedly killed forest guard K.M. Prithvi near Mavukal in Karnataka, when the latter intervened and tried to stop elephant poaching by the gang. By and

large, though, Veerappan preferred to come to terms with pliable forest officials and avoided the honest ones.

But all that changed in 1986, when Veerappan was arrested in Bangalore. He had come to buy ammunition and ended up in a quarrel with the dealer who, in turn, informed the police. Unfortunately for Veerappan, a South Asian Association for Regional Cooperation (SAARC) summit was due to be held in the city in a few days and all antisocial elements were being rounded up as part of the security arrangements.

The police tracked down Veerappan to a restaurant. He was handcuffed and handed over to M.V. Murthy, an SP in the forest cell.

During his captivity, Veerappan, for the first time, met a man who would later become a thorn in his flesh, Deputy Conservator of Forests (DCF) P. Srinivas. A slight man, Srinivas had been a topper all through his school years and later. But book learning alone does not always make one a great officer. The beard-sporting Srinivas rapidly proved to be a conscientious man, who was prepared to think out of the box.

Srinivas knew he had hit the jackpot when Veerappan landed in his lap without much effort. He soon started gathering information about Veerappan's criminal activities.

One day, Srinivas took a handcuffed Veerappan to a guest house in the interiors of the Boodipadaga Forest. He then left the latter in the custody of some forest guards in order to attend to some other work. While he was away, the wily captive sensed an opportunity to escape and decided to capitalize on it.

Veerappan begged for some oil to ease his throbbing headache. While one guard was sceptical, the other, more gullible one obliged. That night, as the guards slept, Veerappan deftly transferred the oil on his head to his spindly hands. In a few minutes, his wrists slipped out of the handcuffs. Then he climbed out through a small window and fled into the darkness. Fourteen years later, during a hearing on the Rajkumar kidnapping case, the Supreme Court reiterated the seriousness of this lapse and demanded to know all details.

I shook my head. It was hard to believe that the guards had bungled up so badly. Veerappan had been in custody and yet he managed to go free.

'Do you believe that's what really happened?' I asked, thinking about the way the man had turned into a menace and a legend after that.

Karuppusamy shrugged. 'That's what the official records say.'

I had read something similar earlier, including the fact that even though Veerappan was in custody for a brief period, his fingerprints were not taken.

Sceptics scoffed at the official version. It was easier to believe that Veerappan had probably bribed his captors to let him go. Whatever the truth, Veerappan was once again a free man. He now nursed a sense of resentment against the authorities. And the brigand, known to hold a long grudge, eventually took it upon himself to eliminate his nemesis, Srinivas.

Karuppusamy went on to quickly recap Veerappan's rise in the area, including the manner in which the man's name in itself spelled awe and terror among the local population.

Veerappan began his rise by first extorting money from the black-granite quarries that dotted the area, forcing them to pass on explosives to him. Eventually, the Karnataka government had no option but to ban quarrying in the area as long as Veerappan remained active. This meant a huge loss in revenue to the state exchequer, as well as a loss of jobs for the locals.

Making matters worse was the fact that police efforts to nab Veerappan were floundering. They suffered an especially demoralizing setback on 9 April 1990, when he ambushed a jeep carrying ten policemen, leaving three sub-inspectors, including a very active SI Dinesh, dead and a constable badly wounded.

By now, Veerappan's activities had become too alarming to be ignored. He had popped up in faraway Coorg and the grapevine was that Kaziranga in Assam too was in his sights for its ivory. On 16 April 1990, then Karnataka Chief Minister Veerendra Patil announced the creation of an STF to apprehend Veerappan. K.U. Shetty, an IPS officer who had previously served in the army, was its first chief.

Soon after its creation, the STF was approached by an unexpected volunteer—Forest Officer P. Srinivas.

Veerappan's escape haunted Srinivas. Every time he heard of a fresh

escapade by the outlaw, it felt like salt being rubbed into his wounds. Unable to bear it any longer, he volunteered to go to the area where Veerappan was known to be active and adopted a strategy that was simultaneously hard and soft.

The 'hard' part of Srinivas's game plan consisted of numerous raids. He joined the STF on its marches. Having heard the story of the brigand's escape, the STF men were sceptical about Srinivas's assistance, but he soon earned their respect, carrying his own equipment and weapon, just like everyone else, and sharing the same rough living conditions.

But it was the 'soft' part of Srinivas's plan that really started to pay dividends. Srinivas set up camp in Veerappan's village, Gopinatham. He worked hard to befriend the locals, often using the funds sanctioned for operations against Veerappan for the villagers' benefit. He even built a small temple in Gopinatham with some funds from volunteers but majorly financed by him. Though he knew that the villagers were aware of this fact, he did not want them to feel obliged, as it was the sense of participation that mattered the most.

Bit by bit, he developed a reliable network of informers. His popularity rose after he set up a dispensary in Gopinatham. His herbal and indigenous medicines soon restored the health and faith of many.

What bothered Veerappan the most was the fact that Srinivas was in regular conversation with Arjunan, the outlaw's younger brother.

Unlike his brother, Arjunan was a bit of a wastrel. Locals claimed that Veerappan would often chide him for his excessive drinking, smoking and womanizing, warning Arjunan that his wasteful ways would one day lead to his downfall. But the brothers were known to stay in touch. Srinivas hoped to convince Arjunan to persuade Veerappan to surrender.

Arjunan wasn't the only sibling whom Srinivas befriended. Veerappan's youngest sister, Mariammal (Mari), a lively, affectionate and well-liked young woman in the village, was a volunteer at the dispensary.

One day, some STF members picked up Mari on the suspicion that she had helped her sister-in-law, Veerappan's wife Muthulakshmi, escape from virtual house arrest and join Veerappan in the forest. Unable to get any information, the STF released Mari, but not before threatening her with dire consequences. Locals claim that she went in tears to Srinivas's

home, but nothing came of the meeting. Shortly thereafter, Srinivas went to Mettur to meet a potential informer. Upon his return to Gopinatham, he learned that Mari had killed herself by consuming pesticide.

A livid Veerappan blamed Srinivas for his sister's unfortunate death. Recalling his time in captivity, Veerappan was convinced that Srinivas had enlisted Mari's support with the sole purpose of getting back at him.

Even as Veerappan nursed a rising hatred, Srinivas led a highly successful raid into one of his jungle hideouts, leading to the confiscation of almost 800 kg of sandalwood and the surrender of twenty bandits. While the loss of sandalwood was undoubtedly a blow to Veerappan, it was the surrender of his men that really riled him.

Gang members who surrendered later revealed how Veerappan successfully used Srinivas's strategy against him.

One night, Srinivas was attending a wedding in Gopinatham when Arjunan sidled up to him.

'Anna is ready to surrender,' whispered Arjunan. 'He has asked you to walk towards Namdelhi (about a two-hour walk from Gopinatham). He'll meet you halfway. Wait for his message.'

A few days later, an excited Srinivas left for the meeting, accompanied by Arjunan and some villagers. In his mind, he must have pictured the moment when Veerappan would surrender, and the celebrations that would follow.

During the trek, Srinivas didn't notice that one by one, all the villagers had quietly slipped away into the shadows till only Arjunan remained. The two men arrived at a muddy pool, where Arjunan stopped. Several figures rose from the bushes. One of them was a tall, rangy man with a handlebar moustache.

Srinivas was initially triumphant, but soon realized that something wasn't right. Veerappan was holding a rifle and staring at him.

Srinivas looked around. Reality sunk in. He realized he was alone with Arjunan. As the extent of his predicament dawned on Srinivas, Veerappan and his men began to laugh.

Before Srinivas could react, Veerappan fired. He slumped to the ground, dead. But Veerappan was still not satisfied. He chopped off Srinivas's head and carried the grisly trophy back to his camp, where he

and the others kicked it around like a football.

The news of Srinivas's murder sent shockwaves throughout the region. The message was unmistakable—nobody was safe from the bandit's vengeance. More than the killing, it was the sheer brutality of the act (Srinivas's head wasn't recovered till almost three years later) that enhanced Veerappan's reputation as a terrifying foe.

'What happened to the temple Srinivas built in Gopinatham?' I asked Karuppusamy as he finished the gruesome tale. I had goosebumps and barely managed to control a shudder at the horrific account.

'It's still there,' he replied, volunteering to take me to the temple, which I visited that same evening.

The temple was about a four-hour journey from the STF headquarters at Sathy. It had a large portrait of Srinivas, and a board displayed the details of his life as well as the Kirti Chakra that he was awarded posthumously. The villagers clearly revered him as a saint.

Karuppusamy told me that a legend had sprung up around Srinivas's death. Locals claimed that there had been many ominous signs, including animals howling in the jungle, on the day that Srinivas was killed.

We hung around the temple area for a while. An aarti was performed before Srinivas's portrait. A sense of serenity pervaded the area, completely at odds with the gruesome manner of his death.

'Srinivas may live on in the hearts of the villagers,' I thought, 'but he has still not got justice.'

Visiting the temple only strengthened my resolve. I would try my best to nab the brigand and make him accountable for all his crimes. He would have to pay for all the lives he had taken.

Death of a Newborn

July 2001

Karuppusamy wasn't done with recounting Veerappan's deeds. One, in particular, was hard to believe.

'What kind of person kills his own child?' I asked. 'Is this fact or just hearsay?'

As a father of two, I could not think of anything more precious than holding my children in my arms and protecting them from harm, even more so given the harsh realities of my profession.

Karuppusamy scowled. 'A complaint was made at Burgur Police Station. It was registered on 17 July 1993, as Burgur PS Cr. No. 17/1993 under Section 302 of the Indian Penal Code, making it a case of murder. One Neethipuram Chinnasamy was with the brigand when he got his daughter murdered. He confirmed this fact when we arrested him.'

I knew Veerappan had committed multiple murders, but the news that he was an accessory to the murder of his daughter came as a shock to me, especially since Veerappan was known to be highly protective of his family. He would wreak vengeance at any perceived slight on them at the hands of the authorities.

As I picked up the file with the records of the death, I asked Karuppusamy to tell me more about Veerappan and his wife Muthulakshmi.

After his escape from captivity, Veerappan, it is believed, made it a point to stay away from intoxicants and women, both of which he perceived as dangerous distractions. He was very clear that he would

never again give the authorities a chance to nab him. However, despite his resolution, he could not help being drawn to Muthulakshmi, an attractive teenager from Neruppur village.

Muthulakshmi soon noticed that Veerappan was a frequent visitor to her village. His bristling moustache, piercing gaze and air of authority—as well as the awe and fear he generated among the villagers—made quite an impact on her. She began responding positively to his attention.

Muthulakshmi's parents were far less enthusiastic about her suitor. Her father even informed Veerappan that Muthulakshmi's marriage had already been fixed with one of her cousins. But Veerappan refused to give up. A few months after his proposal was rejected by her father, he eloped with Muthulakshmi and the two got married in a forest temple.

Soon, Muthulakshmi was pregnant and managed to stay in the forest in that condition for eight months. She finally returned to her parents' house for her delivery. Worried about her being arrested, her father took her to Chennai, where she surrendered to the police.

The police lodged her in a women's hostel. Later, she delivered a baby girl who was named Vidya Rani by an STF officer, Sylendra Babu. He permitted Muthulakshmi to return to her parents' home in Neruppur, though her movements were closely monitored.

One day, one of Veerappan's men came to Muthulakshmi's home, pretending to be a relative. As soon as he entered the house, he whispered that Veerappan had sent word that she leave the infant with her parents and return to the jungle, as he missed her.

No mother can part with her baby easily. For a couple of months, Muthulakshmi ignored her husband's command. Finally, she was convinced that her child would have a better future in the village than in the forest.

One night, she sneaked out of Neruppur and was soon reunited with Veerappan.

In 1992, the couple had another baby girl, Prabha, who was delivered by a seasoned midwife called Chinnapullai. A year later, yet another girl was born to them. But far from being a cause for celebration, this newborn became a source of worry for Veerappan.

By the time the baby was born, his band had swelled to over 100

members, including several women and elderly persons. This was slowing down their movement.

The STF had overrun his virtual fortress in Bodamalai and demined its approaches from three sides, forcing the gang to shift towards thicker forests in Dhimbam, with the authorities in hot pursuit. Veerappan's scouts had already reported that pursuers from the south and east were closing in.

In the forest, an alert patrol can detect the slightest sound from a long distance. A baby's cry can go as high as 110 decibels, barely 10 decibels below a thunderclap. Besides, a baby is completely unpredictable and its crying could instantly reveal a well-concealed location without giving any opportunity to muffle the sound.

'She is turning into a major problem,' thought Veerappan grimly.

According to Neethipuram Chinnasamy's account, one day, the child let out an extremely ill-timed cry. Everyone in the band looked at her, then their eyes swivelled towards Veerappan. Nobody said anything, but the implication was clear.

Veerappan turned towards the midwife. Chinnapullai took great pride in delivering babies safely even under the most harrowing circumstances, but this time, Veerappan had a different job in mind for her.

The midwife began to say something, but changed her mind when she understood Veerappan's intention. 'Some juice of erukkampoo will make her choke,' she said.

Erukkampoo, or Calotropis, is revered as Lord Ganesha's favourite flower. Practitioners of Ayurveda use it regularly for medicinal purposes.

'Do it,' Veerappan said shortly. Muthulakshmi was the only one to shed tears for the baby.

Karuppusamy said that on 13 July 1993, a Karnataka STF team led by Inspector Jegadeesan and a BSF contingent found a suspicious mound at a place called Maari Maduvu. They dug it up, only to find the body of a baby. The medical examiner who conducted the autopsy could not determine the cause of death, as the body was in a highly decomposed state.

'I know he killed many innocents, but to take the life of your own child is inhuman,' I couldn't help exclaiming. 'For Veerappan, tactical

considerations always outweigh ethical ones,' said Karuppusamy darkly. 'Like a Russel's viper that can bite through its own skin, he is capable of turning on his own flesh and blood, if it is a matter of survival.' Karuppusamy maintained that according to Chinnasamy, Veerappan's heinous act had served another purpose. 'It sent tremors through the ranks of his followers,' he said, adding that it ensured that his gang remained loyal to him.

A Blow to Veerappan

July 2001

We were on a routine patrol and had stopped for a tea break. I was rather excited about being outdoors, bonding with the men in my unit after hearing and reading up on Veerappan's many exploits. But what I read in the papers did not come close to the accounts I heard from my men.

In my years of service away from Tamil Nadu, I used to fret about how the media portrayed Veerappan as making a fool of the police. I knew several of the men who were charged with capturing him, and could never understand why the smartest and bravest in the force were unable to get him.

But every minute of my stay in Sathy only reinforced my belief that the task I had undertaken was far from easy, given that Veerappan knew every inch of the dense forest and all its secrets better than our forces. We were impeded, not just by the harsh terrain but also because the locals looked upon us with fear—fear of reprisal from Veerappan if they were even seen in the proximity of the police.

On that particular jungle patrol, as we awaited a pickup near the road head, I got the chance of getting to know Tamil Selvan a little better. He was, undoubtedly, one of the many fascinating characters in the STF. He was also one of the lucky few who lived to narrate his brush with Veerappan. The cerebral, slightly heavy Selvan, who was happiest when devouring books at a rapid pace or playing chess, now spent most of his time hunched over maps. He didn't look like he was made for long,

gruelling treks through the forest, but he more than compensated for it with enthusiasm, sheer willpower and an array of innovative dishes that made our patrols extremely interesting. His yo-yo dieting and feasting had the metronomic regularity of the waxing and waning of the moon.

At that precise moment, Selvan was deftly slapping wheat dough sprinkled with a dash of salt and sugar. He then rolled the dough on to a twig and held it above the campfire. A minute or so later, he offered it to me with a flourish. 'There you go. Tamil Selvan's biscuit-cum-breadstick,' he said.

I couldn't help but laugh as I helped myself to the unique snack. With tea, it was sheer bliss.

Even as I gobbled up the snack, he announced, 'I feel like a smoke.'

'I thought you'd quit,' I said.

'You know me. I've quit so many times.' He laughed.

Looking around, he hailed a constable, 'Hey, thambi (brother)! Have you got a beedi?'

Both moved away and a minute later were chatting together, as the smell of the beedi wafted towards me. I shook my head.

Ranks melted around Selvan. He was extremely popular with the men. The fact that he had stayed with the force even after a severe injury in an ambush by Veerappan only added to the esteem in which he was held.

Selvan was lucky to survive.

My mood darkened as I thought of two STF officers from neighbouring Karnataka who had died in an ambush set by Veerappan.

Early 1992

'Sahebru (Sir), I have some information on Eerappan,' said the voice over the phone, referring to Veerappan by the local Kannada name. 'But I want to talk to someone senior.'

There was a pause. The policeman who answered the call at Ramapura Police Station replied, 'Come to Kowdalli inspection bungalow tomorrow morning.'

Early next day, a Karnataka STF jeep pulled up in front of the

rendezvous point. Two of its most courageous officers emerged: Sub-Inspector Shakeel Ahmed and SP Harikrishna. Harikrishna's wife was expecting a baby when he volunteered to join the STF. Shakeel Ahmed was a second-generation cop who, on hearing of the killing of three SIs in April 1990, had rushed to MM Hills to join the hunt for Veerappan, and declared that he would not get married until the brigand's capture.

The meeting had been set up by Nataraj, a cashier at one of the local liquor shops in Ramapura, and Muthuram, who owned a small hotel at that location. But it was their companion who was of real interest to the two men.

'This is Nagaraj,' said Nataraj. 'He is a daily labourer who has been providing rations to Veerappan for the last three months. He has even met Veerappan in his hideout four times. He told us all this over a round of drinks, and we persuaded him to speak to the police. And with this we can earn some recognition and a share of the reward money.'

The excited officers questioned Nagaraj repeatedly till they were convinced that he had indeed met the outlaw. Then they hatched a plan.

After a few more visits to Veerappan's camp to ensure that he had won the brigand's complete trust, Nagaraj told him about some brokers from Bengaluru who wanted to buy ivory from the gang in exchange for a cache of arms and ammunition. The bandit showed interest, and delegated the task to his right-hand man, Gurunathan, a tall, burly fellow reputed to be an excellent gunsmith and as good a shot as Veerappan himself.

Posing as the brokers, Nataraj and Muthuram met Gurunathan. They were told that the gang needed guns and bullets, and they promised to arrange a meeting with an 'agent' from Mumbai.

A few days later, the 'agent' arrived. It was Shakeel Ahmed, dressed in casuals. It was past midnight when the trio of Nagaraj, Muthuram and Shakeel met Gurunathan and some other men in the forest. They were startled to see a girl with him. Muthuram panicked when he realized that he knew the girl. It was Chandni, a tribal girl from a nearby village.

He introduced himself and asked the girl why she was there.

The girl blushed and admitted that she was engaged to Gurunathan. The two had been introduced by a villager called Kamala Naika, who

had put Nagaraj in touch with Veerappan.

Shakeel, introduced to Gurunathan as Shivraj, took out a box of bullets. 'This is exactly what we want,' Gurunathan said enthusiastically. He also asked for Sten guns. 'Shivraj' was to take back ivory tusks in exchange. After negotiations on the price of the ivory, the two men shook hands on the deal.

'Shivraj' said that the main agent would personally come down from Mumbai for the deal that would be concluded in a few days.

On 17 February 1992, about thirty-five men set off for Dinnalli, Sathyamangalam. They included Shakeel and Harikrishna, dressed in T-shirts and jeans, with concealed firearms. The two officers, Nataraj, Nagaraj and Muthuram, and a driver squeezed into one car. Thirty police constables followed half a mile behind in a lorry.

The car stopped near the forest and Harikrishna told Nagaraj, 'Bring Gurunathan to us. Tell him that the man from Bombay has arrived with the goods.'

About an hour and a half later, Nagaraj returned. 'Gurunathan has asked you to come into the forest,' he said.

'Tell him that the main agent has come, but being a city fellow, he is scared of the forest. Gurunathan should come to the car,' responded Harikrishna.

After a few nerve-racking minutes, Gurunathan appeared along with Chandni. Shakeel got out of the back seat and Gurunathan got into the car. Shakeel got in next to him. Gurunathan was now sandwiched between Harikrishna and Shakeel. Nataraj and Chandni stood outside, chatting.

Harikrishna was introduced to Gurunathan as the 'main agent'. He handed over an empty Sten to the latter. After a moment's hesitation, Gurunathan gave his double-barrelled rifle to Shakeel to hold while he inspected the weapon.

Shakeel casually handed over the rifle to Muthuram and nodded. Shakeel and Harikrishna then gently leaned back to fish out the revolvers from their hip pockets. The unsuspecting Gurunathan was still engrossed in inspecting the Sten when in one coordinated move, the two policemen put their weapons to either side of the startled Gurunathan's head, even as Muthuram levelled the gangster's own rifle at his chest.

Outside the vehicle, Chandni's eyes widened as she saw the proceedings. But before she could react, Nataraj snatched her gun away and jerked her by her hair. A yelp of pain escaped from the girl's lips even as her lover, the fearsome Gurunathan, whimpered with fear inside the car. His hands were forced behind his back and he was handcuffed.

Chandni was taken to the MM Hills Police Station. Muthuram, who knew both Chandni and her mother, pleaded on her behalf, and she was let off after a warning to never get involved with criminals again. Gurunathan, meanwhile, is said to have agreed to lead the police to Veerappan's hideout.

One would think that following such a successful operation and with such a valuable asset, Veerappan would have been captured successfully. But that was not the case, as Gurunathan died before Veerappan was caught. To some, Gurunathan's death continues to remain a mystery to this day.

There are contradictory versions regarding the events that led to his death. Official records state that he tried to escape from custody and was shot during the attempt. But those sympathetic to the gang insist that he was killed in cold blood after he led the police to the place where he had last seen Veerappan—only to find that the bandit had already left the site.

Gurunathan's arrest was probably the biggest blow the police had managed to inflict upon Veerappan thus far, but it only served to enrage the bandit, who vowed to extract bloody retribution.

All my conversations with my men and the locals only strengthened my belief that Veerappan was not a man who would let any action by the authorities against him or his men go unanswered. And his first act of vengeance was an attack on a static location—Ramapura Police Station. So far he had ambushed policemen on the move. Now, for the first time, he planned an attack on their stronghold.

19 May 1992, 1 a.m.

It seemed to be yet another uneventful night.

Constable Rachappa yawned and stretched on the veranda of Ramapura Police Station, where he was on guard duty. Five of his

comrades were in deep slumber. Two policemen were inside the station. A van of the District Armed Reserve was parked across the road as part of the special arrangements to tackle the Veerappan menace. There were five more men sleeping inside. Sub-Inspector Rachaiah was in his house, a stone's throw from the police station.

Unnoticed by anyone, a khaki-clad figure emerged from the shadows. At a gesture from him, men silently surrounded the police station. Then the man raised his rifle and issued an order: '*Kollungada…orutthan thappaamei* (Kill all the SOBs. Nobody should escape).'

The sound of dozens of bullets being fired shattered the peace of the night. Most of the men sleeping on the floor of the veranda died instantly. One of them, Constable Nagesh, tried to run for cover, but was hit in the left arm and fell to the ground. He desperately dragged himself to the SI's motorcycle parked in the compound and ducked behind it.

Assistant Sub-Inspector (ASI) Subbanna and Constable Basavaraju, who were inside the police station, hastily locked the doors and fired back. Some incoming bullets managed to pierce the doors but, fortunately for the men, didn't hit either of them.

One of the men inside the van, Nagaraju, emerged from it and tried to run towards the SI's quarters, but was hit by a bullet in the left thigh and collapsed. The others ducked hastily in the van.

Veerappan and his men inched closer to the station. They broke into a storeroom and picked up six single-barrelled guns and ammunition, some of which the police had ironically seized from the gang earlier.

'Life comes full circle,' thought Veerappan wryly, and then turned to the situation at hand.

Inside the police station, Basavaraju frantically cranked the wireless set. The nearest police station at Hannur, some 18 km away, received the SOS. Inspector Venkataswamy, the man in charge, hastily assembled some men and dashed towards Ramapura.

As the rescue party roared at full speed to help their besieged colleagues, Venkataswamy, anxiously monitoring the wireless, clearly heard the sound of bullets being fired. 'They could easily be overwhelmed by the time we get there,' he thought despairingly. Then an idea struck him.

'I'm coming with a large force. We'll be there any minute. Keep fighting. We'll trap them,' he yelled into his wireless set.

As luck would have it, the wireless set in Ramapura Police Station was kept near the window and was set at full volume. Even through the hail of bullets, Veerappan heard Venkataswamy's assurance.

He quickly signalled to his men to withdraw.

Later, Venkataswamy narrated to me that by the time he arrived with his men, the bandits had already melted back into the forest. Five men were lying dead in the veranda. Nagesh and Nagaraju were barely alive. They had lost a lot of blood and were hastily sent to Kollegal Government Hospital.

The entire police force in the region was embarrassed by Veerappan's act, one that only added to his reputation for boldness. But his men told us after their surrender that the bandit's thirst for vengeance was not extinguished. He had not forgotten Harikrishna and Shakeel Ahmed.

◆

August 1992

'Anna, that fellow Kamala Naika is at it again,' said one of Veerappan's men. 'He's the one who introduced that snake Nagaraj to us. He's been meeting Shakeel Ahmed quite frequently of late.'

Veerappan looked up intently. 'Shakeel Ahmed? Isn't he the one who has sworn not to get married till I'm killed? His poor parents are never going to have the joy of seeing their son married.'

As his men filed away, leaving him alone, Veerappan's mind flashed over the events of the last few months. Nearly a month after his attack on Ramapura, the STF had engaged some of his gang members in Nallur village on 15 June and killed four of them. They were also keeping a close watch on villagers suspected of providing rations to him. This had infuriated him no end. As if killing his men wasn't enough, Harikrishna and Shakeel were also trying to cut off his supply lines.

'I need to hit back decisively and finish off these bastards once and for all,' thought Veerappan. 'But how?'

He sat there for hours, thinking, planning. As the shadows began

to lengthen, a tentative smile appeared on his face, which grew broader and broader.

Early the next morning, there was a knock on Naika's door. 'Who could it be at this hour?' wondered the police informer, rubbing his eyes. The knock became more insistent. 'I'm coming, I'm coming,' he snapped, and opened the latch.

The very next second, the door was shoved open from outside. The impact sent Naika sprawling to the floor. As he looked up, his drowsiness vanished instantly. Veerappan crossed the threshold, followed by some heavily armed men. Naika was seized roughly and hung upside down from the roof. His family was rounded up.

Veerappan walked up to Naika, gripped him firmly by his hair and growled, 'I know you've been acting as an informer for that dog Shakeel, so don't waste my time denying it. You have an important decision to make. I'm going to wipe out your entire family as you watch. Whom should I start with?'

Naika wept, 'Please, no. They are innocent. They didn't do anything. Kill me, but spare them, I beg you.'

Veerappan let him cry a while longer and then patted his head. 'You can still save their meaningless lives and your worthless skin. Would you like to?' he asked.

'Yes, yes. I'll do anything you say. Just don't hurt them, please,' he begged.

Veerappan grinned. 'I like the sound of that. Here's what I want you to do...'

A couple of hours later, an agitated Naika burst into Shakeel Ahmed's office.

'What's up?' asked Shakeel.

'I have some exciting news, saar,' said Naika. 'Veerappan's brother Arjunan is camping nearby. He has some 40 kg worth of tusks and is desperate for a buyer. I've offered to arrange a deal. This is a great chance to nab him.'

Shakeel jumped up. 'I'll get the men ready. We'll go right away,' he said.

But Naika wasn't done. He held up a hand to slow Shakeel down. 'Saar, they said the buyers must come in a white car, wearing white clothes.

How about we go in front and your men follow at some distance? Once we make contact with Arjunan, your men can race to the spot and get him and his gang.'

With no reason to suspect his informer, Shakeel agreed. He went to inform Harikrishna.

Harikrishna was in Bangalore when Shakeel called. 'Tell Naika to stall the deal for a day. Let me get back. There's no way I cannot be part of the raiding party,' he said.

On 14 August, Harikrishna, Shakeel and Naika set off for a place called Meenyam in a white Ambassador. There were three other constables in the car with them. A civilian lorry, filled with fifteen policemen in plain clothes, followed about 2 kilometres behind. Harikrishna was driving, with an AK-47 in his lap.

At around 1 p.m., they approached a bend in the road. Harikrishna noticed some boulders blocking the path.

'Please stop, saar. I'll remove the rocks,' said Naika.

Even as the car was slowing down, he opened the door and leapt out.

'What's his hurry?' thought Shakeel. And then the truth dawned on him. They were in a white car. All of them were in white clothes, but Naika had a bright red towel draped around his shoulders. In the forest, *that* would be extremely prominent.

'It's a trap,' Shakeel shouted, turning towards Harikrishna. Both men lunged for their weapons, but before they could do anything, bullets rained down upon the car.

The two men battled heroically, but were heavily outnumbered. Veerappan's gang still had relatively primitive weapons. There were about twenty guns, spread out across an ambush site chosen so well that it was a certain death trap. As Rudyard Kipling memorably pointed out in his poem 'Arithmetic on the Frontier', the superior technology of the British troops counted for nothing when confronted with a skilled Afghan marksman and his ten-rupee jezail.

As the car jerked under the hail of bullets, Veerappan nodded in satisfaction. 'No one could have survived that,' he thought.

Then he paused as he heard the sound of a speeding lorry. He signalled his men to stay concealed.

The lorry raced up; the policemen inside it were beside themselves with anxiety after hearing the gunshots. As they neared the spot where the car had halted, Veerappan gestured again. Immediately, logs were hurled down, blocking any retreat.

Veerappan's men opened fire once more, while the policemen concealed themselves as best as they could and returned fire. After some time, another vehicle was heard approaching. Veerappan signalled his men and they fled back into the forest.

The vehicle was a civilian bus heading from Meenyam to Kollegal.

The investigation of the ambush was conducted by Venkataswamy, the same man whose inspired bluff had saved the day when Veerappan attacked the Ramapura Police Station.

Venkataswamy later narrated the incident to me. Among those he had spoken to was Inspector Mandappa, who was travelling in the police lorry that was ambushed by the gang and was wounded in the gunfight that followed.

Mandappa had shuddered as he recounted the horrifying scene he saw that day.

The Ambassador in which Harikrishna and Shakeel were travelling had multiple bullet holes. The car seats were stained with blood and littered with broken glass.

As the bus screeched to a halt, male passengers rushed out to assist the policemen lying on the ground. Mandappa recalled their shocked expressions when they saw the state of the two men in the car.

There were six shotgun bullet wounds on Shakeel's body and Harikrishna's body too was riddled with bullet holes. Apart from the two officers, four other policemen died in the exchange of fire that day, while another seven were seriously wounded. Kamala Naika also died that morning. But Veerappan did not suffer a single casualty, causing his reputation to grow further as he claimed credit for the attack.

Harikrishna's death was the first time an SP had been killed in a shootout with a criminal in Karnataka. The 15 August flag-hoisting was a miserable ceremony for his colleagues. But Veerappan's largest bloodbath was still to come.

The Good Friday Massacre

July 2001

Life in Sathyamangalam was a series of patrols, mostly routine, but not devoid of danger. It was elephant territory and we had to be doubly careful never to cross paths with the wild animals. I had merely a section of ten STF men with me, but invisible to me were more troops as backup.

On one patrol, while following up a lead, we were in the forests along the Kerala-Tamil Nadu border. All of us were on edge, not just due to the hostile terrain, but also because we were on the turf of a deadly tusker, which had already killed three people in both states in the last few months.

Just then, I slipped and slid on a slick slope. Warily, I looked around, trying to see if I had brushed against any leaves of aanai miratti—commonly referred to as Devil's Nettle or elephant nettle—during my descent. The itching the plant induces is so terrible that elephants are known to go crazy after brushing against it. If that was not enough, there were hundreds of leeches on our track.

The lean man in front of me turned around, concerned. 'Are you all right, sir?' he asked.

I nodded and replied, 'A couple of tumbles are par for the course when one comes into the forest for a patrol with DSP Ashok Kumar, no?'

Ashok simply smiled, shook his head and mumbled something so softly that I was unable to catch it.

I noticed Ashok wince and surreptitiously scratch his calf. 'Tick rash

troubling you again?' I asked.

He made a face and nodded. 'Let's have a look,' I said.

Ashok's leg was a horrifying sight. The rashes, if you could call them that, were like boils. Some had burst; others were on the verge of it. 'You have been neglecting this for a long time. Why don't you take time off and see a doctor?' I enquired.

'Every time I plan a visit to the doctor, I get some fresh intel and decide to do just one more combing operation. Maybe this will be the lucky one,' he said. 'Who would ever believe this slight, soft-spoken man is one of the most decorated veterans of the Tamil Nadu Police, who took part in the operation to crush Naxalites under Walter Davaram in Vellore and Dharmapuri between 1980 and 1985?' I thought.

Ashok turned around and resumed walking. I followed, paying more attention to the terrain this time. But I still could not stop myself from thinking about what Ashok Kumar had witnessed on that black day in the history of the police force. And yet, he had come back for more of the same.

Ashok Kumar was present at the deadly encounter that had led to the formation of the STF. It was a day that had sent shockwaves through the police and public of the three southern states. Twenty-two people had died on 9 April 1993, but they were collateral damage, as Veerappan's target was an SP of the Tamil Nadu Police, K. Gopalakrishnan, affectionately nicknamed 'Rambo'.

When I asked Ashok Kumar if he ever thought about the Good Friday massacre, he took a deep breath, as though to steady himself, and said, 'Every single day. I don't think I'll stop till we finally get him.'

9 April 1993

Rambo used to head a forty-two-man team called the Jungle Patrol—named after the force formed and commanded by the Phantom in the popular comic series. It was after the brutal murders of Shakeel and Harikrishna in 1992 that the Jungle Patrol was further strengthened.

Extremely well built, with huge biceps, Rambo was an imposing sight. So imposing that his comrades from his stint as DSP in Ramnad district

recalled that whenever he would nap after a long night on the job in his residence-cum-camp office near a school, awestruck children would peep in, giggling as they pointed to his huge muscles.

Like Veerappan, 'Rambo' Gopalakrishnan also belonged to the Vanniyar caste—even sharing the same fiercely martial sub-caste, Arasu Padayachi—and knew the area extremely well. For all his size, he moved with feline grace.

A man to lead from the front, Rambo also had the distinction of having personally looked down from most hilltops in the area. He commanded strong loyalty from his team, not just because he, on occasion, rustled up tasty meals for them but also due to the fact that he dipped into his personal savings for his men if ever the Jungle Patrol's salaries did not arrive on time.

Apart from the policemen reporting to him, Rambo also had an extensive network of informers and guides—many of whom had been associated with Veerappan in some way in the past.

One of Rambo's senior-most guides was Kolandapaiyan, the elder brother of Veerappan's trusted aide, Sethukuli Govindan. Kolandapaiyan used to be one of the top men in Veerappan's gang during the days when he was principally an elephant poacher. But he had drifted away and was now trying to lead a reformed life.

On the morning of 9 April, also Good Friday that year, a huge banner was found in Kolathur village, taunting Rambo in coarse Tamil slang, daring him to come catch Veerappan at a place called Suraikamaduvu. A furious Gopalakrishnan took the bait hook, line and sinker. He summoned his team.

'Things don't seem right,' Kolandapaiyan tried to express his reservations.

'I am going, no matter what,' said Gopalakrishnan. 'What is bothering you?' he asked.

It seemed as though Kolandapaiyan wanted to say something, but changed his mind. He shrugged and picked up his gear. 'We should be careful,' he said.

As Gopalakrishnan neared Palar Bridge, the jeep carrying him and his men broke down. They abandoned the vehicle and borrowed two buses

from the Karnataka policemen stationed at the bridge on the Tamil Nadu-Karnataka border. One bus carrying Gopalakrishnan, fifteen informers, four policemen and two forest watchers took the lead. The second bus, carrying Inspector Ashok Kumar and six Tamil Nadu policemen, plus an escort party from the Karnataka Police, followed.

A restless Rambo stood near the door of the lead bus, an AK-47 reclining on his shoulder, his left hand gripping a steel bar behind a seat, ready to pounce.

Meanwhile, Veerappan, who, as per a debate in the Tamil Nadu Legislative Assembly just a week before this incident, was speculated to be in Mumbai, reclined lazily on a rock overlooking a track next to the dry Palar River—the only route for Rambo's motorcade. He kept a close eye on his explosives expert, Simon, as he made his final preparations. Simon was obviously not too devout a Christian, because the fact that his handiwork would take several lives on such a sacred day didn't seem to have bothered him in the least.

Gang members who surrendered later revealed that on that fateful day, Veerappan's men had just one .303 and twenty muzzle-loaders between them. In terms of firepower, they would have been vastly outgunned by Rambo's party. But the balance of power had shifted in the outlaw's favour, thanks to the explosives they had forcibly procured from the owners of several black-granite quarries in the area.

The gangsters heard the rumble of bus engines and sighted the two buses, but not Rambo's jeep. Confused, they wondered if their prey had stayed away. Then a shrill whistle from Veerappan dispelled their doubts. Even from a vast distance, his eyes, sharpened by years of living in the jungle, had spotted Gopalakrishnan.

Simon joined the leads of a 12-volt car battery linked to the mines; all hell broke loose. The earth beneath the buses erupted, superheated to over 3,000 degrees Celsius. Shockwaves spread, chasing each other, and threw the buses into the air. The bus in front, with Rambo in it, bore the brunt of the impact, instantly turning into a coffin on wheels. The rubble and stone, thrown upwards at speeds of over 1,000kmph, came crashing back to earth in a mixed shower of mud, metal and gore.

Gopalakrishnan was thrown out of the vehicle and fell into a nearby

ditch, with severe injuries on his left leg, left hand and face. Mangled body parts rained down on bushes and rocks alongside the road. Some pieces of flesh got stuck in the branches of nearby trees.

The first bus was reduced to a warped mass of steel. Pieces of its chassis lay scattered all over. The tyres were torn from their rims. Elsewhere on the killing field, ripped parts of steel had mixed with bloodied body parts.

Even Veerappan, who had ducked behind a rock when the blast occurred, was stunned by the sight of the carnage. He started to shiver and sweat. For a moment, one of his lieutenants thought he might have to give his chief a couple of slaps to snap him out of his panic attack. But something else did the trick—gunshots from the buses.

The Jungle Patrol was fighting back!

Ashok Kumar, who was following in the second vehicle, recalled that as the bus in front of him was blown to bits, lots of mud splattered on the front windscreen of his vehicle. The driver slammed the brakes.

Ashok leapt down, followed by Head Constable Krishnasamy, who carried a light machine gun (LMG). The two men sensed movement near the bushes and realized that the gang members had crept down. They wanted to finish off any survivors and loot their weapons. Ashok Kumar began to fire his AK-47 immediately. Krishnasamy joined in, as did the other policemen, and sprayed the surrounding area with bullets.

After some time Ashok Kumar shouted at his men, asking them to stop the indiscriminate firing. Bullets were exchanged from both sides for a while after that as the gang tried to outflank the surviving policemen.

Gradually, the firing died down and Ashok Kumar realized that the gang had fled. He surveyed the surroundings grimly. Fourteen pits had been dug in a row, each 10 feet apart. These pits had been filled with potent explosives, connected by a long stretch of fuse wire. This entire setup had been concealed with stones and mud. The wire had been drawn at a distance of some 200 feet up a rocky hill, where the gang had lain in wait for Rambo and triggered the explosion when his vehicle was in the middle of the pits.

Shock finally set in, and a trembling Ashok Kumar counted twenty-one charred bodies. The groans of the wounded resonated in the air. As

he advanced cautiously, he saw Rambo being carried by two constables.

'Take him to the second vehicle. Load all the other wounded on it and get them out of here fast,' he yelled.

Unfortunately, one of the constables named Sugumar, who eagerly wanted to be among the first to strike, had been hurled a fair distance away and was only spotted after the bus had already left. He died shortly thereafter.

◆

I was brought back to the present by some noise in the underbrush, which forced the entire party to a standstill. As we waited, I remembered what Ashok Kumar had told me about the later events of that day and the subsequent investigation.

When news of Kolandapaiyan's death was conveyed to his wife, she apparently broke down and said, 'This is bound to happen when you ignore Veerappan's warning.'

Three days before the Good Friday massacre, on 6 April, an urchin had met Kolandapaiyan's wife and told her that her husband's younger brother Govindan had asked her to come to the Chettypatty River ghat. When she went there she met a stranger who said, rather cryptically, 'Tell your husband to keep away from the jungle.'

'Is that a warning or a threat?' she had wondered as she mopped the sweat from her forehead. She looked towards the messenger for a clarification, but he had melted back into the forest.

A couple of days later, the same urchin had repeated the message to the thoroughly alarmed woman, who had warned Kolandapaiyan and pleaded with him to sever all links with 'Rambo' Gopalakrishnan.

Whatever his reasons, Kolandapaiyan had decided to go into the forest that day. Perhaps the senseless killing of the twenty-two people could have been avoided had the man simply told the police officer about the warnings his wife had received. But his pride had stopped him, even as a misguided sense of loyalty made him walk into a trap.

The Good Friday blast sent shockwaves through the states of Tamil Nadu and Karnataka. Overnight, Veerappan was catapulted to celebrity-hood, albeit for all the wrong reasons. The price on his head now shot up

fourfold to ₹20 lakh. His name began to evoke awe and dread, particularly in the areas he frequented.

Rambo was severely injured in the blast, but legends like him die hard. Or maybe his sheer size helped minimize the damage. He was rushed to Salem, where the medical team was amazed to see that he had survived. Doctors and nurses who attended to him later said that while being treated he mumbled 'My boys' twice before losing consciousness.

When he woke up several hours later, he was again in for a shock. He found then Chief Minister J. Jayalalithaa by his bedside. 'The doctors told me you've taken it well. You should be okay,' she said.

Rambo may have survived, but was forced to go on medical leave for more than a year. He also underwent almost a dozen surgeries, and lived in constant pain since then. Eventually, Rambo passed away on 11 September 2016 at a Chennai hospital.

I had been standing right behind the CM when she met Rambo, as I was in charge of the CM's security detail at the time. After my stint with the SPG, I had returned to my home cadre, Tamil Nadu. Due to her tough stance against the LTTE, there was a threat to the CM's life, especially after the assassination of former prime minister Rajiv Gandhi. I was tasked to set up an elite protection group for the CM, called the Special Security Group, which I created as a hybrid of the SPG and NSG.

At that moment in the hospital, I bristled at the thought of how much damage one man with so much negative energy could cause.

Jayalalithaa had been grim-faced when she emerged from her meeting with Gopalakrishnan. 'This cannot go on,' she declared, and followed it up with a series of meetings with her counterpart in Karnataka, M. Veerappa Moily. The two states immediately agreed to cooperate to bring Veerappan to justice, once and for all.

As a result of the meetings, the Tamil Nadu STF formally came into being, with my mentor Walter Davaram as its first head. The first thing Walter did was to issue a clarion call for volunteers. Many sub-inspectors simply wrote 'joining STF' in their respective police stations' general diary and went off to join the force. But Walter picked only the finest. Eventually, some 250 volunteers from the 60,000-odd personnel in the Tamil Nadu police force made the cut.

Rambo's Jungle Patrol was transformed into the operational nucleus of the STF, with Ashok Kumar and many others of the original team making it their life's mission to get Veerappan. The Karnataka STF too was similarly energized, with Gopal Hosur reporting as SP the day after the massacre, for the second time, under Shankar Bidari, who had joined as DIG just two months before this episode.

Back then too I had desperately wanted to be part of the STF, but knew that it would be difficult to be relieved from my assignment of handling the CM's security. Even so, I decided that I would do all that I could to help make the STF an elite team.

I recall asking my team member ASP Sanjay Arora if he would like to volunteer. He had jumped at the offer.

'You're very lucky,' I told him, adding that he was free to take anyone or anything from the SSG. Sanjay didn't need to be asked twice. He immediately requisitioned some AK-47s (ironically, these weapons had been seized from the LTTE, which had led to wry jokes among the STF members about how they had probably originated from India to begin with, since it was an open secret that India had equipped the LTTE in its formative years). Sanjay also shortlisted seven of the best sub-inspectors. In all, fifteen men from the SSG went to the STF, whose members also received training at our centre on the outskirts of Chennai.

Jayalalithaa personally met all fifteen men that I had skimmed from her security detail. Far from being upset at losing them, she wished them the best of luck on their mission.

Meanwhile, unknown to us, there was a silver lining to the ambush. We found out months later that when Ashok Kumar and his team had opened fire, Simon, the explosives expert, had hastily jumped from a large rock to flee, but ended up fracturing his leg in the process. Maybe he was being made to pay for his sins.

Simon was quickly carried away by the rest of the gang, but was forced to go to a hospital in Tiruppur a few months later, where he was arrested following a tip-off. As his leg was still pretty badly injured, Simon was carried around in a palanquin by the STF men, when he revealed all the places that he had extensively mined. He, along with three others, was sentenced to death in 2004—the same year that Veerappan was killed.

They are still on death row, awaiting the Supreme Court's disposal of their plea.

Simon's revelations eventually saved many lives. But the disclosure didn't happen till a few months after the Palar blast—by which time a large STF contingent and I had had a miraculous escape.

Three Hit, Not Out

July 2001

Walter patiently emptied about twenty dead leeches—swollen with the blood they had sucked from him—from one boot. He extracted a similar number from his other boot. He had just returned to the travellers' bungalow in Coimbatore after spending a day trekking through the jungle, chasing elusive leads. As usual, he had ignored the fact that leeches and the blood-thinning medicine the doctors had ordered him to take were not a good combination.

His extraction of leeches done, Walter handed me a booklet, 'The Hunt for Kimathi'. 'You'll find this interesting. The Mau Mau insurgents in Kenya used tactics very similar to those employed by Veerappan,' he said. 'They even shared the same large doses of good fortune.'

I couldn't help but smile. At sixty-plus, the legendary super cop still retained his fire and the ability to motivate all those who served under him. With his bristling moustache and imposing physique, he instantly commanded attention, even if one had not heard of his awe-inspiring achievements.

'That damned bandit has had more lives than a cat, and some of his luck seems to have rubbed off on his men. But we'll get him one day,' he continued.

Walter was now overseeing the operations of both the Tamil Nadu and Karnataka STFs. I was delighted to be reporting to him once again. While I was serving as SP in Dharmapuri and Salem between 1981 and

1985, he was my boss and the DIG, Vellore. He was credited with nearly wiping out Naxalism in the area in those five years. He had set many records—including being the only officer to have visited each of the over 1,100 police stations in Tamil Nadu, during which he left delightful visiting notes.

Most of my weekends during my stint under Walter were spent conducting raids or going on treks led by my boss, who liked nothing better than to be out in the field. That suited me just fine, because I too deeply dislike sitting behind a desk, pushing paper.

Exactly a month after the Good Friday blast, the STF entered Veerappan's den. In his first ambush against Veerappan, Walter nearly succeeded in getting him. But not only did the wily bandit escape, the STF ambush in Veerappan's core area produced one of the most interesting episodes in the STF's history.

'I have heard this story before,' I said. 'Could you please tell me in greater detail, sir?'

Walter leaned back, put his feet up, and began, 'It was nearly a month after the STF had been formed, following the attack on Rambo...'

◆

8 May 1993

The fifteen-man patrol party exchanged glances as Walter Davaram took up position with them around midnight. They had been staking out Gundam, a funnel-like place surrounded by the villages of Neethipuram, Marimadoovu and Chinnamalai Kanavai—all favoured hubs of Veerappan—when Walter decided to join the operation.

As dawn broke, Walter told most of the men, 'Go back to the thanda.' A thanda is a cluster of huts of the itinerant Lambadi tribals.

Lying inert for long was not in Walter's nature. He had won numerous medals in snap shooting, where the target would disappear in three seconds. Here, he lay quietly for six hours without a target in sight.

After the inactive night, he felt restless and decided to explore the area a bit. He asked for four men to stay back from the party and accompany

him on an impromptu patrol.

A scout went in front, followed by Walter and the three others. Walter was not wearing his sew-on insignia. This served a dual purpose. One, it quietly spread the 'no distinction on the basis of rank' culture in the STF; and two, it was a tactical move. An epaulette or badge can be spotted from miles away. That's how LTTE snipers perched atop coconut trees had picked off Indian Peace Keeping Force officers in Jaffna, back in 1988.

The five men marched for four hours, each one keeping a regulation gap of about 15 feet. They skipped their breakfast of a loaf of bread. They ate a late lunch instead and continued their march.

Suddenly, the scout turned slightly, raising his finger to his lips. *Human voices!* He leaned forward, his left palm pressing on a tree trunk, neck craned, standing on his toes, straining to see something.

As the rest of the team waited on alert, he signalled. *Enemy. No weapons.*

He spotted the sentry of the gang. The sentry not only failed to notice the intruders, he was completely distracted at that point. Ideally, he should have been aloft a tree. But at the time female gang members were bathing around the bend in the river and would have lost their privacy. So the adolescent sentry was relocated and told strictly not to peek. Rengaswamy, the camp cook who gave a detailed account of that day upon his surrender, said that it was obviously asking a lot of a young lad. The sentry had been battling his voyeuristic instincts for almost an hour, but when a burst of laughing and giggling broke out from the forbidden zone, it dissolved his willpower.

He inched forward, trying to ensure that he would not be spotted by the men in the camp, and craned his neck to get a better angle. He could hear the women clearly, but couldn't see much. As he tried to get a better angle, some movement registered in the sentry's peripheral vision.

What was that?

Jerking his head half a circle, he spotted the five intruders. He looked at his bare hands.

Where was the gun?

It was leaning against a tree. Recovering quickly, he leapt for it.

Walter and his men were hoping to take out the sentry silently. But

the element of surprise was lost and the sentry's gun was now pointed at them.

'Shoot!' yelled Walter.

All five STF men opened up. The bandits, who had not expected a personal visit by the STF chief, were busy washing clothes and bathing in a stream, and were caught completely unawares. '*Oru vaaramachu! Naaruthu. Nalla kullingada* (It's been a week since you bathed. You guys stink. Bathe properly),' Veerappan had joked with his gang. Before he could finish, bullets began flying all around. The sound of the bullets merged with the screams of the women and bewildered questions shouted by the men. Then Veerappan's stentorian voice cut through the hubbub.

'*Odungada* (Run),' he shouted.

The gang did not need to be told twice. Chased by bursts of AK-47 fire, they scrambled out of the water—both men and women, their bodies wrapped in whatever clothes they could grab. Some were still naked.

Two of Walter's men chased them, across the stream and up a small hump and then over the hard ground that suddenly dipped steeply downward.

Walter saw a group of bandits fleeing some 50 metres away. At that distance, it isn't easy to hit a rapidly moving target, but Walter, a pistol champion for over two decades, fired without hesitation. Soon, he caught up with his boys.

One of them excitedly said, '*Ayya, moonu per ulundhutangoe* (Three chaps have fallen).'

'Veerappan?' queried Walter eagerly.

The man shrugged. 'Can't be sure, but three men definitely went down.'

Walter peered into the shadowed underbrush. There was no sign of the wounded men anywhere. As the adrenalin of the sudden encounter wore off, his tactical brain took over.

Running around in the approaching darkness on a riverbed that was probably mined would be unwise. The enemy knew the terrain better and would regroup soon. What if they staged a counter-attack? A full team of fifteen men with an LMG would have really helped. Still, there was no point wasting time on regrets.

He tried to use the wireless set to call, 'LION calling control.' No response. He tried again. He wanted reinforcements, but couldn't get through. 'It's a shadow area, sir,' said the man operating the radio.

'The whole bloody place is swarming with shadows,' cursed Walter and reluctantly ordered the team that had cut its teeth in the very first ops to return to camp.

The next day, Walter returned with the full squad of fifteen at the crack of dawn. 'Be careful about the corpses. The bandits might have booby-trapped them or set an ambush for us,' he warned his team.

The fifteen men split into three groups. Team One's scout and his buddy scampered off to the area where the dramatic chase had taken place the previous day.

The scout slowed down, then stopped. A puzzled expression appeared on his face. The rest of his team peered over his shoulder.

'What's happening?' asked Walter, catching up.

'No bodies, sir,' replied the scout. 'Only blood trails.'

Walter examined the soiled earth. In a few hours, the blood had turned from bright red to dark brown. For the trained eye, blood has its own distinctive signature. If frothy, it must have emerged from the lungs. If heavy and slimy, it is most likely from the head. And if it resembles gelatin, it has probably come from the abdomen, perhaps mixed with digestive juices.

But this blood trail seemed steady, normal. 'Must be from the trunk,' guessed Walter. 'A fair amount of blood had been spilt, but not enough to drain out the lives of the wounded,' he concluded.

Even though ants and fleas were busy on the blood that had not already seeped into the ground, there were still three distinct streaks of dried blood on some rocks.

'Look,' pointed one of the men.

There were some drag marks on the ground that went on for about 50 metres and converged with two other blood trails.

The three men had possibly been given first aid there.

Team Two tracked some intermittent crimson spots for another 100 metres uphill. At that point, the trail went cold.

The mystery was solved three months later, after one of the three men

who were injured that day surrendered and narrated the series of events.

The three—Sundanvellayan, Arunakkaveetu Chinnaraj and the samayal (cook) Rengasamy—had been hit and were bleeding heavily, but the bullets had exited through each one without inflicting fatal damage.

Sundanvellayan was the worst hit—four bullets, each packing nearly 2,000 joules at the muzzle end, which should have normally incapacitated or killed him but had gone through him without doing either.

Chinnaraj had taken three rounds and collapsed to the ground. He had lain there for some minutes, to all appearances dead. But once again, the 7.62 x 39 calibre bullets had not dumped their entire kinetic energy in his body before exiting cleanly. He had managed to drag himself to the rendezvous point, where all three were quickly treated with herbs, even as Veerappan and the remaining men prepared to repel any unwelcome guests.

Rengasamy, who surrendered, gave a blow-by-blow account of the encounter. It was met with considerable scepticism till he peeled off his shirt and showed his scars. The bullet had cut through the forearm muscle and snapped a bone, but had not touched any major artery, vein or nerve. A high-velocity bullet can cause serious damage if it hits the heart, brain or bladder. But it has a more benign impact on muscles and bones, which was where the three had been hit.

Eventually, all three men—including Rengasamy, who later rejoined Veerappan—would fall to STF bullets. But not that day, and not to those bullets.

Their survival only inflated Veerappan's sense of hubris, especially after he learned that Walter himself had been present at the raid.

'The gods love and protect me,' he had bragged to his associates. '*Yarum masurai pudunga mudiyadhu* (No one can pluck a single hair of mine).'

The Fort without a King

July 2001

'Do you miss the STF?' I asked Sanjay Arora, who had just returned to Tamil Nadu as DIG after a five-year stint in the Indo-Tibetan Border Police.

Sanjay was the first IPS officer (apart from Walter) to have volunteered for the STF in 1993, after he relinquished his post in Jayalalithaa's security detail.

He smiled and said, 'I don't think my wife does, though she was a good sport about my first stint with the STF. She joined me along with our son, who was just a baby, and we stayed in one room in the then STF headquarters in Mettur. She never complained even when I was out on patrols every day. I think she's glad she doesn't have to worry about me on a daily basis now. But I must confess that I do get nostalgic every time I come here. It's always good to catch up with the boys.'

The STF personnel reciprocated his sentiments. Tall, good-looking and unflappable, Sanjay's call sign (code name) was 'STAR'. An engineer by training, Sanjay hailed from Jaipur and spoke Tamil fluently. Everyone down to the lowest ranks was addressed by him with utmost courtesy. The boys adored him.

He had been hand-picked by me as part of the CM's security team before he had volunteered for the STF, where he served as Walter's No. 2. The two men got on well, despite the twenty-five-year gap (Walter was from the 1963 IPS batch; Sanjay, 1988).

Sanjay also worked with Shankar Bidari, head of the Karnataka STF, who was ten years his senior, as Walter was frequently called away on important work. He handled this potentially tricky situation with his usual quiet competence. His ability to be either gentle or firm, depending on the situation, and his maturity, which belied his relative youth, made him an ideal foul-weather captain.

Not one to beat around the bush for long, Sanjay got straight to the point. 'You wanted to speak to me about something, sir?'

'I wanted to ask you about the raid on Veerappan's den,' I replied.

May 1993

Following the Good Friday massacre, the media was rife with speculation that the military would be called in to nab Veerappan. Finally it was not the military, but the paramilitary.

On the Karnataka government's request, a battalion of the BSF arrived, with its senior officers expressing confidence that the task would be accomplished within three months.

Anyone familiar with hunting fugitives or insurgents would tell you that catching a wily foe is easier said than done, especially in a hostile terrain that the enemy knows like the back of his hand and with a local population whose customs and language are unfamiliar to you. But strangely, troops often have to go through the same learning curve every time—from Vietnam to Afghanistan, and even during the Indian Army's stint in Sri Lanka.

As the BSF geared up to begin operations, we learned through our network of informants that Veerappan had seeded all the three narrow tracks leading to his virtual fort at the foothills of Bodamalai with mines. The SP in Salem confirmed that after the ground was dug up and the mines planted, cowherds were forced to march their cattle several times over the ground to erase any signs of digging. Veerappan's sentries occupied the knolls that overlooked the tracks round the clock.

All this had been done under the direct supervision of a short man, who sported a crucifix on his chest (later revealed to be Simon of the Good Friday blast fame.) The most alarming part of the intel was that

apart from the buried ones, some mines were also hung from trees.

This posed a bigger tactical threat, especially as brushing accidentally against even one—which was entirely possible, given the narrowness of the tracks, especially if a patrol was conducted at night—would be disastrous.

Even as the STF mulled over the best way to proceed, on 21 May 1993, Sanjay Arora received information that pinpointed Veerappan's den. He ordered his team to prepare for a raid immediately.

Darkness had descended by the time the final preparations were done. In fact, it was almost pitch dark. 'But darkness, like the jungle, is neutral,' reasoned Sanjay. 'If you master it better than your foe, it becomes an advantage.'

'Let's move,' Sanjay told his team.

His team marched, their steps nearly synchronized. In less than two hours, they reached Valankulipatti.

Sanjay then signalled with his right hand, palm down. The team halted. Next to his scout was the informer who claimed that he had broken bread with the gang only two days ago. The man jerked his thumb to his right, pointing to a sort of tunnel through the dense bushes. Sanjay dropped on his stomach and pulled himself forward. The rest of the team followed. Wriggling on their tummies, working one knee and one palm at a time, they moved through the tunnel. The scout pinched his nose to suppress a sneeze that could have wrecked all their efforts.

'This tunnel could have been made either by wild boar or men,' thought Sanjay, sensing that this could easily be a trap. 'If either suddenly comes charging at us from the opposite direction, things could get really messy.'

After a crawl of a few tension-filled minutes, the team ended up in a clearing barely 30 yards in diameter. As they cautiously rose to their feet, their eyes darted left and right, checking every inch for potential threats. Suddenly, the moon, which had been hiding behind thick clouds, shone on the clearing. The men ducked hastily—some, not finding any cover, simply sank to the ground, trying to present the smallest possible target.

In the same light, they saw something dark and squat at the centre of the clearing, but were unable to make out exactly what it was.

The scout thought he heard a rustle in the bushes and threw a clump of earth towards it. All the men familiar with the area knew the simple formula. If there was movement in the bushes, it meant an animal was concealed there. If nothing happened, the odds were that the place was either empty or occupied by the wiliest animal of all—man.

They lay quietly for a minute. The moon disappeared behind the clouds once again.

The men could hardly see their own guns, let alone make out a hand signal. So they resorted to a method familiar to most hunting tribes—quietly tap the head of the man behind. Without even a decibel of sound, the message was relayed to the entire group. They rose to their feet and closed in silently.

The dark form turned out to be the circle of a well, which provided potable water for Veerappan's massive camp of over a hundred men and women. But the site itself was abandoned. A detailed survey revealed some rations, torn garments, sheets and ashes where food had obviously been cooked.

'They've gone, sir,' said one of the men. 'They must have left at least a week ago.' If only the STF had had helicopters and drone backup, then this march of the bandits could have been stopped in its tracks at Bodamalai and a hundred deaths could have been avoided. But that was not meant to be. The STF became heliborne only in the year 2000.

Unknown to the STF, which relied on human intelligence that, at times, could be several weeks old, or even misinformation provided by the locals to create diversions for the brigand, Veerappan and his gang had embarked on a westward migration. They would not return to their old hunting grounds till 2001, though Veerappan was known to make the odd quick trip to Gopinatham, accompanied by one or two men.

Sanjay recalled being puzzled about the absence of the brigand. 'Where could they have gone?' he had wondered at that time. The answer was revealed soon in a blaze of gunfire that almost claimed the life of another senior officer.

Ambush in MM Hills

July 2001

I slapped the file down on the desk. My head was spinning, trying to make sense of what I was reading, but it seemed to be a big hotchpotch. There were almost as many versions of the events of that day in MM Hills as the number of people. Given the remoteness of the region and the fact that news, at times, took days to reach the police, it often got embellished to add dramatic effect in the retelling. And every retelling changed the story a bit, depending on the leanings of the storyteller.

'Just how many descriptions exist on this encounter? The media says one thing quoting Veerappan's sympathizers, our report says something else, and even the people who were present at the battle don't seem to agree on what happened,' I wondered.

Even as I rubbed my forehead to ease a twinge, Karuppusamy said, 'It's the fog of battle, sir. Everything happens so fast. The people present only manage to grasp glimpses of the incident. You too played a part that day, remember?'

I nodded. It was by sheer chance that I had been present when the badly wounded Gopal Hosur, an SP in the Karnataka STF, was rushed to hospital after what was one of the most dramatic attacks staged by Veerappan.

This is what happened that day, to the best of my knowledge...

◆

May 1993

Veerappan's courier was on edge. As he scurried away from the village, he kept sneaking furtive glances all around him, trying to ensure that he was not being followed. Then a familiar voice called his name and his heart sank.

'Dei Punnuswamy, where are you going in such a rush?' asked Sethukuli Govindan, Veerappan's distant cousin and a new rising star within the gang.

Punnuswamy laughed nervously, 'Oh hello, what are you doing here?' he asked.

Govindan walked up to Punnuswamy. He placed his palm on the back of Punnuswamy's head and stared into his eyes, speaking in a soft but menacing voice. 'Funny, I had the same question for you. Why don't you answer first?' he asked.

Punnuswamy's faltering nerves crumbled and he collapsed to his knees. 'Please don't hurt me. I'll tell you everything,' he wailed.

A few hours later, Govindan was pushing Punnuswamy into the gang's camp. The commotion brought Veerappan to the scene. 'What's going on?' he demanded.

Punnuswamy later told the police that he had fallen at Veerappan's feet and wrapped his hands around his legs. '*Anna, nananu ksamisu* (Elder brother, forgive me). I had no intention of harming you. They forced me to take the gun. They said I should sneak into the camp and kill you whenever I get the chance. I was going to tell you everything. Spare my life, I beg you,' he snivelled.

'Who are "they"?' asked Veerappan.

'The STF dogs,' whimpered Punnuswamy.

A smile crossed Veerappan's face as he leaned down to pat the man grovelling at his feet. 'The Karnataka STF is planning to kill me, da? I think it's time they too were taught a lesson,' he snarled.

It was a beautiful morning on 24 May 1993 in MM Hills, some 150 km from Mysore. The road to Mysore has many S-curves and the surrounding greenery and bright sunshine made for a picturesque setting. The beauty of it was completely lost on Veerappan as he lay on a

hillock, eagerly awaiting his prey. He knew every inch of the place. Once, not far from here, hordes of villagers on a daily wage of ₹20, which they cheerfully took, used to harvest one of the world's best sandalwood varieties.

Veerappan only had eyes for the road, where the Karnataka STF convoy was expected any moment. His men had kept watch on the STF camp, monitoring all movement in and out of it for almost a week. They had picked out the ambush spot a couple of days back and were lying in wait ever since.

Around 7 a.m., Veerappan tensed as his keen ears picked up the sound of approaching vehicles. He nodded grimly. Three distinct sounds. Soon, three police jeeps came into view. The front and rear jeeps were probably escort vehicles. Veerappan's eyes focused on the middle one, which was carrying Gopal Hosur, the STF SP who commanded the camp in MM Hills. He was a major thorn in Veerappan's flesh.

'Not for much longer,' thought the bandit grimly, even as he began savouring the moment when he would give the order to open fire.

Bang!

A shot rang out just seconds before the convoy would have been hopelessly trapped.

'What the hell! Which idiot fired before I gave the go-ahead? I'll kill him myself,' roared Veerappan.

But his voice was drowned out as his other men too began shooting in a chain reaction. A furious Veerappan roared with impotent rage as he emptied his weapon at the vehicles.

Despite the premature firing, the convoy was riddled with bullets. Many STF men were hit before they could even process what was going on. Others quickly spilled out of the jeeps to take cover behind the trees and fired back.

Gopal's driver, Ravi, felt a sharp pain in his right wrist as a bullet went through. Groaning, he quickly sized up the situation. 'It's hopeless,' he thought and turned to look at the back seat.

He saw that Gopal had raised his AK-47, even though he was bleeding profusely from the neck. The sight jolted Ravi into action.

Frantically, he tried to manoeuvre the jeep, but it didn't respond.

Puzzled, he looked at his right hand and realized that there was no strength left in it. Ravi swore, then grabbed the steering wheel with his left and reversed as fast as he could.

'He's getting away,' yelled Veerappan. 'After him!'

The outlaws broke cover and raced towards the road. But the jeep was too fast.

Veerappan turned his face to the sky and howled in frustration. 'I'll get you another day,' he screamed.

With effort, he composed himself. 'Time to get out of here,' he ordered. 'Make sure to cut down a tree and block the route in case they send a search party after us.'

As his men began to melt away, Veerappan strode up to one of the jeeps in which all the occupants were lying dead.

'I'll get myself a little souvenir,' he said, pulling out a 7.62 mm SLR that belonged to one of the jeep's unfortunate occupants. He carried that weapon with him till his last day.

The gang had prepared its ambush so thoroughly and was so sure of its success that it moved on to a designated rendezvous spot where piping hot tea and snacks were laid out. An exuberant Veerappan rewarded his key associates liberally with gold chains, his earlier anger forgotten.

At the time I was at the STF headquarters in Mellur (Tamil Nadu) on a visit for a few days that I had managed to extend to almost a month. A long lull in the CM's tour calendar had meant that she was not travelling for a while, and was surrounded by a well-trained, reliable team in Chennai. Ravi Sawani, also an alumnus of the Rossie school of hard knocks and known to be meticulous about security protocol, was leading the team in my absence.

It was a perfect opportunity for me to take off for a few days. I requested the CM for permission to spend some time with the STF. Walter Davaram was just as delighted by our reunion as me. I spent a hectic month with him, engaged in combing operations. I was holding the fort at the headquarters while Walter led a team into the forest the day of the attack.

The wireless operator at the STF camp came rushing up to me, an anxious look on his face. 'Bad news, sir,' he panted. 'An STF party has

been ambushed in MM Hills. The SP was badly wounded and it will take them too long to get him to Mysore. We're an hour away. They've crossed the Palar checkpost and are bringing him here.'

We had a couple of doctors at hand, but they were able to do little more than provide first aid. Gopal's injury clearly needed advanced medical attention.

'Tell them to meet us on the highway,' I said. 'Where is the nearest hospital?'

'In Salem, about 50 km away,' I was told. It was the same Gokulam hospital where they had rushed 'Rambo' Gopalakrishnan after the Good Friday blast.

'Well, Salem is where we're going,' I replied. 'Call up all the police stations en route and tell them to ensure that we get a clear run.'

We quickly organized some vehicles and rushed to the highway where we rendezvoused with the Karnataka STF. Gopal was unconscious. The doctors patched him up as best as they could and put him in the field ambulance. I was in the lead vehicle and instructed the driver to keep the pedal pressed to the floor all the way to Salem.

The doctors there had already been alerted and had the operation theatre ready by the time we came screeching into the hospital. Gopal was stabilized and then shifted to St John's Hospital, Bangalore. He underwent multiple surgeries and had some 55 inches of sutures in his neck.

Karnataka CM M. Veerappa Moily flew by helicopter to Salem to visit Gopal as soon as he learned of the attack. The flight path took the copter over the hills where Veerappan was hiding. We learned later that Veerappan thought the helicopter was being used to search for him and that the manhunt for him had already begun.

The Karnataka STF was chafing at the way one of their own had been attacked so brazenly. Shankar Bidari personally spent the next 120 days in the forest without a break, leading intensive searches. Retaliation was swift and decisive, and some gangsters were killed. But the wily Veerappan had vanished.

I still remember Gopal's close encounter with death. The man was bedridden for months, but was fortunate to survive. It was an extraordinary combination of three strokes of luck that had saved him. To begin with,

the premature firing on his convoy (we never did find out who fired that first bullet). If the ambush party had waited for Veerappan's command, they would have definitely succeeded in not just trapping Gopal, but perhaps, even wounding him mortally.

Two, he had a quick-thinking and resourceful driver in Ravi. When the rescue party reached Hosur's jeep, they found Ravi's injured right hand on the verge of being severed from the wrist. Despite the agony, he displayed raw courage and presence of mind to get out of the death trap in the nick of time.

This has led me to believe that in any potentially threatening situation, you must choose your driver carefully. He could prove to be a life-saver! Who can forget the dramatic manner in which General Augusto Pinochet's driver did a bootleg turn and saved the general's life during an ambush on his car-cade in 1986?

The third piece of luck was the presence of an STF camp and an accessible hospital that helped save precious hours at a time when every second was critical.

We had lost far too many good men in the long years spent hunting Veerappan, but sometimes Lady Luck was kind to us. She was certainly smiling on Gopal Hosur that day. And as I found out a couple of days later, she would be equally generous to me.

◆

26 May 1993, 7.30 a.m.

I brushed the leaves from my battle fatigues and gently stretched my muscles, cramped from lying still for hours. It had been a long, fruitless night in the forest. We had received a tip-off that some men had been spotted moving around in the foothills of Bodamalai and we had lain in ambush through the night, but it had passed uneventfully.

My gaze went up to the hills. *Was he still holed in there?*

I frowned; the sultry heat was not helping my mood. Sooner or later, I would have to return to my job in Chennai, even as Veerappan remained as elusive as ever.

My thoughts were interrupted by our scout, Constable Seemaichamy. 'We should be moving out,' he said.

We faced a trek of almost three hours to get to our rendezvous point. Since we were in the jungle, there was no question of cooking a meal. We simply wolfed down some nuts, dry fruits and a powder made of pounded millets that was a local favourite.

Seemaichamy took point. The rest of us split into three squads of fifteen each. Each squad maintained a certain distance from the other two—far enough to ensure that we wouldn't get trapped collectively in case of an ambush, but close enough that the other two squads could rush to aid any team that ran into trouble.

As we trekked through the forest, I studied the surroundings. We were in a densely forested area. There was a shallow rivulet to our left and to the right was a steep slope that worried me. If anybody was standing on top of it, he would have the advantage of higher ground in the event of an attack on us.

Even as the thought crossed my mind, I noticed the man next to me stiffen. I began to ask what the matter was, when I heard the sound of barking.

'Just dogs,' I said softly.

'Not this deep in the jungle, unless there are some humans,' he reasoned.

As the implication of his reply began to dawn on me, we heard a muted explosion. *Phut!*

All of us froze. I scanned the area for Seemaichamy, but couldn't see him. Trees were obstructing the line of sight.

Rat-a-tat! A rifle opened fire.

I ducked instinctively and the boys too hugged the ground, losing precious seconds of the chase in the process. Even as my brain began to process what was happening, we heard the sound of somebody splashing through water. Seemaichamy was yelling at the top of his voice; he was in hot pursuit of whatever was out there.

'Come on,' I shouted and we raced after him. We came upon a clearing and, with some relief, spotted Seemaichamy standing on the edge of the rivulet, firing at the area across, screaming abuses.

'Easy. Friends behind you,' I shouted. When someone is spraying bullets in a life-or-death situation, you don't want to startle him by sneaking up behind him and end up a casualty of friendly fire.

He stopped shooting and swung around, still wide-eyed from the adrenalin rush. We went up to him and peered across the rivulet. Leaves and branches were still moving. Clearly, someone had run through them, but we couldn't see who.

'What happened?' I asked.

Seemaichamy wiped his forehead. 'I heard this "*phut*" sound. Then I saw somebody get up from behind a tree and dash across. I tried to shoot him, but the rascal zigzagged and I missed.'

I turned to a sub-inspector. 'Take a search party after him, but don't go in too far. Make sure you don't walk into a trap.'

Then, I turned to the clearing. 'What the hell just happened?' I wondered.

One of the men gently tapped my arm. 'Look, sir,' he said, pointing to a twisted piece of wire lying on the ground. The earth around it was charred. I approached it warily. A distinctive burnt smell filled the air.

'Cordtex,' I exhaled. 'Check the ground for more wire, but be very careful. No sudden movements.'

Cordtex is a type of detonating cord generally used in mining. Once triggered, it charges at 8,000 metres per second—well over ten times the speed of an AK bullet.

What a narrow escape it was that day. It is these close brushes with death that make you value what you have—family, friends and comrades in arms who stand by you in sticky situations.

Upon further examination of the area, my team and I found a long wire running all the way to the tree behind which Veerappan's man had been concealed. The clearing we had walked into was a minefield and we were bang in the middle of it. We found beedi butts, empty peanut packets and a battery near the end of the wire. It was pretty obvious that someone had kept a vigil there.

It took hours to demine the area, and finally the gravity of the situation began to sink in. I found that almost 450 kg of dynamite jelly and ammonium nitrate had been placed in pits in the entire clearing. The

pits, which were dug up in a sort of diamond formation, were carefully covered up.

I couldn't help but admire the clever tactic, even as I realized the huge risk we had stumbled into unknowingly. If anyone had been blown up in front of us, our training would have kicked in, making us zigzag instinctively to the right or the left, straight into a mine. I would like to think that it was an eerie coincidence, but there were forty-five pits—the same number as the strength of the ambush party I was leading that day.

To our good fortune, these mines were not the 'smart mines' of today that can redeploy themselves and are often called 'brains without a heart'. What we had run into were basic ones linked by cordtex wire to a device that was activated when a plunger was pushed down. For some reason, the wire malfunctioned that day.

Cordtex has an interesting property. If the wire gets twisted into a knot, it turns into a mini-explosive and goes off. But if the ends turn at 90 degrees, it behaves differently. That's exactly what had happened that day. The muffled explosion that had followed was too mild to cause any damage, but it had tipped us off that something was amiss.

Veerappan's man, who was watching us from hiding, had then tried to set off the mines, but couldn't as the wire didn't work. When the boys realized just how close they'd come to death, they hugged each other in relief and excitement and shook hands with me. The maxim 'there's no atheist in jungle combat' suddenly made perfect sense to me.

It wasn't the first narrow escape of my career. But it reinforced my belief in the fact that capturing Veerappan would be a daunting challenge. It made me even more determined to stay on with the STF and help complete the job. Unfortunately, fate had other plans.

When I returned to the camp, I was told of a lightning call which I took while watching the Cauvery River from the balcony of Mettur STF camp. 'The CM is fasting on Marina Beach over the Cauvery River water issue. You better rush back,' Karuppannan, her secretary, told me over the phone. The waters of the Cauvery had divided the two states territorially and emotionally, even as the STFs across the river still stood united.

As I drove from Mettur, I couldn't help but recall my narrow escape. Later, though, we learnt of Veerappan's close encounter just a week before

my team's operation.

A couple of STF intel boys, both greenhorns, intercepted a suspect near Chinna Thanda. He was quizzed and allowed to go. Had they smelt his hands or searched in a 100 metre radius, things would have taken a different turn. The smell of soap and a barber's kit would have led to a raid, and Veerappan and his top aides, who had their week-long stubble removed by those very hands, would have had very little response time. He turned out to be the designated barber of the gang.

It would be almost a decade before I would return to the jungle that Veerappan had turned into his killing fields.

The Biggest Raid on Veerappan's Camp

August 2001

Within a few weeks of rejoining the STF after that fateful call from CM Jayalalithaa, I headed for Asanur Police Station, located at the southern tip of the Carnatic Plateau. The terrain around Dhimbam Hills was scenic, but now had a grim and bloody history, as it was during his stay around this region that Veerappan's killings had peaked.

My plan was to recce every site in the area where Veerappan had staged an ambush or a massacre. In the run-up to the visit, I wanted to read up on most of the investigation and reports surrounding the incidents, but was failing miserably.

I was forced to plod through what seemed like fascinating footnotes. What should have made for racy reading was incredibly hard to decipher, due to the unintelligible scrawl. Exasperated, I glanced wryly for the umpteenth time at the writer, Inspector Mohan Nawaz, who stood next to me with a sheepish look.

Quite clearly, Nawaz was much happier conducting raids than writing about them. Another thing most men of action have in common. When they finally get around to writing, the reports are barely legible or even comprehensible.

Mohan Nawaz was both a key member of the STF and also the local inspector. He had jurisdiction over nearly thirty villages. A fair-complexioned burly bachelor who—like Shakeel Ahmed—had vowed not to marry till Veerappan was brought to justice, Nawaz was well liked by

villagers, especially since he often dipped into his meagre income for their welfare. As a result, in a stint of nearly ten years around Asanur, he had developed a reliable network of confidential informants (CIs).

Given the hostile terrain, road connectivity was a major issue in areas within Nawaz's jurisdiction. Nawaz, a great believer in the Do-It-Yourself school of thought, had managed to mobilize villagers and organize the construction of a rough road in the area, which had added to his popularity.

This move by Nawaz flew in Veerappan's face, as he constantly tried to project the STF and police as oppressors of the local populace. Not just Nawaz but several other officers like him were living contradictions of Veerappan's propaganda.

Even as Nawaz and I caught up on the logistics of the day-to-day running of the police station and discussed finding a long-term but permanent solution to the Veerappan problem, one of his men gestured towards the gate.

Excusing himself, Nawaz went and spoke briefly with a shabbily dressed man.

'Sir, Jadeyan found out you are here. He wants to pay his respects,' Nawaz walked back to me and said.

'Jadeyan?' My eyebrows shot up. 'The one who had provided the tip-off that helped us inflict major damage to Veerappan's gang in 1993?'

Nawaz beamed his approval at my field knowledge. 'Yes, sir, the same. His appearance is deceptive,' he said.

◆

September 1993

A stone's throw from Asanur Police Station, the STF sentry frowned as stray dogs around the camp began barking. A man who looked like he hadn't bathed for several days came into view, taking great care to show that his hands were empty.

'What do you want?' growled the sentry.

'I've come to see Mohan Nawaz Sir,' replied the man.

'Sir is not here right now,' the sentry told the stranger.

The man shrugged and replied, 'I'll wait. What I have to say is for his ears only.'

'Get lost! Don't hang around here,' said the sentry.

The stranger walked away. But unknown to the sentry, he stayed close to the camp and watched it from a concealed spot.

The next day, as Nawaz entered the camp, the man leapt out to meet him. 'You again? Didn't I tell you to go away?' asked the furious sentry, ready to shoot the man that he now saw as a potential threat.

'Wait, I know him,' intervened Nawaz.

Despite his deceptive appearance, Jadeyan was the headman of Geddasal, a village largely inhabited by members of the Sholiga tribe that had blood ties to nearly thirty other villages nearby. Nothing happened in the area without Jadeyan's knowledge. 'You have something to say?' asked Nawaz.

The man nodded, an excited torrent of words tumbling out of his mouth. 'Ayya... in this forest... our village boys... they saw... lots and lots...'

'What?' asked an exasperated Nawaz.

'Human excreta,' Jadeyan said.

Nawaz made a face. The sentry, out of earshot but alert, read his boss's face and thought his services may be sought any moment to frogmarch the visitor out of the camp.

'Not our people. Strangers. Rice eaters. The stool is yellowish, not brown. I sent more people. They saw thatched sheds and a lot of people, including children. Must be the ones you are looking for,' said Jadeyan.

Nawaz scratched his head thoughtfully. The local populace ate ragi and grains, a diet that tended to make the stool dark. The people Jadeyan was talking about were definitely outsiders. But who could they be? Rosewood smugglers from Kerala? But they rarely travelled in large numbers, or with children. Could it be Veerappan's gang?

But the gangsters erased even traces of cooking or walking, pretty much like cats cover their scat. Jadeyan noticed Nawaz's puzzled expression and remarked, 'The presence of too many kids may have prevented them from covering their tracks.'

'We'll check it out,' Nawaz said, before hurrying off to his single-room office-cum-residence and informing his boss Sanjay Arora, whose last raid on Veerappan's stronghold had been unsuccessful because the gang had fled.

Sanjay wished to be doubly sure and brought Walter and Shankar Bidari into the loop. Karnataka STF and some BSF troops (on loan to Karnataka from the Centre) were also roped in for the ops.

By the next morning, the sizeable contingent of assembled men shouted 'Bharat Mata ki Jai' with great gusto and set off, halting only for a few minutes to eat some idlis.

Someone once said, *A guerrilla is like a poet, keen to the rustle of leaves, the break of the twigs, the ripples of the river.* Each STF boy was now a poet. His movements turned more subtle. His eyes and ears were wide open.

The three columns, that resembled three long snakes slithering up the hills, split. By first light, they were to converge on the possible location of the camp from different access points. However, Arora's team reached the camp ahead of the other two.

The scout of Arora's team managed to locate the camp, deep in the forest. Its approach was blocked by chest-high Genangu grass. Quietly, the scout parted the grass and peered, and was stunned by the sight.

There were about a dozen or so huts with thatched roofs. Women were going about their chores, children played in the clearing and men were engaged in cutting logs and cleaning rifles.

He quickly crawled back and signalled Arora that he had spotted the camp. Arora raised his binoculars. Even from 300 metres, he could see the encampment. From the sounds emanating from the camp, it was clear that some women were pounding grains, while others were grinding masala. It was also evident that the men weren't expecting any trouble. Arora saw one man sitting on a flat rock cleaning his gun, with another sitting near him helping.

'The foot soldiers are here. But where are the generals?' wondered Sanjay, scanning the camp for familiar faces.

Just then, as luck would have it, a small barking deer jumped out of the underbrush near one of the BSF men. The startled man promptly

dropped the aluminium utensil that contained food for the entire party, and yelled out, thinking he was being attacked by a ferocious animal. The other men in his team, whose nerves were already on edge, reacted by opening fire, even though they were still not in the perfect position.

Pandemonium erupted. The element of surprise was lost yet again. Everyone in the camp ran helter-skelter. Veerappan's brother, Arjunan, who was in the camp, grabbed his sister-in-law Muthulakshmi by the hand and fled into the forest. Veerappan was away at a place near Gopinatham, gone apparently to withdraw some money from one of his well-hidden stashes (his jungle ATMs, we would joke).

In the heat of the moment, Arjunan and Muthulakshmi got separated and she was left to fend for herself, on the run from the police.

Early the next morning, she met five elderly men and begged them for help. The men told her to hide on a hillock and promised to return later in the day. By that time, the STF had already spread the word that they should be alerted if any strangers were noticed in the area.

When the elderly men returned, they were accompanied by the police.

Muthulakshmi was arrested and taken to the Karnataka STF camp, where she revealed what had happened during the raid. She later went on to allege that she had been tortured there.

On the whole, it was a successful raid that led to major losses for Veerappan. Reports from my counterparts in Karnataka revealed that as the gang scattered, Veerappan was forced to deal with multiple losses— of not just his wife Muthulakshmi, but also of two of his trusted aides, Mariappan and N.S. Mani. Within days of the raid, both men were dead, killed in encounters with the Karnataka STF team that had apparently crossed into Tamil Nadu.

It was a huge blow to Veerappan. But it had another unforeseen effect. The bonhomie between the Karnataka and Tamil Nadu STFs was affected, especially as ego, as well as the matter of jurisdiction, came into play. Just before the raid, a Karnataka STF van was seen near the Tamil Nadu STF camp. Nobody disembarked, but it went further and circumambulated the Bannari Temple next to the camp. The Tamil Nadu STF later figured out that Shankar Bidari's men, after a quick invocation of Devi Bannari, had left for the successful assault below the Dhimbam slopes. Within

hours, the men had appeared at Bhavanisagar Police Station to report N.S. Mani's death.

However, before hawks on both sides of the border could escalate the tension, Walter and Arora stepped in.

The prize money announced for Bidari was not collected by him until Veerappan's death in Operation Cocoon. He was also eligible for a medal, but declined it, insisting that he would accept it only after Veerappan was brought to justice. Later, when he collected the prize money, he used a huge chunk to gift a gold trishul to the Bannari Temple.

After the raid, Veerappan was never able to gather such a large number of people under his leadership. From commanding over 100 people, he was now reduced to leading just ten to fifteen men at a time. Muthulakshmi's imprisonment was also a huge source of anxiety for him, not just fear for her safety, but also because of the information that she could unwittingly reveal during interrogation.

Gang members who surrendered later revealed that even as Veerappan desperately dodged the police, another thought raged through his mind. 'I must find the informer and settle scores. People must be reminded that they cannot mess with me without paying a heavy price.'

◆

October 1994

Nearly a year after the raid on his camp, Veerappan and his men were back in the area near Geddasal. As they observed the idyllic village from their vantage point high up on a hill, they noticed an old shepherd grazing his sheep, along with his grandson.

At the sight of the strangers, the shepherd tried to flee, but was quickly surrounded. 'Some men in your village spoke to the police. I want their names,' Veerappan told him.

'I don't know anything. I'm just a simple shepherd. Please let me go,' the man pleaded.

'Let's see if some special treatment helps you remember,' Veerappan said.

Sure enough, the shepherd cracked under torture and quickly revealed the names of Jadeyan and five others suspected to be Nawaz's informers.

'See! That wasn't so difficult, was it?' smiled Veerappan. Then, turning to his men, 'Take a lunch break. We'll go to the village after that.'

As the men began to settle down, the shepherd made a desperate attempt to escape and warn the villagers. But before he could get far, he was shot. Veerappan and his gang went about preparing their food calmly and ate lunch. Even as the shepherd's stunned grandson huddled near the old man's body, the gang taunted him and forced him to eat, the boy later told the police.

'Keep your trap shut when we come to the village or I'll send you as well to your grandfather,' warned Veerappan.

As dusk settled upon the village, the gang entered Geddasal. 'Police,' called out Arjunan. 'We want to meet these men,' he said, listing the names provided by the shepherd.

In the poor light, the villagers only saw that the men were wearing fatigues and carrying weapons. Eagerly believing the lie, they came forward. But one man was missing.

'Where's Jadeyan?' asked Arjunan.

'Not here,' came the answer.

By a stroke of incredibly good fortune, Jadeyan had gone to meet Mohan Nawaz that day.

Eyewitnesses say that Arjunan looked quizzically at his brother. Veerappan shrugged and nodded. Suddenly, the gang members swung into action. They seized the bewildered men, tied them with ropes and hustled them to the village square.

'What are you doing? We are your men. We always help you against Eerappan,' one of the hapless villagers pleaded.

'Oh you do, do you?' roared an infuriated Veerappan, alternating between filthy abuses in Kannada and Tamil. 'Bervasi (Bastards), I am Veerappan. You'd sell your mothers for money. How much did the STF pay you, you traitors? I would have paid you more. I will kill anybody who helps the STF. Let this be a lesson.'

According to police reports and eyewitness accounts, at Veerappan's signal, the gang shot the men, hacked their necks with machetes and set

fire to their houses.

An STF party led by Karuppusamy that arrived on the scene hours later found the five men, one of whom was miraculously alive. Raman had not just survived the gunshot wound and a machete cut, but had been lying there bleeding for several hours before the STF party rushed him to the hospital.

Geddasal became a magnet for the media, who nudged the shocked survivors to relive the horrific experience over and over again. Twenty years on, Raman still lives, though the scars on his thigh, face and neck serve as a daily reminder of the massacre on 8 October.

As the traumatized villagers gathered around for the funeral of the fallen men, one of them spoke up, tears streaming down his face, 'God has forsaken us. We should close the temple dedicated to the village deity Jadayasamy. We will only reopen it after justice has been served.'

When I met Nawaz during my trip to Asanur in July 2001, I went with him to visit Geddasal as well.

The shut doors of the temple seemed to be silently reproaching me. 'One day,' I promised myself, 'one day, I will come and pray in this temple after it has been reopened.'

The STF's First Casualty—Senthil

August 2001

We were at the STF memorial at Thattakarai. I looked at the names of all the STF martyrs carved into the slab of rock, an edifice to remember the sacrifices of our fellow officers and men. Its sheer simplicity only served to make it more poignant.

As I started to turn away, I touched the ground next to the memorial, trying not to make a big show of it. My driver noticed my show of reverence. He seemed touched by the gesture, but said nothing.

A couple of days later, I ran into Sanjay Arora in Coimbatore, where he had taken up office as commissioner. 'We've lost some good men,' I said, mentioning my visit to the memorial and the fact that it weighed on my mind.

'Far too many,' said Arora. 'I still remember the first loss like it happened yesterday. What makes it even worse is that I was on that raid at Sorgam.'

'That means paradise in Tamil, doesn't it?' I shook my head. 'Talk about irony.'

'The strange thing is that when I told the team about the location, one of the men pointed his finger towards the sky and quipped, "I'm going to Sorgam." It turned out to be a deadly statement, as he was the first to fall that day,' said Arora.

That man happened to be SI Senthil. A team man, he was always remembered for a unique habit. At the end of a day-long futile jungle

search, he would charge up a tall rock and scream at the top of his voice, 'Veerappan! Where are you? I've come for you.'

◆

September 1994

The informer burst into the Karnataka STF's camp in Dhimbam. Although located in Tamil Nadu, it was Shankar Bidari's second headquarters. The news the visitor had brought immediately got the officer's attention.

'We had gone to hunt sambar deer in Sorgam Valley and came across gangsters who snatched our guns and our rice.'

'What time?' asked Bidari.

'The sun was that high,' the informer said, gesturing with his hand to indicate the approximate time of day.

Bidari immediately called Arora. 'I'll meet you over a meal,' Arora replied to his message in code.

By 2 a.m. on 17 September, several Tamil Nadu STF members reached Dhimbam by van and climbed further up the hills on foot. The Karnataka team was already waiting at a forest depot. They were accompanied by BSF men, carrying LMGs and 2-inch mortars. A headcount revealed that 150 men were present.

After a quick but short joint briefing, mixed teams were formed. Conventional wisdom suggests that variety is the spice of life. But in life-and-death situations, especially during intense operations where stealth and time are of essence, it can add a layer of unwanted and even unwelcome complexity, since the man standing next to you may be a stranger to the functioning of your unit.

SI Senthil led the Tamil Nadu STF's Delta team. The fifteen-member team included STF constable Ramesh, who had suffered an ankle injury a couple of weeks ago. Though only midway through the four weeks' rest that he had been advised, Ramesh was the first to jump into the van when he heard about the op.

When the signal was flashed to take a ten-minute break, the teams

halted gratefully and spread out on the ground. They had been trekking through the dense terrain for nearly three hours. As he munched on six chutney-soaked idlis, Ramesh turned to Senthil and asked, 'Did you notice fresh incense sticks at the temple we just crossed?'

'I was also wondering about it. What if they were left by the gang? Do you think we'll get A-1 today?' asked Senthil.

Later, a petty shopkeeper confirmed that he had indeed sold the incense sticks to the gangsters. And yes, he had seen many guns.

Short break done, Senthil gestured to the team. The cheery mood vanished immediately and the men resumed their silent march, taking great care not to crush any dry leaves beneath their boots.

Gradually, the terrain began to dictate the movement of the men. Senthil's team came upon a shallow stream 15 feet wide, its slopes 10 feet high and steep like a wall, forcing them to split into two sections—one under Senthil, and the other under Ravi.

The track petered out. Ravi's team reached a narrow ridge and fell into single file. He looked at Senthil, who gestured, 'This is the area.'

Their gaze met one last time. They nodded at each other and parted.

The mist had cleared, but there was still a nip in the air. Senthil's team skirted a shola grove whose huge trees let in only a bluish green haze—the kind of hue you see through night-vision goggles. Their bodies were alert and tense, eyes scanning the area for any indicator of recent movement—bushes disturbed, grass stepped on, cobwebs broken—that could signal that a man or beast had passed by. A smear, a piece of torn fabric—spotting any of this in time could mean the difference between life and death.

Senthil pantomimed, 'Stop,' his index finger pointing towards the ground. His senses were tingling, warning him that something was wrong, even though he could not see anything. Everyone stopped, except one person.

Ramesh pirouetted and began sprinting, ignoring the shooting pain in his ankle. In his peripheral vision, Ramesh had spotted a flash of black, green and red. STF men always avoided wearing red in the forest. Alarm bells rang inside his head.

Ravi saw Ramesh's about-turn. Puzzled, Ravi began to walk towards

him. The next few events occurred in a split second. From amidst a clump of shrubs, Ramesh suddenly saw something rising and froze in shock. The famous moustache and face came into view. As with the hood of a cobra, the rest of the anatomy seemed irrelevant. As adrenalin rushed through his system, Ramesh instinctively fell flat on his stomach. But he had made a fatal mistake. Even as Ravi realized that he had Veerappan in his sight and aimed, Ramesh got up again, blocking his line of fire.

Sorgam turned into hell as guns opened up. Bullets ripped into Ramesh, even as he reflexively pressed the trigger. There was no strength left in his index finger. Sticky fluid began covering his eyes. He fought the urge to shut them, suddenly terrified that he would never open them again.

As if in a dream, Ramesh found himself face down on the ground. Stones and rubble smacked his face, kicked up by more shots that came his way. Ramesh's body jerked, his arms moved as if he was dancing. Darkening shapes whizzed past him in a blur.

A BSF havildar came running up and tried to align the LMG he was carrying. Bullets ripped into him and he went down. A wounded Ravi saw Senthil charging towards them. Then he passed out. When he woke up hours later, he saw a nurse.

Gradually, Ravi pieced together what had happened after he fell unconscious. His first response was a philosophical 'It could have been me', which was quickly followed by bone-crushing guilt that afflicts every combat-hardened soldier whose comrades have died in action—why him and not me?

Adrenaline pumping furiously, Senthil had raced towards the sound of the gunshots and seen the three men lying on the ground, but no one else. He moved a few paces in the 10 o'clock direction where the injured lay. Suddenly, acting purely on instinct, he veered 7 o'clock, zigzagging between a clutch of shrubs, and crossed a clearing. Then, he noticed a big boulder.

He squinted due to the sudden glare of the sun and turned his neck towards a smaller boulder to the right.

Senthil would never come to know it, but his instincts were spot-on. Veerappan's men had split into two sections. One group crouched behind

the big boulder and the other behind the smaller one. As Senthil tried to decide his next move, a bullet rang out.

The projectile tunnelled through his left eye and penetrated his brain. As the rest of the team arrived and gave covering fire, Senthil's buddy crawled up to him and felt his neck for a pulse. Then he tried the chest, followed by the wrist. With rising desperation, he checked again. No sign of life!

In the adjoining hills, Arora frowned as his walkie came alive. 'Delta calling Star,' the voice at the other end quivered.

'Star answering,' Arora replied, assuming that he would get an update on the fierce exchange of fire that had echoed in the hills and had just stopped.

Then he paused, wondering if he had given away his position to the enemy. After all, it was Senthil who used the call sign 'Delta' for the team he headed. What did this mean?

Even as these thoughts went through his head, the words that followed hit him like a hammer blow.

'Senthil Ayya is no more,' the voice said.

Arora clenched his fists. It was the first casualty suffered by the Tamil Nadu STF. What made it worse was the fact that the man they had just lost was one of the most popular officers on the force.

'BSF Havildar Bhupender Singh and Constable Ramesh too are dead,' the voice went on.

Arora shuddered. The teams came back three men short that day. The deaths of the men weighed on their minds. No mission haunts you more than the one from which you return carrying the stiffening body of a buddy, even if you are a commando. As the grim news spread, Arora saw some of his boys consoling the others before breaking down themselves.

I remember I was in Madurai, where I was overseeing security drills for the CM's medal parade, when I heard the news. The thought that elite forces choose and lose the best flashed through my mind, even as I rushed to Erode to share the STF's grief. My wife accompanied me on that four-hour journey, throughout which I stayed silent. I remember being thankful for her quiet support. Sensing my need to come to terms with the event, she wisely refrained from trying to initiate any conversation,

instead placed a consoling hand on mine a couple of times.

Senthil was one of the fifteen members (a total of seven SIs and eight others) from the CM's protection detail that I had hand-picked for the STF. Yes, he may have volunteered to go, but somewhere deep down, I could not shrug off a crushing sense of guilt. As I drove towards Erode, I vowed to return to the STF and complete the job for which it had been set up. It was almost as if the fates had colluded that day to allow me to return to the STF seven years later.

When we reached Erode, I found three wooden coffins that lay wrapped in the tricolour in the corridor of the town hospital, where ministers were leading a long row of mourners. Twenty-one guns boomed during the next three days at three funerals in three remote villages. The last post was sounded and arms reversed. This was a sign that the gun had been shamed, since it was the means for committing a shameful act.

The CM extolled Senthil's work and sanctioned ₹15 lakh—the highest solatium then in India. Senthil's name went on to become an invocation and a battle cry for his comrades. For a few in the STF, his death triggered a wave of panic, paving the way for their departures, as they sought and were granted transfers. But for others like Nawaz, Karuppusamy, Ashok Kumar and F.M. Hussain, it became the reason for not leaving the STF till their job was done.

In the years that followed, we went on to lose many more good men—but not all of them to the enemy's bullets. But that is a story for another day, as Veerappan's next escapade led not just to a serious loss of face on his part, but also to the death of men crucial to his functioning.

The ₹1,000 crore Ransom Demand

August 2001

After the massacre at Geddasal, we posted guards in the village. We sent out lots of patrols into the jungle, followed by undercover ops. 'But nothing worked,' Karuppusamy recounted as I sat listening at the STF headquarters.

'Speaking of undercover, you had spent a lot of time with Arjunan under an assumed identity, isn't it?' I said, adding, 'What was he like?'

The extremely prim and proper Karuppusamy pursed his lips. 'God, did he use foul language, especially when talking about Shankar Bidari and Mohan Nawaz. And the amount of food he could eat, even though he was lanky like his brother! He was under medical care at the time, but that certainly didn't affect his appetite. It all started when Arjunan developed a cyst on his right thigh...'

◆

December 1994

'Anna, the pain is killing me. I can't take it any more. Do something, please,' wailed Arjunan, pointing at his thigh.

Veerappan grunted in frustration. After the attack on his camp, the remnants of his gang had shifted further west, close to the eastern Nilgiris and the Bhavanisagar Dam. But they were constantly badgered by patrols

and raids. In an effort to create some breathing space, Veerappan had tried to lure Sanjay Arora—who had moved the STF out of Mettur to Bannari in the west and was now focused on the dam area—into a trap.

Veerappan had sent him a recorded tape, in which he said, 'You are a good man from North India. I would give you ₹25 crore. You could keep ₹5 crore for yourself, and donate the rest to the PM. I wish your wife and your little boy who stay in Mettur well.' Veerappan further said that he was willing to surrender if Arora came alone and unarmed to meet him.

With the brutal deceitful murder of DCF Srinivas still fresh in the minds of the STF, the brigand's message had set alarm bells ringing. But Arora was tempted by the prospect of using Veerappan's bait to capture him. He had relayed a message that he was willing to meet the man.

On the appointed day, Veerappan's emissary Selvaraj had arrived on a motorcycle to pick Arora up. But to his shock, he had found Arora getting into a specially modified bulletproof Jonga, accompanied by four other STF officers—Ashok Kumar, Mohan Nawaz, Balasubramaniyan and Karuppusamy.

Selvaraj immediately turned his bike around and drove away at top speed. He managed to warn Veerappan and the proposed meeting was abandoned. Veerappan, who saw the Jonga approaching at a distance from a knoll, was puzzled by its appearance. He mistook it for a mini-tank and wasted no time in taking to his heels the moment Selvaraj yelled out his warning.

Another agonized moan from his brother brought Veerappan back to the present. The escalating cries of pain made him realize that some drastic action was needed.

'Nobody in the gang has the skill to treat him. He needs a proper hospital. But the moment we go there, the STF will arrest him. We need a hostage we can use as leverage,' mused Veerappan.

One of his trusted aides spoke up: 'Anna, you remember some villagers were telling us about this DSP Chidambaranathan, who has a farm nearby and visits it frequently?'

A grin appeared on Veerappan's face. 'Perhaps it's time we paid him a visit too,' he remarked.

On the evening of 3 December, Veerappan and his men kidnapped

DSP Chidambaranathan; his brother, a head constable; and the officer's brother-in-law, a high-school teacher.

Ashok Kumar had repeatedly warned Chidambaranathan that it was unsafe for him to be moving freely in the area, but his advice had been ignored. Chidambaranathan's abduction immediately made the headlines, but the gang itself was silent. There were no demands or statements of intent.

It was an anxious wait. On the sixth day, the Coimbatore district collector received an audio cassette from Veerappan, stating that he had Chidambaranathan and the others in his custody. He also said that he would send his trusted lieutenant Baby Veerappan to conduct negotiations.

Baby, a kinsman of Veerappan who had joined the gang six years ago, had rapidly risen through the ranks. Veerappan was said to be so fond of him that he had even contemplated getting his elder daughter married to Baby when she came of age. With his long hair, bandolier and flamboyant manner, he could have easily been mistaken for a transplant from the Chambal ravines of the 1960s.

The collector immediately went into a huddle with Arora, and it was decided that Karuppusamy would pose as a revenue inspector and talk to the gang. One of the STF's veterans, Karuppusamy was ideal for the role, as his wiry build and gentle manner would not rouse any suspicion.

Karuppusamy met Baby in the Lingapuram forest area in Coimbatore district. Baby emerged from the forest, a .303 rifle in hand, accompanied by another gang member. He spotted the government jeep and signalled it with a flourish, as if hailing a cab.

Once the party reached the Coimbatore Municipal Inspection Bungalow, Baby asked his man to 'check out the place'. The men entered the building after getting the all-clear. Baby then handed over a fresh cassette to Karuppusamy.

On the tape, Veerappan demanded the best possible medical care and safety for Arjunan. He also issued a demand that made the collector's jaw drop. '₹1,000 crore if you want the DSP back alive.' That kind of ransom must surely have been a record!

As the collector conveyed the demand to his equally stunned seniors,

Karuppusamy was given the directive to travel with a tehsildar in the latter's jeep and pick up Arjunan from the edge of the forest.

Their journey out of the jungle turned into a media circus, during which Arjunan obligingly lifted his lungi to display his cyst. Bulbs flashed and a chorus of exclamations then filled the air. Mercifully, he didn't offer any sound bites.

For twenty-seven days, Karuppusamy and Arjunan shared the same room. An ardent devotee of Lord Ayyappa and a simple vegetarian, Karuppusamy was stunned at Arjunan's gargantuan appetite. The man could polish off huge portions of fish, crab, mutton and eggs, washing it down with copious quantities of fresh fruit juice.

As negotiations dragged on, Karuppusamy drew Arjunan into prolonged conversations where the man insisted that his brother was a misunderstood person, a religious man and a good leader.

'Who does he hate the most?' Karuppusamy asked once.

Arjunan's reply was instantaneous. 'Shankar Bidari and Mohan Nawaz,' he said, and then launched into a venomous diatribe against both men.

While Karuppusamy and Arjunan talked, Inspector Ashok Kumar, dressed as a peon, would drop by and respectfully take instructions from his boss, the 'revenue inspector'.

The message to Arjunan was relayed in clear and uncertain terms—forget ₹1,000 crore, not even a rupee would be forthcoming as ransom. But as he was getting excellent medical care and living in comfort, he was in no hurry to wrap up talks.

While Arjunan was comfortably ensconced in the inspection bungalow, Baby came up with one demand after another. He wanted to meet the members of Veerappan's gang detained in MM Hills as well as Muthulakshmi and enquire about her well-being. Both wishes were granted.

When they met, Baby handed over a cassette from Veerappan to Muthulakshmi. She, in turn, recorded her reply, speaking bitterly about the treatment that the Karnataka STF had meted out to her.

Baby even visited the MM Hills headquarters of the Karnataka STF. Needless to say, our counterparts in Karnataka weren't too happy about

this, but they gritted their teeth and cooperated because a fellow officer's life was on the line.

A few days later, Baby returned to the forest, carrying baskets of apples and oranges. His hygiene had gone up a notch, with his long hair combed tight. The collector heaved a sigh of relief, the kind usually reserved for successful completion of visits by high-ranking dignitaries for inspections.

Before long, word about the ₹1,000 crore ransom leaked and hit the front pages of all local dailies. It made Veerappan the butt of many jokes. But if anyone thought he had muddled up his maths and actually wanted a smaller figure, his next list of demands set all doubts to rest.

He demanded that a granite quarry be leased to him for a hundred years, one hundred gun licences be awarded exclusively for his close protection detail, and that he be protected by the same commandos that guarded the Tamil Nadu CM (that, ironically, would have meant that I would supervise his security too!). His most urgent demand, however, was for the immediate removal of the STF.

Meanwhile, Walter Davaram, chafing in a hospital bed in Chennai after suffering a life-threatening accident, defied the orders of his doctor to be on bed rest for twelve weeks and returned to the field. After merely eight weeks he rushed 500 km by rail and road, with several broken bones held in place by steel rods.

'This nonsense has gone on long enough. Time to end it,' he thundered.

There was an immediate impact of his arrival on the STF's morale. But there was also an element of luck.

On 28 December, the STF's intelligence wing received hints that Veerappan may soon meet the media. He was apparently worried that his image had taken a beating due to the hostage situation and his outlandish demands, and so he was keen to present his point of view. A new tape recorder and a set of new clothes had gone into the jungle the previous evening.

Mohan Nawaz's sources revealed that the hostages were probably being held near a village called Lingapuram. Based on this information, Sanjay Arora worked out an elaborate operation. A dozen teams began

combing the area on 29 December. While descending a slope, one team member noticed something pink fluttering near some bushes. Closer scrutiny revealed it to be the gang's campsite. It was empty, but for some dried meat.

Unfortunately, even as the team moved in, Baby Veerappan spotted them and opened fire, hitting a constable in his right shoulder. Two of Veerappan's most trusted men began to hustle the hostages away. The 'funnelling fire' with LMGs, however, forced the fleeing fugitives to head east towards Lingapuram, rather than allow them to vanish into the forest.

Later, a livid Chidambaranathan revealed that he was convinced that the STF had acted irresponsibly and had almost got him killed. According to him, 'Nobody rescued us. We rescued ourselves.'

Meanwhile, Veerappan's two men were shaken after their close brush with death. They also realized that they were now cut off from the gang and that it was only a matter of time before the STF would close in.

Chidambaranathan later told the police that he could sense their vulnerability and convinced the two men that it was better to surrender and live than get killed. That night, the five men surfaced in a nearby village, Kanthavayal, and turned themselves in.

As luck would have it, Veerappan was not with the gang when it had come under attack that day. He had actually gone to meet the media. But as he neared the rendezvous point, a lizard fell off a tree on to his left shoulder. 'It's an ill omen,' Veerappan said and immediately dropped his plan to hold a 'press conference'. As he returned to the camp, he heard heavy firing and turned tail instantly, according to gang members who surrendered later.

On 30 December, as a blissfully ignorant Arjunan relaxed in his room, a burly man entered and saluted Karuppusamy.

'Do you know who this is?' asked Karuppusamy.

'No. Who is he?' asked Arjunan, still unconcerned.

'The same Mohan Nawaz you've spoken about so often,' chuckled Karuppusamy.

Though both Arjunan and his brother knew of Mohan Nawaz because of his actions and hated him with passion, neither had actually set eyes on him till then. Arjunan's demeanour changed instantly. He turned pale

and began to tremble. His eyes were ready to pop out.

'Hello Arjunan, I'm delighted to finally meet you,' said Nawaz pleasantly. Then he pointed at Karuppusamy and asked, 'Do you know who this is?'

Arjunan shook his head silently, his cornered gaze darting from one man to another.

'My senior in the STF, Inspector Karuppusamy,' Nawaz informed Arjunan, who by now had broken into a sweat. 'Oh, and you might want to meet the "peon", Inspector Ashok Kumar. Now, get ready. There's a nice prison cell waiting for you. For once, your brother is not going to be of any help to you.'

Within days of Arjunan's arrest, the Karnataka Police demanded that he be handed over to them for interrogation. They went to court and eventually obtained a court order to this effect.

On 26 June 1995, Arjunan and Veerappan's two aides were formally transferred into the custody of the Karnataka Police. They were immediately bundled into a police van that headed for the STF base in MM Hills, approximately 140 km away.

According to the report filed later by the inspector-in-charge, Madhukar Musale, the van had moved about 40 km when he heard strange sounds emanating from the back. He stopped the van and jumped out to investigate. When the back of the van was opened, he found the three men squirming on the floor. They happened to have taken cyanide capsules. Death followed almost instantaneously.

Their deaths raised several questions, most of which remain unanswered. How did they manage to get hold of cyanide capsules in a high-security confinement? What provoked them to kill themselves after almost six months in Tamil Nadu Police custody?

An enquiry panel eventually absolved the Karnataka STF of allegations that it had deliberately killed the men.

But when Veerappan learned of Arjunan's death, he was furious. Both his younger brother and sister Mariammal had died in circumstances that Veerappan found highly suspicious. His wife's captivity also rankled him no end and it was only a matter of time before his wrath would explode.

Known to nurse his hatred, on 9 August 1995, Veerappan entered

Punajunur village and walked straight to the headman's house, yelling and cursing. The headman's son had bragged to the media that it was his family that had provided the police with the information that led to the arrest of Muthulakshmi. Word of the interview had reached Veerappan as well and he decided to take matters into his own hands, his former comrades said.

Police accounts reveal that when he heard the commotion, the headman's son unlatched the back door quietly and fled for his life. The rest of his family was not as fortunate. Five of them were lined up against the house and shot at point-blank range. A daily labourer, who rushed to the spot when he heard the bullets, also became a victim. He was shot in his left arm, which later had to be amputated.

That nobody else in the village dared to intervene hardly surprised me. The jungle-hamlets were under siege. It was as though a man-eater was on the prowl next door. There was an air of terror all around.

Unfriendly Fire

August 2001

'An excellent spot for an ambush,' I said, gesturing at the lone banyan tree that we had crossed a while ago.

There was ample cover and a clear line of fire at anyone trying to cross the Moyar River, a natural bottleneck that separated the Eastern and Western Ghats and was home to several species of flora and fauna. Soon, we camped on the western banks of the river. Rucksacks were unzipped, some Velcro softly pulled, peanuts and dates munched and water gulped.

Veerappan also appreciated the area's hidden potential. At least that is what was revealed by one of his gang members whom we captured later. 'We'd set a trap for him, but...' said the lean man standing next to me.

I swivelled and looked at DSP F.M. Hussain, who was shaking his head ruefully even as he shoved a handful of freshly caught fish into an improvised clay oven. Hussain was clever, with a knack of rustling up good food without much smoke, smell or noise.

We were at a place that the locals referred to as 'vin meen kaduvu' (roughly translated as 'fish like stars in the sky'). Silvery on top and pale below, the fish in the region indeed resembled stars when they leapt out of the water in shoals on a moonlit night.

Hussain's .303 was propped up against a shrub nearby. Contrary to all regulations, its barrel was sawed into half, reminiscent of the Sicilian lupara made famous by Mario Puzo. Experts—and Hussain certainly was one—believed that the shorter barrel made for easier handling in wooded

areas. It was a trade-off between power and portability.

Hussain had personally modified his weapon. He almost always meddled with any gun or machine part that was remotely connected with police work. His range of contacts was wide, extending from scientists from the Indian Institute of Science, Bangalore, to street mechanics from any small town.

A sniper and a gunsmith, a hunter and a cook—and superb in each role—Hussain was another old-timer who had been with the STF right from the Jungle Patrol days. In between, he had also rushed to Chennai when the city had faced an outbreak of swine flu and stray pigs needed to be culled swiftly. Hussain and another marksman, Samy, were reportedly spotted roaming around with .22 rifles. It was rumoured that about 5,000 pigs were taken off the streets of Chennai within days. Samy's friends then took to calling him 'Pig' Samy. Hussain had missed that title by a whisker.

Hussain's resourcefulness was legendary in the forces. In his early days in the police, when he was posted in Ooty, his boss had bemoaned the fact that there was no mounted police for ceremonial purposes and for conduct of patrols during peak tourist season. Overnight, Hussain ensured that all the stray ponies in the scenic hill station were rounded up. The next morning, he paraded them, although not in perfect alignment, before the beaming SP. Years later, Hussain still cracked up whenever he recounted that episode.

Right now, though, there was no sign of a smile on his grim face. 'There was a time when my boys and I, who were in plain clothes, were mistaken for Veerappan's men by the Karnataka STF. They almost opened fire on us,' he gestured with his hands towards a spot that was about a couple of kilometres from our present location.

'Really? How did you avert that?' I asked.

'I got lucky. I overheard their conversation over the radio set and yelled out to them in the nick of time not to shoot. Friendly fire is a real hazard in this terrain. Poor Ananjeya found out the hard way right here...' he trailed off.

◆

June 1995

Ananjeya Kumar cursed softly as his stomach rumbled. Blinking the sweat out of his eyes, he gently lifted the small camouflage patch over the dial of his watch. Nearly 2 a.m. Technically, 26 June had begun two hours ago.

'What a time and place to get a stomach upset,' he thought bitterly. The still, humid night added to his sense of suffocation even as he kept up his night vigil.

Ananjeya and three other STF men, all volunteers, had been camping at the spot—between the Moyar River and Bhavanisagar Dam—for the past several days, following a juicy tip-off that Veerappan and his men were in the area and could cross the river at any time. The terrain would force them to enter a cul-de-sac, making it the perfect spot for an ambush. Therefore, Ananjeya was put in charge of the team and asked to lie in wait for the brigand.

As a constable, Ananjeya was somewhat junior for such an assignment, but he had made a favourable impression on the STF leadership a year ago. News had reached the STF that Veerappan was camping in the Velampatty jungles and receiving supplies from Nallur. But when the STF set up a camp near the village, its inhabitants had formed a human shield of women and children and surrounded it, giving the fugitives time to melt away.

Emboldened by their numbers, the motley crowd had begun to morph into a hostile mob. The situation was turning uglier by the second when Ananjeya had stepped forward with a sickle in hand. As the crowd looked on, he had drawn a line on the road in typical larger-than-life southern film-star style and yelled, 'If anyone crosses this line, he is dead. If you think I'm not serious, try me.'

The mob had paused and looked at the earnest young man who stood resolutely, weapon in hand. His eyes moved in slow deliberation from one face to another, implying that he was trying to decipher a way to maximize the damage and daring them to make a move. Nobody was able to meet his gaze and after a while, the crowd had quietly melted and his team gelled. Since that day, Ananjeya was marked out by his seniors

for higher things.

Ananjeya and his team were quickly briefed about their current mission and left in no doubt that the terrain was bound to make them miserable. Land and water battled for space, with the land shrinking considerably after the rains in the Nilgiris. But the real winner was the buffer in between: the sticky, slushy, slimy marsh that separated or linked the land and water. The depth of the marsh was deceptive and the surface, treacherous. It was not a good place for either the hunter or the hunted.

'You can set up an observation post. There is a huge banyan tree that you can camp under. But if you move even an inch beyond the tree, you can be spotted from the hills on either side,' the ambush party was briefed.

And so, the four men set up camp with care. The solitary banyan tree provided excellent cover. They checked in silently, setting up their bivouac at night. Its colours—light green, yellow and brown—blended well with the surrounding shrubs.

A few days passed uneventfully. Seeing no threat in their rare but gentle movements, the birds, jittery at first, ceased to raise an alarm.

Staging a successful ambush requires long hours of waiting in silence. But in the back of beyond, it can start to get on your nerves.

Ananjeya sighed softly and shifted his weight from one leg to the other.

He winced as his stomach rumbled again. He squinted in the direction of the bivouac. Everyone seemed to be sleeping soundly. 'It'll take just a few minutes,' he thought. 'No point waking up anyone.' He grabbed a bottle of water and moved 10 metres away.

A few minutes later, Constable Suresh woke up with a start. He had been on sentry duty before Ananjeya, and had happily relinquished charge to him. But he slept fitfully.

Groggily, he looked for Ananjeya. Nobody there!

A lone owl's hoot and the croaking of frogs only disoriented him further.

A jolt of panic ran through him. What had happened? Why wasn't Ananjeya at his post? Had he been attacked and taken out silently? Could an enemy be surreptitiously creeping up on them even as they lay there?

As these fevered thoughts ran through Suresh's mind, he heard two vague sounds—something splashing to the ground, followed by steps. 'Something or someone?' he wondered.

Suresh remembered the way they would ensure that no one would creep in through the sentry's blind spot. They would carefully lay some flat stones, tiles and flakes, and make a carpet of dry leaves and barks over it. Even a mouse couldn't enter the zone unchallenged. That was where the sound was coming from.

Then there was silence, followed once again by the sound of footsteps.

Suresh knew by now that he was not imagining things. This was for real. Something or someone was moving close by.

Pushing his sheet noiselessly aside, Suresh grabbed his AK-47 and stood up. He focused his vision on the ambient light, a little off the banyan tree. Again, he heard a rustle. Then a silhouette appeared.

Suresh tensed. Not just his life but those of the other two men sleeping beside him were potentially in danger. He eased his gun's slide from the safety position.

'*Yaar nee* (Who are you)?' he shouted, his voice barely recognizable even to himself.

Having relieved himself, Ananjeya was feeling slightly better. Unaware that the days of vigil for Veerappan and the time of the night had frayed Suresh's nerves, he chose to ignore the question and moved forward.

'Enemy,' thought Suresh. 'He's coming for us.'

Even as his mind was completing the thought, his finger pressed the trigger. Seventeen bullets ripped through Ananjeya's torso from a distance of barely 5 metres. He collapsed to the ground, blood pouring out from his multiple wounds.

His mouth stuffed with betel leaves and areca nuts, he replied with difficulty through the haze of pain, '*Dei suttuteiyada* (You've shot me).'

Suresh froze.

The horror of his action hit him with sickening force. He threw down his weapon and ran towards Ananjeya, weeping inconsolably. The other two men, who had woken up at the sound of fire, were shocked by the sight. They rushed up to Ananjeya, who was, ironically, consoling Suresh. '*Parava illay* (Don't worry),' he said, as he lay cradled in his buddy's arms.

Then he muttered his sister's name twice, and added, 'Take care of her.'

Those were Ananjeya's last words.

Hussain said that the policemen with Suresh reported that even as Ananjeya's body stilled, Suresh lunged for his gun and tried to place it in his mouth. The two of them grabbed him and wrested the weapon away.

'Give me the gun. I can't live with myself,' Suresh had pleaded, they said. His comrades held him close as sobs racked his body. Finally, when he was completely drained, they released him. Between the two of them, they carried four guns on their grim journey back. Their own, as well as those of Ananjeya and Suresh. They also made sure that Suresh walked in front of them at all times, well within their line of sight.

Hussain said that Suresh's peers and senior officers had counselled him extensively. 'It's not your fault,' they said. 'It could have happened to anybody. Stay on and redeem yourself,' they advised. But there were just too many memories that tormented Suresh. The STF camouflage, the haversack, the green sheets, the camps—everything reminded him of Ananjeya Kumar and that ghastly night. Finally, unable to take it any more, he quit the STF.

Hussain said that Veerappan's man confessed that three days later, Veerappan and his gang crossed the site. Veerappan remarked as he glanced back, '*Dei avangalukkullei ingeydan suttukittangalam. Nallududaan* (It seems they shot at each other here. Good for us).'

Hillside Ambush

August 2001

'Easy, boys, I have something for all of you,' Mohan Nawaz laughed, as the four stray dogs gathered excitedly around him, their tails wagging furiously, at the Asanur STF camp. Then, he turned to me. 'Sir, may I present Tiger, Kaiser, Rocky and Rambo,' he said, pointing out each one.

'You seem to be very fond of them.' I smiled.

'I've named them after the ones who saved my life,' he said, turning serious. 'My best guards ever. We only found out later that they had helped thwart a well-planned attack by Veerappan. We would not have stood a chance had it not been for my four.'

His eyes misted as he recalled the way the four had bravely fought a leopard that had strayed near the present camp and met with a tragic end soon after. 'They were all badly wounded. Tiger, the natural leader, died a few days later. Kaiser was the next to go. Rocky outlived them all,' he said.

He paused and then added that Rambo's loss was harder to accept. 'He started behaving erratically and was shifted to Dhimbam camp, where he began to attack Sambar deer many times his size and other smaller animals. The forest guys complained. A written order was issued by the DG's office that Rambo be removed at once, probably one of the few times a DG had issued an order specifically naming a dog for removal. I was worried he might be put down, so I quietly shifted him to another camp, which was quieter than Dhimbam. But he passed away there after

some time,' recalled Nawaz.

Sensing the change in the mood of their favourite human, the four strays started whining and pawed at him, trying to cheer him up. Nawaz sighed, 'Too bad the original four weren't around the day Veerappan ambushed me and Tamil Sir.'

'Isn't that where we are going today?' I asked. 'Will you accompany me?'

Nawaz finished feeding his dogs and joined me in my vehicle. As the jeep began the circuitous hill journey, he narrated his remarkable story.

◆

February 1996

Veerappan was holed up below the western slopes of Dhimbam Hills, trying to rebuild his shattered gang. He had recruited a tribal named 'Tupaki' Siddan and his wife, Kumbhi. Tupaki means gun in Tamil and Siddan had acquired the nickname because he was a superb gunsmith, which proved to be advantageous to the gang.

With Tupaki's aid, more tribals joined his gang, rebuilding it into a force of a decent size. Emboldened, Veerappan planned another audacious attack.

On 10 February, four stray dogs near the Asanur STF camp, where Mohan Nawaz usually stayed, began barking loudly. The sentry tensed and peered into the dark, ready to spring into action.

'Who's there?' he called out.

The dogs redoubled their barking. Other policemen inside the camp woke up, grabbed their guns and took up positions, but nothing was visible.

The four dogs ran towards the trees near the camp and continued to bark frantically. Hidden in the vegetation, Veerappan grunted in frustration.

Members of his gang said that he was furious about the element of surprise being lost. He weighed his options about still going ahead with the attack, but the risk involved had now risen dramatically. *There*

would be no attack today. He signalled his men and they quietly filed back towards their hideout.

'Wretched dogs,' said one of them as they returned.

The dogs in question, though not completely domesticated, had saved the lives of several policemen. The men in the camp used to toss them food every now and then, and a bond had developed between the humans and animals. That day, the generosity shown by the men had been repaid many times over.

But Veerappan was determined to get even with Nawaz. Over the years, he had developed a visceral hatred for Nawaz, owing to all the damage—real and imagined—the officer had inflicted upon him by his relentless raids. In some ways, Nawaz had become a symbol of all the slights and pitfalls that Veerappan had faced in his long years evading the law.

To that effect, he decided to use the local populace and human greed to his advantage. Veerappan began to spread rumours that a single-tusked elephant had been spotted near a village called Balapadugai.

Lured by the prospect of procuring ivory, several villagers went to the area. They were accosted by Veerappan's gang and forced to join him. Most of the men were used for sentry duty or to perform menial jobs, but a few of them had muzzle-loaders—and were ready and willing to use them.

Manpower in place, Veerappan then staked out a spot on the Dhimbam–Germalam road, which is narrow and winds uphill. He stationed men on either side to trap anyone driving through right in the middle. He was so anxious to ensure a favourable outcome that he even visited a local astrologer who gave him a copper plate with triangles, squares and half-circles etched on it. It resembled a CD. Veerappan was instructed to sit on it as he waited for his prey.

It was a long wait, his surrendered gang members told the police later. Six days went by. On the seventh, Veerappan had almost decided to pack up and try another ambush site when one of his lookouts wolf-whistled. A chorus followed. Nawaz's vehicle was on its way. Its distinct green colour could be made out from miles away.

On most days, Mohan Nawaz would have been seated in the front,

next to the driver. But that day, he was giving a ride to Tamil Selvan, then SP, STF. Driver Elangovan, Constable Raghupaty, Head Constable Selvaraj and Sub-Inspector Loyola Ignatius also accompanied them.

As per service protocol, the senior officer is given the front seat. Therefore, Nawaz sat behind the driver. Tamil Selvan and Nawaz were catching up on various ops when the vehicle started climbing uphill. The engine struggled up the gradient, wheezing so much that Nawaz was unable to hear Tamil Selvan. He gestured to Selvaraj and they exchanged positions. Now Nawaz was right behind Tamil Selvan.

Within an instant, shots rang out from above as well as from the right of the road. Selvaraj was killed instantly.

But the occupants of the jeep were well trained to respond to such an ambush, thanks to constant harangues by Nawaz, who had always felt uneasy every time he crossed that spot. Despite being wounded, Elangovan immediately halted the jeep next to the mountain.

The men waiting to ambush them swore. Their view was now obstructed by overhanging rocks. They were denied a clear line of fire by the driver's sudden manoeuvre. Meanwhile, the jeep itself provided some cover to Nawaz and the others, who were now crouched between the vehicle and the mountain.

Still, the situation was dire. A bullet had pierced SI Loyola Ignatius's skull and knocked him unconscious. Owing to its delicate position, the bullet has never been surgically removed. It remains in his skull even today, though it has shifted position over the years.

Tamil Selvan was hit on the left hand, but rolled under the jeep and began firing with his AK that he had kept cocked and ready, as usual. Raghupaty also opened fire.

Hit by shrapnel on the right side of his head, left shoulder and the left of his nose, Nawaz saw some men running downhill. He rolled under the jeep, came out on the other side and started following them. But the incline was steeper than he had expected and he slipped, rolling over and over till he slammed into a rock. The shock jarred his AK-47 out of his hand. Desperately, he fumbled for it. A wave of relief flooded through him as his hand closed around the familiar grip.

With effort, Nawaz got up. He found himself staring straight at a

startled Veerappan and a few of his men. Veerappan was holding his SLR and a muzzle-loader. Nawaz, who by now had no strength left to hold the AK-47, propped it up against the rock. Blood and sweat pouring down his face, yelling at the top of his lungs and looking like a demon straight out of a nightmare, he opened fire.

The bullets went haywire. An unnerved Veerappan and his men scrambled away hastily. It is entirely possible that Veerappan didn't recognize Nawaz, otherwise he would have almost certainly tried to finish him off that day.

Nawaz slumped back to the ground, completely drained. He could feel his consciousness flickering. 'Losing too much blood,' he thought grimly. He cupped some of the blood streaming down his face and drank it, even though he knew that it was rather desperate.

'The gang might circle around and come back. They like to loot ambushed vehicles,' Nawaz thought. 'I don't even know what's happened up there. They might all be dead. I should go uphill to the other side. I'll be able to keep an eye on the vehicle from there.' He began crawling uphill, slowly and painfully. About halfway, his battered body gave up and refused to move.

'I'm done,' thought Nawaz. 'But I can't let myself be taken prisoner by Veerappan. He'll kill me in the most agonizing, humiliating way possible when he finds out who I am.'

Drawing on all his willpower, Nawaz forced himself into a sitting position and propped himself up against a tree. Then, he took his AK-47 and put it under his chin, with the finger on the trigger. He waited, falling in and out of consciousness.

The sound of footsteps nearby jolted him awake. 'I must have passed out,' he thought. The footsteps came closer.

'Mohan Nawaz. SI Mohan Nawaz,' called out an unfamiliar voice.

Nawaz shut his eyes, said a quick prayer and readied himself to press the trigger.

'Alpha 3! Are you there, Alpha 3?' called out another voice. Nawaz froze. Alpha 3 was his call sign. Only a fellow STF member would know that. Or was it a trick? There was only one way to find out.

'I'm here,' he croaked, keeping his finger ready on the trigger.

Familiar STF faces burst into view. Nawaz hung on to his battered senses just long enough to ensure that he was not imagining it, then gratefully passed out.

Later, it emerged that the unfamiliar voices belonged to members of the Karnataka STF, who had also been searching for Nawaz. Karnataka STF Inspector Jayamaruthi and his team were in the vicinity when the ambush had occurred. As soon as Jayamaruthi heard the shots, he rushed with his team to the spot. The sudden arrival of reinforcements had led Veerappan to abandon the ambush—just one of the many remarkable coincidences that day.

I remember rushing to the hospital in Mysore where Tamil Selvan was first taken. Once stable, he was shifted to Malar Hospital in Chennai where CM Jayalalithaa met him and Nawaz. Tamil had damaged three fingers of his left hand, but made it a point to rejoin the STF as soon as he was declared fit to report for duty—a move that further raised the already high esteem in which he was held by his colleagues and men.

As if cocking a snook at his injury, Tamil Selvan resumed wielding guns again. He even managed to improve his shooting scores.

Veerappan, meanwhile, toned down his criminal activities. He went hyperactive releasing video tapes, which got a lot of mileage on television. He actively canvassed against Jayalalithaa in these tapes. The state elections were just three months away, and Veerappan was hell-bent on seeing the person he considered a thorn in his flesh ousted from power.

Nawaz, however, remained on Veerappan's trail. Skipping the home rest advised by doctors, he rebounded straight from the hospital bed to his office and was soon able to nurture a valuable informer—who would later cause Veerappan much grief.

Execution of an Informer

August 2001

One morning, as I scanned through the files on Veerappan and our confidential informants with Mohan Nawaz, I came across a series of photographs of a badly decomposed body.

It appeared to have been left out in the open for a few days before the pictures were taken. The scavengers of nature—larvae, flies and beetles—had already done a thorough job. Even so, the man's hip-length hair was a dead giveaway.

'Baby Veerappan?' I said. 'Quite a sticky end, isn't it?'

Nawaz nodded. 'Yes. We weren't really surprised. Baby was always a bit of a womanizer. His death saved us all a lot of trouble. He would have turned out to be even worse than Veerappan himself.'

◆

April 1997

When DSP Chidambaranathan was kidnapped in 1994, Baby Veerappan had acted as the negotiator. Temperamental, ruthless and arrogant, Baby was particularly vain about his hair. It had turned into a brand in its own right, like Veerappan's infamous handlebar moustache. Baby liked to keep his hair open, and every now and then would dramatically shake it off his face with a jerk of his head. He fancied himself a ladies' man, and didn't

let things like someone's matrimonial status bother him.

In April 1998, Baby unfortunately picked the wrong woman to hassle—Kumbhi, 'Tupaki' Siddan's wife. Siddan was influential with the local tribals, the Sholigas, and, as a result, he had emerged as Veerappan's key ally.

One day Siddan arrived at his camp and stood in front of him. The former wanted to say something, but was clearly reluctant.

'Speak up. What's troubling you?' asked Veerappan impatiently.

Siddan scratched his head, shuffled his feet, and then began weeping as he blurted out, 'What I'm going to say will upset you, Ayya, but it's God's own truth.'

'What?' asked Veerappan, waving the others away.

'Ayya, Baby is bothering my wife.' The words came out in a rush.

'Kumbhi?' Veerappan asked, thunderstruck.

Siddan nodded and wept some more, covering his face with his hands.

With a furious expression on his face, Veerappan raised his left palm, gesturing Siddan to keep quiet. Siddan complied hastily, not sure who Veerappan was annoyed with more—him or Baby.

'You may go.' Siddan was dismissed.

He wanted to ask Veerappan about his intentions, but quickly folded his hands in a vanakkam and exited the camp.

Informers in the camp later told the police that the moment Siddan left, Veerappan yelled for Baby.

As soon as he arrived, Veerappan gave him a piece of his mind. 'You idiot, what were you thinking? That man is important to us. And you fool around with his wife? Control your libido,' he yelled.

Baby's face reddened. It had been a long time since anyone had spoken so harshly to him. Without saying a word, he stormed out of the camp.

Veerappan sighed and rubbed his eyes. 'Go fetch that ass before he gets himself killed,' he snorted.

Baby was mollified and persuaded to come back, but the rift between him and Veerappan widened. Eventually, Veerappan allowed him to leave the gang and go his own way. As a sign of his affection for his distant nephew, Veerappan allowed him to keep his .303 rifle and also gifted him

a pair of tusks so that he could sell them and start afresh.

Baby immediately headed off to meet Giddhabhai 'Kulla' Bacha. Kulla means tiny. Giddhabhai wasn't quite as small as the nickname suggested, but he had been given the moniker to distinguish him from a couple of namesakes who were a few inches taller than him. The name stuck.

In the underworld circles, Kulla Bacha was the man you went to if you had illegal ivory. So it was no surprise that he was the first person Baby went to see. But in his arrogance, Baby made no effort to hide his movements.

Before long, Nawaz found an informer whispering into his ear, 'Kannukutti thaniya suthudhu (A stray calf is on a loose tether).'

'Bring in the calf at the right time,' he responded.

The informer, Kandavel, nodded. 'Soon,' he said, and left for Kulla Bacha's camp.

Like Baby, Kandavel had once been an armed member of Veerappan's gang. His stint with them had lasted three years till a minor fallout occurred between him and the other gang members. Veerappan had stripped him of his weapon and ordered him to leave. But for old times' sake, he still functioned as a courier for the gang and visited their hideout every now and then.

What Veerappan didn't know, however, was that after Kandavel was evicted from the gang, Nawaz had carefully cultivated him. Instead of arresting Kandavel for the multiple cases against him, the STF had given him some money and asked him to keep them informed about Veerappan's activities.

On his way to meet Kulla Bacha, Kandavel ran into Baby in Thalavadi Forest. Baby was cooking upma in a clearing, while three young boys, who worked with Bacha, hovered around and chatted with him. They had to make sure that everything was in order before Bacha arrived to negotiate a deal for the tusks.

'Come and sit with me, Kandavel. You're right in time to taste my delicious cooking,' laughed Baby.

Kandavel settled down as Baby continued preparing the meal. After a while, Bacha's boys left. Kandavel noticed Baby's rifle on the ground. The two of them were then alone.

'It's the perfect opportunity,' thought Kandavel. He briefly toyed with the idea of taking Baby captive and producing him before the STF, but that would have involved walking many miles in an area full of potential threats while guarding a dangerous, wily foe.

'Too much risk. It will have to be right here, right now,' Kandavel decided. In a flash, he grabbed the gun, slid the bolt and pulled the trigger. The powerful ammunition of the .303 is designed to take out an enemy from even 600 yards. Baby was barely a yard away. The bullets tore through his body, leaving gaping holes in their wake.

In the quiet of the forest, the sound of the rifle carried to Bacha's men. They exchanged panicked glances.

'Police!' exclaimed one of them. They fled for their lives, making no effort to contact Bacha for the next few days. It was only after they were convinced that there had been no police crackdown and Bacha was alive and well that they mustered the courage to approach him again.

Meanwhile, Veerappan learned of Baby's death and flew into a towering rage. Whatever his kinsman's faults—and there were many—he had been immensely fond of him.

As luck would have it, Kandavel was in the gang's camp when the news arrived. He was unaware that Bacha's men had heard the rifle shots. He believed that the best way to ward off any suspicion was to pretend to be unaware of Baby's fate.

'Where is Tupaki? He had complained about Baby. He must have killed him,' thundered Veerappan. 'Find him.'

By then, Tupaki had also heard of Baby's death and realized that he was the prime suspect. Rather than depending upon Veerappan's rough-and-ready method of dispensing justice, which did not involve any legal niceties like presuming a person innocent until proven guilty, he decided to go underground with his wife.

This only cemented Veerappan's belief that Tupaki was responsible for Baby's death. The misunderstanding might have lasted longer, but unfortunately for Kandavel, Bacha decided to meet Veerappan. It was ostensibly a condolence call, but he also wanted to assure the bandit that he had nothing to do with the killing.

'I was stunned when I learned about Baby's death. You know, I was

on my way to meet him. My boys and Kandavel were probably the last friends he saw,' Bacha told Veerappan.

The bandit had been nodding silently and stroking his moustache. He stopped abruptly and glared at Bacha.

'What was that about Kandavel?' he asked.

'He and my boys met Baby just before he died. In fact, my boys left Kandavel and Baby alone. That was the last time they saw him,' said Bacha. 'They heard gunfire a little later.'

Veerappan's eyes widened slightly as he turned to Govindan and asked, 'Kandavel was here the day we learned of Baby's death, wasn't he?'

Govindan nodded and replied, 'He didn't mention meeting Baby.'

The two men stared at each other, first perplexed and then with mounting anger. Veerappan hit his forehead. 'The bastard sat right here while we talked about Tupaki. He must have been laughing his head off the whole while,' he remarked.

After his outburst, Veerappan became quiet. For those who knew him, it was an ominous silence.

'A thorn has to be removed by a thorn,' he finally said, with icy clarity. 'I want Kandavel shredded. Call him here. No, wait, let's not make him suspicious. Bacha, you bring him to me.'

A few days later, an unsuspecting Kandavel walked straight into the trap devised by Veerappan at a place called Kenjimaduvu (ironically, kenji means to plead or beg). He greeted the bandit with a smile that faded as Veerappan stared back at him stone-faced.

Govindan broke the awkward silence. 'Have you been meeting anyone in the STF?' he asked Kandavel.

'No,' said Kandavel, weakly.

Govindan's expression hardened. As Kandavel looked into his eyes, the enormity of his predicament dawned upon him. 'I should have questioned Bacha more closely,' he thought. But it was too late.

Still, he tried to bluff it out. 'What are you talking about?' he asked.

Govindan poked him in the chest with his rifle and remarked, 'You met Baby just before he died?'

All the fearlessness went out of Kandavel. His legs began to shake. His shoulders slouched in defeat, as he began inhaling in short, rasping

breaths. His throat went dry.

'You son of a bitch, we suspected Siddan. We would have killed him. You were sitting there like a snake in our lap while we condemned him,' snarled Govindan.

'Forgive me, I didn't mean to… It was Mohan Nawaz,' Kandavel began to blabber.

Nawaz's name acted like an electric prod on Veerappan. 'That bastard, again. He springs up everywhere,' he snarled.

Veerappan raved and ranted at Kandavel, listing his acts of treachery—real and imagined—even as his men systematically beat him up. He started to shiver, although it was a humid day.

Kandavel sank to his knees, writhing in pain. Dimly, he became aware of Govindan standing behind him. He gave Veerappan one final look, a mute appeal for amnesty, which went unheeded. The click of a gun being cocked snuffed out the last feeble ray of hope. There was an ominous pause. Then a gun roared, only once.

The informer's death sent a shockwave through the STF. To serve as a warning to any potential informer, Veerappan got Kandavel's last moments recorded on camera. A few days later, graphic photographs of his brutal end appeared in the Tamil magazine *Nakkeeran*, along with a screaming headline: 'Trial in Veerappan's Court—Death for Betrayal'.

The accompanying article sent chills down the spines of several readers, mostly concentrated in towns and villages. In the hills and forest areas, Veerappan's stomping grounds, the news was conveyed in hushed voices through simple word of mouth, the story getting even more horrifying with every retelling. Veerappan had made his point forcefully: if you don't wish to do anything for me, then make sure you don't do anything against me.

A year later, another gang member found himself facing Veerappan's wrath for molesting a woman. Meikei Rengasamy, a fringe member of the gang, was accused by a farmer, who was in regular touch with Veerappan, of forcing himself on the man's wife. Veerappan was in image-makeover mode by then, collaborating with radical Tamil groups and trying to project himself as a saviour of the oppressed masses. He had let Baby leave the gang, but no such lenience was forthcoming for Rengasamy,

who was brutally executed. Once again, Veerappan's 'justice' was recorded on camera.

Meanwhile, other rumours abounded. Veerappan, suffering from a persistent cough, had acquired medicines from a local quack a few days before the execution. The STF's intel had picked up a rumour, probably planted, that Veerappan was extremely unwell. Other whispers of a similar nature also began reaching the STF. Some claimed that he was suffering from tuberculosis, others that he could barely walk. Greenhorns in the intelligence wing started to enquire, not so discreetly, if it was true that he was no more. This caused a rumour to spread like wildfire that Veerappan had died near Manigarai, a hamlet halfway up a hill, which had been abandoned several decades ago during a severe drought.

It seemed to add up to one conclusion—Veerappan was indeed dead and his gang was making sure that the cops would never get their hands on his corpse, as a matter of honour.

The news of Veerappan's death was received by the STF with a combination of excitement and disappointment. There was excitement that the Veerappan menace was finally over and disappointment that he had cheated justice in death.

An STF search party under Ashok Kumar was rushed to the site to ascertain the truth. It dug out a *Nakkeeran* magazine, muzzle-loader guns, travel bags containing clothes, hermetically sealed diaries and a huge stash of rice, oil and food, all sealed in three layers of polythene, suggesting a long stay of a sizeable number of people. The search party also came upon a coconut shell and a shattered mud pot, before finally stumbling upon a skeleton (which matched Veerappan in height). Later, it turned out that Sethukuli Govindan had conducted the last rites with the coconut and the mud pot. The STF was more or less sure that the deceased person was Meikei Rengasamy. Still, some doubts lingered. Could it be the dreaded bandit himself? Even before the forensics team could identify the deceased, reliable information arrived that Veerappan had been spotted elsewhere.

But the real skeletons that tumbled out of the bandit's cupboard came from one of Veerappan's diaries.

These, for the first time, revealed the bandit's outreach plans.

Nellikuppam Ramesh of the Tamil Nadu Viduthalai Padai (or the Tamil Nadu Liberation Army—TNLA), a banned and underground extremist outfit, was part of his camp. The redoubtable Q branch of the TN Police later unearthed diabolic plots not only of the TNLA but also of the TNRT—Tamil Nadu Retrieval Troops, of a quid pro quo between the gang and the radicals.

One Day, Two Escapes

August 2001

'Two narrow escapes and that too within a span of barely twenty-four hours?' I remarked. That was quite unbelievable, as Veerappan was known to give only two–three darshans a year to security forces, and here he was appearing twice on the same day. Curious, I opened the file.

◆

November 1998

Assistant Commandant V.S. Naik heaved a contented sigh as he looked around. He, along with a patrol party of the Karnataka STF, was taking a break near Kundri, next to a water point. Some of Naik's men walked up there to freshen up. Just then they heard a rustle behind them. They whipped around and were dumbfounded to find themselves gazing upon Veerappan and some of his men.

For one long, seemingly interminable moment the two sides gaped at each other. Then everybody went for their guns at the same time. But in the confusion and adrenalin-fuelled frenzy, none of the bullets found their mark.

With a savage oath, Veerappan lowered his rifle and took to his heels. By the time the members of the patrol could figure out what had happened, they found their target bounding from one rock to another

and vanishing.

Naik and his men tried to give chase, but the window of opportunity had closed. It was after a very long time that a policeman had seen Veerappan face-to-face, and Naik was inconsolable.

A few hours later, it was the Tamil Nadu STF's turn to go through the same gamut of emotions.

A local police station up in the hills informed the STF's Bannari camp that Veerappan had sent word to a local vendor that he would shortly arrive at his home to have dosas. The man's son immediately headed for the police station to pass on this once-in-a-blue-moon intel. This time, Hussain, an expert sniper himself, personally volunteered to lead a team to surround the vendor's house, which was little more than a hut. The men threaded their way carefully through the thick undergrowth. 'Careful, lads. Don't jerk the trigger in excitement,' whispered Hussain.

The team, which included several crack shots, exchanged glances and nodded. They knew all too well how easy it was to get carried away in a rush of excitement, and how a split second could make all the difference between life and death.

Suddenly they heard a strange noise. It sounded like someone was shooing away birds. Hussain didn't want to take any chances. He dropped on all fours and moved stealthily towards the hut. Their view of the target was cut by almost 90 per cent. Still, it would be impossible for anyone to enter or exit the hut without being noticed by them, or at least their scout.

Hussain peered over the earthen bund of the half-ploughed field that led towards the hut. 'His head will be the size of a papaya,' the sniper in Hussain thought, as he lay quietly with his right cheek resting on the butt of the 7.62 self-loading rifle.

Suddenly, the stillness was shattered by a shot.

Hussain's jaw fell. 'Not again,' he thought, recalling all the previous occasions when the element of surprise had been lost. He glared at his team, but a voice inside his head was already telling him that based on the direction of the sound, the bullet had not been fired by any of his men.

He grabbed his night-vision binoculars and focused. His gaze rested on a fence. The lone gate was open.

'Come on, they're getting away,' shouted Hussain.

All caution was jettisoned as the squad charged towards the hut.

'Don't shoot. There's no one here but me,' yelled the terrified owner, as Hussain and his men burst into the hut. Hussain looked around. There were some empty plates. The dosa stone was lukewarm; the embers had still not died out.

'Where is he?' yelled Hussain.

'He left fifteen minutes ago,' came the reply.

♦

The mystery of the anonymous shot was solved soon thereafter.

Hussain shook his head ruefully as he narrated the manner in which he and his men had found another hut about 50 feet below the vendor's. It belonged to a farmer, who owned a muzzle-loader and nursed a deep hatred for some wild boars that were raiding his fields and ruining months of hard work.

As luck would have it, that evening, the farmer had decided to kill as many of the boars as he could and had been waiting for them since sunset. It was his shot that had startled Hussain and probably hastened Veerappan's departure.

By the time the STF reached the man's house, he was already chopping the meat with rhythm and relish. He was whistling a cheerful tune as he worked. The STF men looked at him, then at each other, and burst out laughing, rueful at another missed opportunity.

Demanding yet exciting times with the SPG (1986): With the then Prime Minister (late) Shri Rajiv Gandhi, Rahul Gandhi and leaders of the CPT, R.R.P.N. Sahi and Ravi Sawani (partially seen)

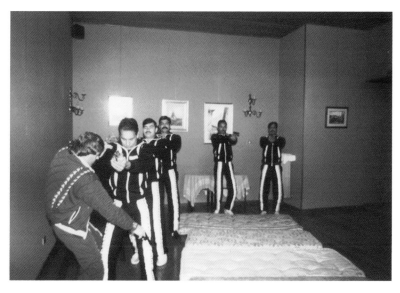

Dancing to the tunes of Rossie and Whitney Houston (1986): Behind Gosain and Tikku (third from right)

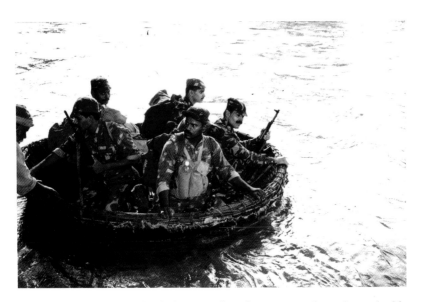

A united force across divided waters (1993): In a coracle with my buddy Sundaram

Saluting a brave heart (1996): Paying homage to (late) Head Constable Selvaraj. Ashok Kumar (far left in white shirt) Sanjay Arora (3rd from left) DIG Radhakrishnan, Shankar Bidari, ADG Kumarasamy and DGP Walter Davaram

Winners never quit, quitters never win (1999): (from left to right) Hussain, Rajarajan and Kannan on a dry riverbed

Fighting fit (2003): Sitting in a jungle camp with the alert and agile mini-team

Forging a 'joint team' with the Karnataka STF (2003): (From left) SP Shanmughavel, DSP Ashok Kumar, me, IG Mirji, SP Madhukar Shetty

A solemn oath in the New Year (2004): At the STF memorial at Thattakarai

Before the final assault (2004): On a recce during Operation Inundation (standing in the centre)

The more you sweat in peace, the less you bleed in war (2004): Briefing the men before the 'one-minute drills'

Leading the charge (2004): Tracking the 'wired nomad' with Kannan and Hussain

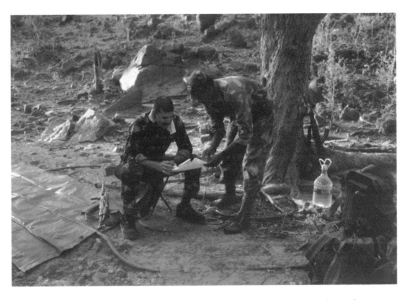

It's a jungle out there (2004): A quick update next to the green sheet that was a bed sheet, blanket, holdall and roof, all rolled into one.

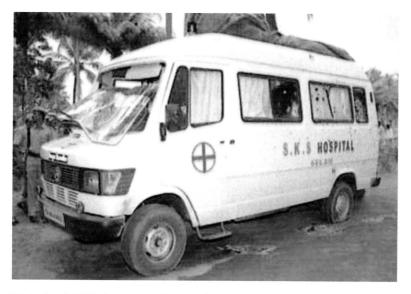

Battle hardy (2004): Cocoon, after the shootout, with the misspelt word 'Selam' (instead of Salem).

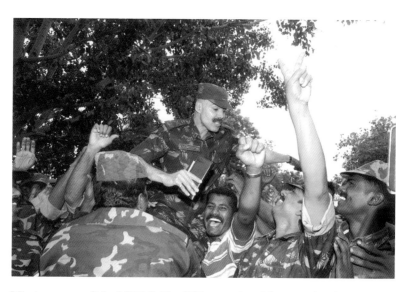

Mission accomplished (2004): The STF erupts in celebration after the success of Operation Cocoon

Felicitations after Operation Cocoon (2004): (from left) ADG R. Nataraj, me, DGP I.K. Govind, then Chief Minister (late) J Jayalalithaa and senior officials

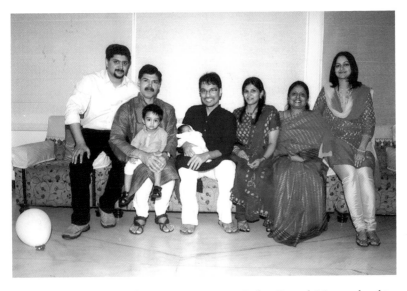

At home (2008): (from left) Son Arjun, me, son-in-law Deepak Menon, daughter Ashwini, wife Meena, daughter-in-law Dr Gita Arjun and grandkids Aditya and Adhvai

The Rajkumar Saga and its Fallout

An Audacious Abduction

Srinagar, 2000

At the turn of the millennium, I was IG (Ops) of the BSF in Kashmir, heading a 50,000-strong force. The Kargil war and fidayeen attacks—particularly after we lost a DIG in Bandipur to the latter—kept us on our toes.

One evening, during chile-kalan—peak winter in Kashmiri—I was at the Lal Chowk bunker, one of the hundreds that dotted Srinagar. I was amazed at the way my boys would always keep their morale high, despite the abysmal living conditions. Within minutes of my departure from Lal Chowk, the post was rocked by a grenade attack. A jawan patrolling nearby was fatally shot when a passer-by, part of the milling crowd, suddenly whipped out a pistol from under his phiran and opened fire.

Days later, I received a late-night call from the control room. Some militants were holed up in a house in Srinagar that had resulted in an intense gun battle with troops from four different forces—the army, the Special Operations Group of the J&K Police, the Central Reserve Police Force (CRPF) and the BSF. All troops were pinned down on the street opposite the house, unable to move in.

A heavily armoured truck, also referred to as a mobile bunker, was positioned nearby.

'Why doesn't someone drive that in? I enquired, 'The boys can follow under its cover.'

'The CRPF driver was hit by a bullet through a little beading at the

top of the windscreen,' I was told. 'We've managed to extricate his body but nothing has happened since. The boys are badly shaken.'

I ran up to the truck and jumped on to the driver's seat. It was sticky with the dead man's blood. A split second later, the other door opened and my staff officer entered. The look on his face suggested that I was violating a full chapter of the SOPs (standard operating procedures).

Though BSF had overall responsibility of the city, this particular operation was being handled mainly by the CRPF and J&K Police, with the army in a supporting role. Also, the IG's participation had only compelled the BSF Quick Reaction Team and other personnel to get involved, albeit unwittingly.

I fired up the engine and drove in at full throttle. The metal antenna of my bunker got tangled with a bunch of overhanging cables and some electricity poles, leading to considerable damage. Though the bunker almost stalled, it had, by then, achieved the intended purpose. A cheer went up and the boys came charging in behind me. A few shots were fired at the windows of the building. Then the boys brought down heavy covering fire. One brave jawan crawled up and lobbed a grenade through a window.

The militants retaliated with intense firing, constantly shifting positions. A few bullets hit the truck, but pinged off the armour.

After a while, the firing became sporadic. 'Just some mopping-up operation to be done now,' I thought and got off the truck. Satisfied that things were under control, I went home and turned in. However, on getting information that firing had restarted, I had to head out again in -4 degrees Celsius and search every inch of the shack. Such is life!

◆

Even though I was engaged in a battle of a different intensity far away from Veerappan's hunting grounds, I continued to hear about his escapades and brushes with the police.

A few months later, I moved to New Delhi on a staff appointment. Never much of a paper-pusher, I was anyway quite restless in my new assignment. Then news from Tamil Nadu made me desperate to get back to the STF again.

After lying low for a while, Veerappan contemplated abducting a

celebrity. He had already gained expertise in kidnapping people over the years, starting with the son of a granite-mine owner in 1992.

In July 1997, Veerappan abducted ten Forest Department employees in Karnataka. The hostages were finally released after forty-four days in captivity, with the editor of *Nakkeeran*, R.R. Gopal, acting as the negotiator on behalf of the government for the first time. It was rumoured that the bandit was quite unhappy about his hostages being small fry.

The choice of Gopal as the negotiator raised serious doubts in the minds of the public. The popular perception was that the press was able to contact Veerappan at will, even as the police struggled. However, Veerappan was not an isolated case. Whether an underworld don in Colombia, an insurgent in Beirut, a militant in Kashmir, or a Naxal leader, they tend to access the media when they want to. Mostly, the communication is one-way. Veerappan actively courted the press and reached out to them, just as he assiduously avoided the police. When someone was taken to his hideout, it was usually through a circuitous route. There would be multiple guides, with each one knowing only part of the route. People who went to meet him could hardly ever retrace their steps. If it had been all that easy to nab Veerappan, it would have been done years ago, especially since the STF in both states had outstanding personnel.

On 8 October 1997, Veerappan abducted wildlife researchers and photographers Krupakar and Senani. The next day, he stopped a bus carrying fifteen tourists through Bandipur Forest and took them hostage. The same fate was reserved for the six Karnataka Forest Department staffers who went searching for the bus. Though Veerappan set most of the tourists free the same day, along with three government staffers, he refused to release Dr Satyabrata Maiti, a scientist with the Indian Institute of Horticultural Research in Bengaluru.

Maiti, Krupakar, Senani and the three foresters stayed in Veerappan's captivity for a fortnight, before finally being released. Krupakar and Senani later wrote the book *Birds, Beasts and Bandits* on their enforced stay with Veerappan.

These daring abductions were followed by a meeting of the CMs of both states in August 1997, which resulted in a nine-point agreement regarding Veerappan's demands.

However, some of the more outrageous demands were turned down. One of them was that Veerappan be kept in a special camp in Tamil Nadu, where he would receive visitors freely. It reminded me of Colombian drug lord Pablo Escobar, who had got a jail built to his specifications, comprising a soccer field, a bar, a jacuzzi, his own guards and women of his choice. But Jayalalithaa, then the Leader of the Opposition, blasted Veerappan's request.

After the many close calls with the STF, Veerappan had kept a low profile. As winds of political change swept through the state, speculation was rampant in the press that Veerappan was possibly negotiating his surrender on very soft terms.

Veerappan's lofty ambitions were rudely shattered after Walter Davaram publicly declared that if the bandit was ever given favourable treatment, he would personally shoot him!

Those of us who knew Walter well joked that getting a gun would not be a problem for him. Apart from his service issue weapon, he had built up a sizeable personal collection. His most prized possession perhaps was a revolver awarded to him by the Home Ministry for being the topper of the 1963 IPS batch.

Anyway, a leopard cannot change its spots. Veerappan too was getting itchy. Men who were part of his gang at the time told the police that though his previous abductions had made headlines, Veerappan yearned to be the stuff of legend. And for that, he knew he needed to reel in a really big fish.

Then, in the summer of 2000, one nefarious act made Veerappan a household name in India. It not only sent shockwaves throughout the country, but also made headlines the world over and catapulted the brigand to the status of India's most wanted.

◆

July 2000

Deep in the forest, Veerappan's group huddled together, talking about potential targets.

'Anna, Rajini's house is near ex-CM's (Jayalalithaa's) house. We can get him when he moves out to a studio. Or near Chola Hotel,' said one man.

Rajinikanth is the reigning deity of Tamil cinema, a superstar whose fans' emotions border on religious devotion. He was undoubtedly tempting prey, but snatching him from the heart of Chennai and bringing him into the forest posed many logistical challenges.

'What about Stalin?' asked someone else, referring to the son of then Tamil Nadu CM, M. Karunanidhi.

'He's the Chennai mayor, always surrounded by gunmen. Too risky,' cautioned another.

Several ideas were floated and discarded. Through it all, Veerappan remained expressionless.

'How about Rajkumar?' somebody suggested.

The name made Veerappan look up. Dr Rajkumar was a legendary superstar of Kannada cinema and the recipient of many prestigious honours, including the Padma Bhushan and the Dada Saheb Phalke award. He was regarded by his fans as a national treasure.

The gang began to discuss the idea. 'His ancestral village is Doddakajanur. He has a farmhouse there that he loves. Our informers tell us he is there right now. He doesn't like too much security around. Perfect target'.

'Anna, it will fetch us big money. And your image will change,' one of them told Veerappan.

Veerappan's neck swivelled. That one word—'image'—seemed to touch a chord.

'How far is Doddakajanur?' he asked.

'About 20 km, very close to the Karnataka–Tamil Nadu border,' came the reply.

A smile settled on Veerappan's face. 'Let's go pay Rajkumar a visit,' he said.

30 July 2000

Veerappan waited patiently in the fallow fields, his eyes fixed on the

farmhouse where his prey was having dinner with a small group.

'Enjoy your meal. It will be the last one in a civilized setting for a while,' he thought. As he counted down the minutes, he remembered his horoscope that had predicted: *The state will listen to your words.*

'Let's see if that comes true,' he muttered.

The sky was changing colour. Finally it was pitch dark. Veerappan slowly let out a deep breath and nodded. It was time to move.

The gang's advance team, dressed in khaki and olive green, knocked at the door. Before someone could answer the door, they pushed it open and barged in forcibly. Watching from his concealed position, Veerappan allowed a smile to play on his face. 'So far, so good,' he mumbled and marched in.

As Veerappan entered, all eyes turned towards him. The occupants looked befuddled at the sudden turn of events. But one look at Veerappan and the shock gave way to fear and dismay.

Veerappan walked up to Rajkumar. '*Ayya, polaam* (Let's go),' he said. Then he handed over an audio cassette to Rajkumar's wife, Parvathamma. 'Give this to (then Karnataka chief minister) S.M. Krishna. He'll know what I want. Ayya will be safe.'

'Please give him his medicines. Don't harm him,' Parvathamma pleaded as her voice choked.

'No harm will come to him in the forest. But make sure Krishna listens,' Veerappan told her.

In the melee, however, the gangsters ignored her plea about the medicines. Later, through All India Radio, the family reminded Veerappan of it.

Apart from Dr Rajkumar, the gang also rounded up three more hostages—his son-in-law Govindraj, relative Nagesh and assistant Nagappa. Luckily, the driver was spared as Veerappan realized that he would be needed to drive Parvathamma to Bangalore.

'Don't try to raise an alarm or make any sound as we leave,' Veerappan warned. 'If I hear the slightest sound, I'll act. Don't blame me later.'

Moments later, the bandits melted away into the darkness. The operation went off more efficiently than they had hoped, setting the stage for a 108-day hostage drama that gave sleepless nights to the

administration of two states and riveted the attention of the world.

In the four long hours that followed, and which seemed like a lifetime to Rajkumar, the gang made their prize catch walk about six miles. It was slow going, but they could walk only as fast as the aged actor. At seventy, Rajkumar was fit, but suffered from arthritis and diabetes. Veerappan knew better than to push him beyond his physical limits.

In the opposite direction, a frantic Parvathamma drove through the night, only taking a break in Mysore to consult her family astrologer, Bhasyam Swami. After looking at his charts and performing some calculations, he assured her that her husband would come out safely from the ordeal within a few days.

Parvathamma then drove straight to the CM's residence, where he was woken up at about 3 a.m. and given the shocking news.

Krishna immediately summoned Home Minister Mallikarjun Kharge, DGP Dinakar and Home Secretary M.B. Prakash. Later, Transport Minister Sageer Ahmed, Chief Secretary B.K. Bhattacharya and Rajkumar's son, Shiva Rajkumar—a Kannada film star himself—were added to the crisis management group. (In 2016, Shiva Rajkumar played the lead role of an STF officer in director Ram Gopal Varma's film, *Killing Veerappan*.)

That night the men summoned by the CM met in his camp office in Bangalore. Steaming hot coffee served to everybody in the room lay untouched as the men listened intently to Veerappan's tape. There was no talk of death, mutilation or torture. But the subtlety of the message was even more terrifying.

It almost seemed as though Veerappan knew he would have the audience's undivided attention and revelled in that knowledge. It was both threat and theatre.

One of his first demands was that the government send an emissary to 'discuss some of the problems I face'. He also warned against any dramatic rescue attempt.

As the audio tape rolled to an end, many present in the room exhaled audibly. A brief silence descended. It was broken by a member of the group who said, 'Let's be clear. Our priority is to get Rajkumar back alive.'

Within a few hours, Bangalore and the rest of India woke up to the dreadful news. Schools, colleges, shops, business establishments and even

banks shut down for the day in Karnataka. Phone lines were jammed as people made frantic calls sharing titbits and speculations. Most people stayed indoors. Those who dared to venture out found that the public transport system had plunged into chaos.

The abduction of a celebrity like Rajkumar has a devastating psychological impact. Any police officer can tell you that there is far more economic loss involved in, say, electricity theft than in a street crime. But such crimes evoke far greater fear in the minds of citizens because each person instinctively thinks: 'It could have been me.' When a high-profile person like Rajkumar is involved, people immediately start thinking: 'If the state cannot protect a VIP, how safe is the aam aadmi?'

In such a situation, the government's first response always is to prevent breakdown of law and order. The Karnataka government immediately pressed several companies of the armed reserve police into action. Luckily, there were no riots, though spontaneous protests took place across the state.

In a show of solidarity, the Kannada film industry announced that no films would be produced, distributed or exhibited in Karnataka till Rajkumar's safe return. It was a heart-warming gesture, but as the days wore on, it took a heavy toll on the industry's finances.

Media personnel, ranging from lesser-known local dailies to multinational TV channels, rushed to Rajkumar's ancestral home. The remote village suddenly arrived on the global map, for all the wrong reasons.

CM Krishna, accompanied by senior officials, flew to Chennai to meet his Tamil Nadu counterpart, Karunanidhi. As the two emerged from the meeting, TV anchors jabbed mikes in their direction, hoping for a bite.

A senior officer said on camera, 'Negotiations are a must. If we shut the doors on his (Veerappan's) face, the safety of Tamils in Karnataka may be threatened.'

The officer had voiced the unspoken fear haunting both governments. His candour was appreciated by the media, but not by his bosses.

Towards evening, Karunanidhi announced that *Nakkeeran* Gopal,

who had helped secure the release of the forest officials a couple of years ago, would serve as as negotiator on behalf of both the sates.

◆

August 2000

Gopal began his journey to meet Veerappan on 2 August. During the entire crisis, he went into the forest five times, even as the Karnataka government ordered the STF to cease all operations in the area. By moving just one man into his camp, Veerappan had managed to create an asymmetrical fight.

While the STF operations had officially been called off, a few mavericks of the Tamil Nadu STF kept their confidential informants (CIs) active, with strict instructions only to observe and report suspicious activity in the forest. 'Do not engage with them under any circumstances,' it was emphasized.

By 10 August, a Forest Department plot watcher met Mohan Nawaz. He claimed to have seen three gang members, along with four strangers. 'One of them was in green dress, the others in neat clothes. They came from the roadside, rested for a while and then dispersed,' he said.

Nawaz felt a frisson of excitement run through him. Veerappan and his hostages could not be very far. Unfortunately, before he could act on this intelligence, Veerappan's trusted aide, Govindan, got to know about some strangers being spotted in the area and immediately rushed to him.

'The sons of bitches must be from the STF,' Veerappan snarled. 'Tell Gopal.'

Gopal made a huge fuss about this. 'Veerappan had clearly stated that the government must do his bidding or else blame itself for Rajkumar's fate,' he told both chief ministers.

The option of mounting an STF rescue op was taken off the table even before it was assembled cogently. The STF men were dispatched on other tasks. Some were asked to do traffic duty, with comical results. More used to hefting rucksacks and AK-47s than managing traffic, they probably ended up causing more jams than easing them.

The STF's Bannari camp wore a deserted look, with just a handful of members left behind—a storekeeper and a few guards, checking the residual inventory at night.

From Veerappan's vantage point, he could see that the lights were still on at the camp. Beside himself with fury, Veerappan's ultimatum came swiftly, 'Withdraw the STF immediately; Nawaz and Hussain first.'

I remember thinking that Veerappan's demand had only reinforced the kind of monumental threat he considered both Nawaz and Hussain to be and the amount of psychological damage the duo had done to his morale.

And while both states scrambled to comply, I thought, rather ruefully, that in their haste, they had overlooked one vital clue.

If Veerappan was so well informed about the STF's activities, he, or at least some of his gang members, were obviously keeping a close watch on the Bannari camp and, therefore, must be geographically close to it. Perhaps the two governments simply chose to ignore this fact because nobody wanted to risk an operation that might leave the authorities with the daunting prospect of handling an outraged public and a vociferous media.

It was later revealed that Veerappan was hardly 5–10 km from the Bannari camp. His strategy was as simple as it was audacious—hide in the open. He would move camp every now and then, but only by a kilometre or so—right under the policemen's watch, but not in their direct line of sight.

It also emerged later that the abduction could have easily been averted had a warning by Arkesh, a CRPF officer on deputation to the Karnataka STF, been taken seriously. As recently as in May 2000, the officer had warned the Karnataka government that, according to his sources, Veerappan was plotting to abduct Rajkumar. Unfortunately, his warning failed to reach the right ears.

One of the biggest challenges senior officers have to deal with is information overload. According to the US government, this phenomenon resulted in vital clues, which could have prevented the 9/11 attacks, being ignored. When one encounters too many false leads and misleading clues, fresh warnings only trigger fatigue and one is too quick to dismiss them.

It should ideally never happen, but every now and then, it does. And that is what happened during 9/11, with Veerappan, and continues unabated with many terror attacks.

Hostage Crisis

August 2000

Veerappan's first list of ten demands post the Rajkumar abduction—or 'Ten Commandments', as the media labelled it—surfaced on 4 August. As the crisis group listened to the cassette, eyebrows shot up. The illiterate outlaw was talking like a seasoned politician.

Among other things, Veerappan sought the implementation of the interim award of the Cauvery Water Disputes Tribunal and the release of 205,000 million cubic feet of river water to Tamil Nadu. (Ironically, during the tenth anniversary of Veerappan's death, posters in some places hailed him and blamed his absence for Karnataka's alleged intransigence on the Cauvery water issue.) Other demands included compensation to Tamilian victims of the 1991 Cauvery riots in Karnataka, declaration of Tamil as the second administrative language in Karnataka, installation of a statue of Tamil saint-poet Thiruvalluvar in Bangalore, immediate release of compensation to the families of nine Scheduled Caste and Scheduled Tribe persons allegedly killed by the STF and increase in the procurement price of tea leaves to solve the financial crisis of the Tamil Nadu tea industry.

Veerappan also asked for the lifting of the High Court's ban on the functioning of the Sadashiva Commission, which had been set up to enquire into alleged atrocities on villagers by the STF, and the release of fifty-one people imprisoned in Mysore jail under the Terrorist and Disruptive Activities (Prevention) Act (TADA). He also demanded the

release of another five members of the TNLA being held in Chennai jail.

As the tape came to an end, one of the persons in the room said, 'The devil is quoting scripture.'

'How has he become so politically aware sitting in the jungle?' wondered another.

'We heard that he had come in contact with radical Tamil groups. It must be their influence,' said the first person.

That assessment was not far off the mark, the obvious proof being the demand to release the five TNLA men. Veerappan is believed to have been associated with militant groups fighting for Tamil Eelam in the 1980s during their training in forest camps, not very far from his gang's area of operation. The friendships he forged proved beneficial later, when they apparently provided him money and materials to help rebuild his shattered gang.

The five prisoners that Veerappan wanted released included three men accused of attacking a police station in Tamil Nadu along with Veerappan in 1998. The other two men were Ponnivalavan and 'Radio' Venkatesan, who had acquired his nickname due to his supposed expertise at making transistor bombs. Photographs that showed Veerappan hoisting a Tamil Desam flag emerged somewhere between 1998 and 2000. Though some STF personnel were distressed by these images, others keeled over with laughter at the pictures of Veerappan sporting a Che Guevara Cuban military beret.

On 9 August, a fresh audio tape arrived, which proved that Rajkumar was alive and well. In the recording, he insisted that he was being looked after well and that there was no need to worry about him. He appealed for peace and harmony. The atmosphere of the forest was so enchanting that he had forgotten food and sleep. He also added, 'Veerappan wants to lead a normal life. He wants both governments to facilitate the same. We've become good friends.'

Interestingly, on all his tapes, Veerappan referred to Rajkumar as 'periyavar' or venerable elderly man. Rajkumar, in turn, described Veerappan as a good man. It seemed to be a classic case of Stockholm syndrome—a well-known psychological phenomenon in which hostages express empathy and sympathy towards their captors. Studies reveal that

the longer negotiations drag on, the greater are the chances of a strong bond developing between the hostage and the abductor. Evolutionary psychologists explain this as an unconscious strategy by the captive to maximize goodwill in order to increase the chances of his or her survival.

But Veerappan was not going to let this goodwill come in the way of negotiations. On 11 August, Gopal returned to Chennai with four new demands. This time, the two governments were given an eight-day deadline to respond. Gopal also noticed a change in Veerappan's behaviour. There was now a distinct aloofness and inflexibility about him.

Most demands were reiterations of the Ten Commandments, with minor changes. This time, Veerappan pressed for the Cauvery water dispute to be referred to the International Court of Justice at The Hague, the immediate release of the five TNLA men and introduction of Tamil as the medium of instruction up to the tenth grade in Karnataka schools. However, there was a new demand—that the government provide shelter to the 'rape victims of the Vaachatti and Chinnampathi villages, where the STF went on a rampage'.

In 1992, it was alleged that STF personnel entered these two villages on the pretext of searching for smuggled sandalwood and Veerappan, and assaulted and raped some of the locals. The involvement of the STF in the Chinnampathi case was never proved. Investigations into the allegations began in 1997 with an identification parade of STF men in Coimbatore. Instead of probing the undergrowth to ferret out the bandit, several STF personnel were engaged in the preparation of lengthy affidavits. Even after reams of paperwork, there was no assurance that a witness would not wrongly identify one of them as the culprit. Ultimately, not a single STF person was held guilty. But the force's morale took a hit.

To avoid such charges we turned proactive later. During my stint at the STF, we ourselves asked for a magisterial probe when an allegation was levelled against Inspector Rajarajan. A senior SP, Mr Chinnaswamy, communicated with the Hill Tribals' Association and other groups. They initially suspected an ulterior motive on our part, but were ultimately reassured about our intentions. We never faced any problems thereafter.

After frantic talks between the two state governments, it was decided that the five TNLA men would be released immediately. The Karnataka

government heeded the bandit's demands and released ₹2 crore as compensation for the 1991 Cauvery riot victims. The plight of the two state governments bowing meekly to Veerappan's demands was too much for some sections of the media.

Shekhar Gupta, then editor of *The Indian Express*, lamented the lack of people like K.P.S. Gill—the officer credited with crushing extremism in Punjab—in the ranks of the Karnataka and Tamil Nadu police forces. His article caused me a great deal of anguish, even though I was many miles away from the scene. I had served with many of the officers and men in the STF, who had regularly risked their lives in a bid to bring Veerappan to book. Several had died. To me, such an article was an insult to their sacrifices. I could only imagine the frustration and humiliation their fellow officers must have felt.

I promptly wrote a rejoinder highlighting the efforts of many brave policemen, and added that many others, including me, were willing to take up the challenge. My letter was published, rather prominently, in the same newspaper. But it was poor consolation for a man who longed to head back to Tamil Nadu and rejoin the efforts to nab Veerappan.

While I could do little more than dash off a letter to the editor, one of the relatives of a brave martyr approached the Court of the District and Sessions judge, Rajendra Prasad, in Mysore and challenged the Karnataka government's move to free the fifty-one men held under TADA. The petitioner, Abdul Kareem, was a seventy-six-year-old retired DSP, whose son SI Shakeel Ahmed, along with SP Harikrishna, had been ambushed and killed by Veerappan as described earlier in the book.

'It's a shame that the state kowtows before a criminal, like a banana republic,' he lamented. These sentiments resonated in the Independence Day address of the President of India, in which he alluded to the 'nexus between crime and politics', 'glorification of banditry' and 'media's craze for sensation'. Two days later, this address was quoted in a Mysore court.

On 19 August, Justice Prasad upheld the prosecutor's plea to drop TADA charges against the accused. Undaunted, Kareem moved the Supreme Court of India. The court asked for Joint STF Head Walter Davaram's opinion. The man, true to his blunt style, told the court that allowing the men to go free would encourage a lethal combination of

crime and politics.

The court wasted no time, and stayed the release of the fifty-one detainees indefinitely. When the Karnataka government pleaded that this could endanger the lives of the people if riots broke out, the court responded sternly, 'We make it amply clear that it is the Karnataka government's responsibility to maintain law and order and if you can't do it, then quit and make way for someone else who can do it.'* The new twist did not go down well with Veerappan. Having spent most of his life in the forest, he found the intricacies of the Indian legal system baffling and frustrating. His favourite emissary Gopal emerged from yet another meeting in the forest, warning that Veerappan was adamant that Rajkumar would be freed only after his men were released.

◆

September 2000

Rajkumar's fans threatened to storm the forests. Rajinikanth offered to go into the jungle, if need be. Anti-Tamil and anti-Kannada poster wars raged. Tamil Nadu claimed that it had shared a threat report with Karnataka. Pulled up by the Supreme Court for laxity, Karnataka clarified that Rajkumar had not informed the state police of this specific visit. The higher echelons of both the states were on tenterhooks.

Meanwhile, Rajkumar's wife Parvathamma complained of chest pain and was rushed to hospital on 20 September. Rumours began circulating in the state that she was gravely ill and at death's door. However, that was not the case. Stress and anxiety had taken a toll on her health but she was showing signs of recovery the very same evening.

Rajkumar's family and fans were the most vocal in favour of negotiating with Veerappan. 'If the government could negotiate during the Kandahar hijack, then why not for my husband?' Parvathamma demanded. Further, in its affidavit, Tamil Nadu cited the precedent of

*Source: http://www.rediff.com/news/2000/sep/01fakir.htm. Last accessed on 10 January 2017

the release of terrorists in exchange for Rubaiya Sayeed in 1989, daughter of late Mufti Mohammad Sayeed, the then home minister of India. Such rhetoric only complicated matters.

The debate and dilemma about negotiations for hostages encouraging abductions is a global one. Even Israel, which officially follows a strict no-negotiations policy, released 1,027 prisoners for its soldier, Gilad Shalit, in 2011. In 2006, India formally declared that it would not yield in case of any abduction. Fortunately, the policy has not yet been tested, and one can only hope that it never will.

Meanwhile, back in the forest, Veerappan realized that an immediate exchange would not be forthcoming and settled down for the long haul. He claimed to his inner circle that CM Krishna had personally spoken to him over a mobile phone. He later repeated the claim in a tape, stating that Krishna had asked him not to harm Dr Rajkumar, to which he had replied, 'That's entirely in your hands.'

As negotiations wore on, Veerappan appeared to have been lulled into a sense of complacence. He relaxed his guard to the extent that one day there were only four men—Veerappan, Rajkumar, Gopal and Rajkumar's assistant Nagappa—in the camp.

As Nagappa tossed and turned, he realized that Veerappan was snoring only a couple of yards away. Gopal was engrossed in a book.

Nagappa's heart raced. He broke out in a cold sweat. He craned his neck the other way. Rajkumar was also asleep. *It was a golden opportunity. Should he seize it? Could he use anything as a weapon?*

He looked around, careful not to make any sudden movements. A couple of metres to his left was an aruval, a sort of long sickle that can be used both as a tool and weapon.

He debated frantically for a few seconds, which, to him, seemed like eternity.

Then, he sprang to his feet and grabbed the aruval in one fluid, gravity-defying move, totally out of sync with his physical build.

He prepared to bring the weapon crashing down on Veerappan's neck. But the bivouac, which served as their shelter, had a low ceiling and prevented him from generating too much force. Before he could complete his swing, Gopal leapt up and grabbed Nagappa's arm.

'What do you think you are doing?' hissed Gopal.

'It's our best chance. Let me,' Nagappa whispered.

'Fine, finish him. And then? His men must be nearby. Do you think they'll just let us walk away? You'll get us all killed,' said Gopal.

Nagappa's shoulders slumped, but his mind was racing. 'I can't stay here. Veerappan will punish me once he finds out,' he thought. Abandoning caution, he ran away as fast as his legs could carry him.

He blundered through the forest all night. A couple of times, he tripped on tree trunks and tumbled to the ground, bruising himself. Each time, he dragged himself back to his feet. 'Don't stop. Keep going,' he commanded his exhausted, battered body.

As the first light of the morning appeared, Nagappa found a dirt road, which he continued to follow with determination. A few hours later, he came upon a tarred road that led him to Bannari. Instead of approaching the police for help, he begged for some money from a villager and took a bus to the village from where Rajkumar had been abducted.

For a while, Nagappa was hailed as a hero who had escaped from the villain. But soon, some started regarding him as a coward who had deserted their hero.

Back at the camp, a thunderous Veerappan paced up and down before the three remaining hostages.

'So this is how it will end,' thought Rajkumar.

Strangely, now that the moment of reckoning had arrived, he felt no fear for himself, only anxiety for the others. 'I have lived a full life. Shoot me, but let the others go,' he pleaded with Veerappan.

The bandit glowered at Rajkumar for a long moment. Then, he shook his head. 'Don't worry, Periyavar, nothing will happen to you. I care for your well-being, even if nobody else does.'

A Hero's Welcome

October 2000

Nagappa's escape added urgency to the negotiations. In his tapes, the bandit maintained a discreet silence on the matter. But once Gopal conveyed that Veerappan still grudged the incident, the governments feared drastic retaliatory action. Following an emotional appeal by Dr Rajkumar, a bandh on the eve of Dussehra passed off peacefully.

In the midst of this entire hubbub, a cassette arrived in which Rajkumar was heard saying that Veerappan now wanted Nedumaran, president of the Tamil Nationalist Movement, to be added as another negotiator. Nedumaran was spotted entering the jungles with human rights activist Professor Kalyani.

For some reason, Veerappan seemed to have lost faith in Gopal. It is rumoured that the bandit suspected his once-trusted negotiator of trying to double-cross him. And while there was never any evidence against Gopal, the relationship between the two men soured to such an extent that Veerappan later spoke bitterly to his confidants about wanting to teach the man a lesson.

The next time Gopal left for the forest, he was accompanied by Nedumaran, Professor Kalyani and G. Sukumaran, another proponent of the Tamil cause. At one stage though, upset by a barrage of criticism, Nedumaran threatened to withdraw. The crisis handlers somehow prevailed over him.

On 16 October, Veerappan released Rajkumar's son-in-law Govindraj,

a diabetic and heart patient. The ordeal in the forest had taken a heavy toll on his health, which may have convinced Veerappan to let him go. But there was no question of Rajkumar's release. He would be freed only after the release of Veerappan's men.

The stand-off continued. Rajkumar completed one hundred days in Veerappan's custody on 6 November. A day later, the Supreme Court announced that none of the TADA detainees would be released. It also quashed a Tamil Nadu court order dropping charges against 'Radio' Venkatesh and overruled the Karunanidhi government's decision to revoke detention orders against TNLA's Satyamurthy, Manikandan and Muthukumar. The court also questioned the states on the likely impact (of yielding to the bandit) on the morale of law-enforcing agencies and witnesses.

The possibility of swapping prisoners for Rajkumar no longer existed. This meant that the emissaries had to appeal to Veerappan's finer sensibilities and hope for the best.

On 9 November, Nedumaran returned to the forest with Kalyani and Sukumaran. They were accompanied by a Bangalore-based businessman and a Tamil lady, Bhanu, who posed as a doctor.

The moment the party reached Veerappan's camp, Bhanu made a beeline for Rajkumar and put up an elaborate show of examining him. She shook her head and looked concerned.

A worried Veerappan rushed to her. 'What's the matter?'

Bhanu held up a palm, indicating that he should wait, and went back to the show of examining Rajkumar. After a few minutes, she gestured Veerappan to follow her some distance away.

'I can't believe he's still alive. All the medical parameters are very negative. You could end up with a dead man on your hands at any time,' she said in a low, urgent voice.

The scowl on Veerappan's face deepened. 'Rajkumar dies in Veerappan's custody'—not the best headline, from his point of view. Riots were virtually certain to break out thereafter. If Rajkumar died in his captivity, Veerappan knew that his image would be irretrievably tarnished.

So far, the authorities had treated him with kid gloves because he

held Rajkumar alive. But if that precious bargaining chip was lost, the police and army would probably descend on him in full fury.

More suspense followed after 9 November. There was speculation that the hostages would be released any time. But no such thing happened. Later, without much ado, Rajkumar and Nagesh were finally released on 15 November, after 108 days in captivity. In his trademark theatrical style, Veerappan presented both his hostages with shawls before releasing them, as a mark of respect.

The two emerged close to Bannari. But the emerging point was officially shown as Ammapet, about 90 km away. When Rajkumar arrived in a helicopter arranged especially for him, thousands turned up for his welcome.

An air of festivity pervaded all over the city of Bangalore. Delighted fans celebrated Rajkumar's safe return enthusiastically with crackers and sweets. He waved to his adoring supporters as he was taken in a convoy to the Vidhan Soudha, the majestic building of the Karnataka Legislative Assembly.

Later, at a press conference, he recounted his ordeal without any bitterness. In fact, there was even a touch of sympathy for Veerappan. Years later, after the bandit's death in Operation Cocoon, Rajkumar went on record to say that an evil force had been removed.

Police reports following the incident as well as debriefing with Rajkumar and Nagesh revealed that throughout the entire episode, Veerappan took great care to project himself as some sort of 'Tamilian Robin Hood'. In his audio cassettes, he repeatedly proclaimed that he was simply fighting for the rights of the poor victims of atrocities, and was taking the best possible care of Rajkumar. He repeatedly accused both state governments of being manipulative and insincere.

After Rajkumar's release, there were several rumours regarding the payment of a hefty ransom to Veerappan. It was speculated that the money, which ranged between ₹20 crore and ₹50 crore, was paid ostensibly in instalments. The final payment was handed over on the day of the release. According to unconfirmed reports, the money was raised from multiple sources, including granite-quarry owners, liquor contractors and even the Karnataka film industry, which had suffered

heavy losses due to its voluntary shutdown.

The Karnataka government always officially denied the payment of any ransom to Veerappan to secure Rajkumar's release. But conspiracy theorists expressed scepticism about Veerappan permitting Rajkumar to walk free, after more than a hundred days in captivity, without receiving anything in return.

Their arguments are supported by some strange coincidences. Shortly after Rajkumar's release, there was a sudden suffusion of ₹500 notes at hamlets frequented by Veerappan's gang members and among the people known to have links with them.

Later, the STF and Salem Police seized a considerable stash that was carefully concealed in the forest. There were probably many such caches. 'Around the same time, the chatter over Palk Straits was peppered with the word "four". It was unclear if this meant that money had exchanged hands, as nothing was heard thereafter,' revealed the late Jose Tarayil, the Chennai head of the Intelligence Bureau (IB).

Also, STF intelligence revealed that in the years leading up to Rajkumar's abduction, Veerappan had fallen upon hard times. On one occasion, he had even resorted to looting a jeep carrying liquor sale collections and had been forced to mortgage his gold chain to raise some much-needed capital. So if his gang was spending ₹500 notes with wild abandon, how had he become so flush with funds soon after the actor's release?

Rajkumar's abduction undoubtedly marked the pinnacle of Veerappan's infamous career. But he had overplayed his cards and crossed a line. Furious and humiliated, both state governments unleashed a massive hunt for him that extended beyond the borders of Karnataka and Tamil Nadu into Kerala.

I too was set to play a role, although not exactly the one that I desired.

Close Encounters in Semmandhi

Though I was still posted in New Delhi at the time of Rajkumar's release, I took keen interest and followed up regularly with my fellow officers in the STF about the operations to nab Veerappan. An even more determined STF, livid at being told to stand down during the Rajkumar negotiations, was out in full force.

As IG (Ops) of the BSF, I was asked to take 117 Battalion BSF to Tamil Nadu in January 2001 and hand them over to the authorities to join the hunt for Veerappan. The battalion was airlifted from the Burma border and landed at Coimbatore.

Though such a task was usually assigned to a junior officer, I was delighted to visit my old hunting grounds. Once again, I met many old comrades who said they wished for me to be part of the ops. The feeling was mutual, I assured them.

I secretly hoped that the BSF would ask me to continue in Tamil Nadu. When I called on CM Karunanidhi, he confirmed the thoughts communicated by my colleagues. Soon after the Rajkumar episode, the CM had, in fact, expressed the desire to get me back into the STF fold. For some reason, that did not happen. My friend Jose, after this detailed update, fumed, 'Vijay, how I wish you were here!' After a couple of days, I returned to Delhi reluctantly and continued to monitor the situation. Little did I know that in a few months' time, I would be heading the Tamil Nadu STF.

Jose Tarayil (he later passed away after a cardiac attack) and others recounted Veerappan's close shave at Semmandhi Hills to me.

◆

November 2000

The night before Rajkumar's release, a few figures had emerged from the jungles. They quietly boarded a car and a van and sped away to an unknown location. The STF was either caught unawares or told to keep to the barracks.

It was an ill-at-ease Veerappan who was on the move in a Matador, accompanied by seven men, including Govindan. Three others were in an Ambassador. The vehicles were probably provided as part of a safe passage deal.

Veerappan wasn't particularly fond of vehicles—he believed in a prediction that they were unlucky for him. But at that point, he didn't have a choice. He expected retaliation from the authorities for the audacious abduction the moment they were certain that Rajkumar was safe. He needed to get far away from the spot where he was last seen, as fast as possible.

Disguised as pilgrims to Sabarimala, the shrine of Lord Ayyappa in Kerala, about 300 km to the west, some of his men were clad in black, others in blue. They sported stubbles and beards and had smeared their foreheads with ash. Their guns were at their feet, concealed in clothes or tucked under the mat. At that time of the year, the roads to Sabarimala were packed with pilgrims. Veerappan and his men would have blended right in had the journey been uneventful. His men later told the police that Veerappan kept asking, 'Dei enda ivvaluvu chandalanga? (Why are there so many demons on the road?)' He wasn't referring to the crowds, but to the many police patrols and checkposts that the mini-motorcade encountered throughout the journey. One by one, the fugitives managed to bypass all of them.

The gang maintained wireless contact between the car and the Matador and stayed within visual range. But as they turned a corner near a small town, they lost contact.

'Try the wireless,' ordered Veerappan.

No response. Govindan tried again. No result. 'Yenda, Govindan, engey vandi (Where is the car)'? asked Veerappan, as he tried to control his rising panic. Unknown to Veerappan, the battery in the walkie-talkie

with the car passengers was dead. He spent the next 45 km of the journey in a state of dread, wondering if his comrades had been captured by the cops and had divulged vital information.

The trip finally ended at the foothills of the Velliangiri Hills, close to the Kerala border. The hills form a major range in the Western Ghats in the Nilgiri Biosphere Reserve. The terrain is steep and makes for difficult climbing. In winter, the hills also tend to be chilly, with gusty winds and lots of mist.

It was pitch dark as the vehicles stopped. All the gangsters dismounted; their leader was last. Without a word or sign, they picked up their bags and began to climb quickly and silently. Ayyappa's name had brought them to apparent safety, but little did they know that a man of the same name would almost cause their downfall nearly a month later.

<p style="text-align:center">◆</p>

January 2001

The head constable of Madukarai Police Station removed his spectacles, rubbed his nose and put them on again slowly as he gazed incredulously at the short, nondescript tribal standing in front of him.

'What did you say?' he asked.

'My name is Ayyappan. Some men with weapons came to me a few hours ago and asked me to arrange rations for them. They were strangers. They seemed to be outlaws. I've heard that lots of policemen are searching the hills. I thought these might be the men they're looking for,' Ayyappan repeated.

The head constable nodded, his insides churning with excitement.

'Wait here,' he said, and began working the phone.

The news burned the line all the way to Coimbatore, where senior STF officers were camping. Two DSPs—Ashok Kumar and Periaiah—rushed immediately to the police station.

After questioning Ayyappan, they were satisfied that he had indeed been contacted by Veerappan and quickly came up with a plan.

'We'll encircle the village, but we can't be too close, otherwise the

bandits may get suspicious. Keep Veerappan inside your hut on some pretext and then come to the rendezvous spot and alert us. We'll surround the place and take matters from there,' he was told. A few hundred rupees changed hands.

He had also received a sizeable advance from the gang. Ayyappan had never seen so much money in his life. As he left the police station, the tribal's mind was reeling.

'What have I got myself into?' he muttered, clutching his head. Just then, he noticed a liquor shop. 'I'll have a quick drink to calm my nerves,' he thought. 'Just a small one, and I'll be on my way.'

It was Govindan who arrived for the rations, not Veerappan. By then, Ayyappan had guzzled down several drinks. Govindan collected the food, then threatened Ayyappan, 'If you try to contact the police, I'll remove your intestines.'

The shaken tribal promptly bolted down a few more drinks to soothe his nerves. The next thing he knew was a rough jerk felt on his shoulder.

'Whassamatter?' he slurred, his tongue thick and swollen in his dry mouth. He yawned heavily a couple of times, rubbed the sleep out of his eyes and found an STF man glowering at him.

Several empty bottles of liquor were strewn on the floor of his hut. The smell from his mouth left no doubt about the disposal of their contents.

'We've been waiting for hours. It's 4.30 in the morning. Why the hell didn't you come? We thought the bandits had killed you, so we came to check on you. Where's the gang?'

'Oh, them? They came and went hours ago,' said Ayyappan and rolled back into a contented sleep.

As the policemen left the village, one of Veerappan's gang members, who had kept a watch, signalled his leader. Veerappan observed the area from the hills.

'It's a good thing we kept an eye on that son of a bitch,' remarked Govindan.

Veerappan grunted irritably. It had been a close shave and their rations were running low. He slapped a leech that was burrowing into his forearm.

'Time to switch locations,' he said sourly. 'How much longer will we

have to stay in this hellhole?'

Even as Veerappan tried to figure out his next move, the police had already raced ahead with a new plan. The bandit had no clue that things were about to get a whole lot worse for him.

The hunt for Veerappan had turned hi-tech due to the joint efforts of Ramanujam, Tamil Nadu's intelligence chief and Jose Tarayil, joint director, Intelligence Bureau.

Ramanujam was a quiet, self-effacing man who teamed well with the big-built, effusive Jose Tarayil.

Tarayil's untiring efforts at Chennai, New Delhi and other places led to the procurement of a special surveillance aircraft, capable of hovering at above 20,000 feet. It landed at the Sulur Air Force base, about 30 km from Coimbatore. Some sixty-odd STF men were also simultaneously trained to slither down from a helicopter into hostile terrain. Once the plane pinpointed Veerappan's location, a helicopter would carry the STF team there, ensuring the operation's success within a limited time frame.

◆

Veerappan, who previously always treated gadgets as abominations, made a blunder after the year 2000. Technology sneaked into his camp and turned him into a wired nomad.

As a result, intelligence agencies were able to intercept a call Veerappan made from a cell phone. The call confirmed that he was within a vicinity of 5–6 km, but could not get more specific.

Jose Tarayil made a few calls. Within twenty-four hours, a new cell phone tower emerged along the lower slopes of the hills. It must have been the first time a tower was installed for just three customers—Tarayil, Ramanujam and Veerappan.

Within days, the location reading shortened to 2 km.

Then Tarayil made the long-awaited call to Ramanujam. 'The bird is chirping,' he said. His message to the Sulur Air Force base was: 'Fly in.'

But Veerappan's luck hadn't run out yet.

Thick clouds had settled atop the Velliangiri Hills. The sensors located in the aircraft's underbelly were incapable of penetrating the cloud cover. Without them, the plane was rendered useless and unable

to help pinpoint Veerappan's exact location. The STF pondered over a plan B—a helidrop without the surveillance plane. But the helicopter would effectively be flying blind. The pilots ruled this out.

'Can't you get a plane with more powerful sensors?' Jose asked.

It would take at least a week, he was told.

The STF's best-laid plan had gone awry. It brought back memories of Operation Desert Eagle in which a desert storm brought down the helicopter of a special team that was tasked with the rescue of American hostages in Iran.

By the time the clouds finally lifted off Velliangiri Hills, the bandit had moved away and the signal was lost.

An inconsolable Tarayil was convinced that a huge window of opportunity had been lost. But he wasn't ready to abandon his plans just yet.

◆

Veerappan swore as the Russian MI-8 helicopter hovered overhead. A shudder passed through his thin frame.

'It's the third straight day that this wretched bird has been hounding us,' he said.

Diaries seized later indicated that it had been a hellish week for the gang. The hills were teeming with STF personnel and leeches. A battalion of the BSF had laid siege, cordoning off all exits. And to make matters worse, Veerappan and his men had to deal with constant, energy-sapping hunger.

During his earlier camps at Nachiboli and other leech-infested areas, Veerappan had used bags of salt to make 3-inch-high walls around his bivouac to keep the invading hordes at bay. Now, there wasn't even salt for his meals. The gang's rations were scattered across several spots and constant STF patrols made it impossible to retrieve them.

And now this bird.

On his way to the hills, Veerappan noticed an ashram run by the Isha Foundation. He was also informed that the area often got foreign visitors who indulged in birdwatching. He promptly identified both as potential kidnapping targets. But the constant pressure of the STF meant

that he was unable to carry out his plans.

The noise of the hovering helicopter engine brought Veerappan back to the present. The top of the big trees swayed. The thinner trees seemed to dance to the rotor wash. Veerappan hunched low. His spine tingled, as if expecting bullets to slam into it any second. He slithered to a tree and slid his back up against it, muttering, 'Govinda, Govinda.'

He had never seen a chopper up so close. It was like a vulture.

They have seen me, he thought. He heard the thump of the helicopter as it swung back thunderously. *Perhaps not.* But it could come back again; it always did.

In truth, the poor visibility made it virtually impossible for the occupants of the helicopter to see anything on ground. But the gang was unaware of this fact. The presence of the chopper had a tremendous psychological impact on their already dented morale.

The moment it moved away, Veerappan began to run blindly. Suddenly, he felt Govindan tugging his arm. 'Careful, you are only going to get shot by blundering around like this.'

Veerappan glared at him, but had to acknowledge that he was right. The previous day, they had nearly run into a waiting BSF ambush. Only the alertness of the scout had prevented a disaster. He nodded shortly at Govindan, 'Looks like we'll be sleeping hungry again tonight.'

◆

A team led by DIG Sylendra Babu had been practising the slither-down action from the helicopter for over a month. The surveillance plane had left. The STF was ready, awaiting a call.

Then a tip-off arrived. Veerappan was in Koothadikal—a place mainly known for an abandoned stone structure that lay in ruins and a chill that cut through the bones.

'Time for the helicopter-borne ops,' thought an excited Sylendra Babu. 'It is just a question of a day or two now.'

But that was easier said than done. Getting the helicopter airborne for training purposes was easy, but for operations there emerged the need to take a long, circuitous route of approvals that started from the IG (intelligence) and went through the DG, the state home secretary,

the chief secretary, the union home secretary in New Delhi, the defence secretary, the Air Force HQ and the Southern Air Command before the request finally reached the Sulur airbase. This, despite the best efforts of the then Union Home Secretary Dhirendra Singh to cut through the red tape.

The helicopter did take off, finally, from the airbase some 30 km away. But the STF men ran into a fresh set of problems.

The informer who had tipped them off feared he had been spotted by Veerappan's gang and left the area, leaving the team without a guide. They searched the area thoroughly, but were unable to locate the gang.

The entire cost of this unsuccessful helicopter operation, including training and waiting charges, was a whopping ₹70 lakh. The bill was finally settled in 2007, three years after Veerappan's death.

The failure of the heliborne ops yielded one certain result: Veerappan was still holed up in the area. It gave the STF teams momentum to stay and continue to apply pressure on the beleaguered bandit.

◆

February 2001

The STF constable coughed quietly into his shirt sleeve. Even though the sound was muffled, SI Vincent turned and scowled at the man, barely visible through the heavy mist shrouding the forest. It would be dawn soon.

The team, led by Inspector Ramalingam, had split into smaller groups. This group was led by Vincent.

A few feet ahead, the scout slowed down. He couldn't see anything, but his instincts, honed carefully over many years, were on high alert. As the dawn of the second day of February broke, he strained his ears and sniffed the air gently for any possible leads. *Nothing.* But he could feel his heart throbbing. His subconscious picked up signs that his brain was unable to decipher.

He signalled, 'Enemy ahead.'

Even as he did so, he heard the rustle of a plastic sheet being folded.

The scout immediately waved to his team to crouch. Then he heard the distinctive sound of a gun being cocked. But it was not coming from his team's side.

In one smooth motion, he slid the safety lock on his AK-47—the only one the team possessed (everyone else had 9 mm guns)—and brought up the barrel. He tensed to yell out a warning. But before he could do so, the quiet of the jungle was shattered by a voice screaming, 'STF', and a gun being emptied.

It was the gang's designated cook who had yelled the warning and opened fire. He had spotted the team as he was folding his plastic sheet—the noise that had alerted the STF scout.

In a fraction of a second, the cook's mind had considered and discarded multiple possibilities. The men were dressed in plain clothes, but were clearly not local tribals or hunters. He had not noticed any goats or cows, so they were not goatherds or cowherds either. By the time he had figured out all this, he had already raised the alarm.

Veerappan was on his morning constitutional when he was rudely interrupted by the report of a gun. Panicked, he searched for his rifle. It was three paces away. He leapt for it, grabbed it and scrambled for cover.

He looked around wildly, trying to make sense of the episode. Before his horrified eyes, Govindan went down, clutching his chest. But his despair turned to amazement as the man got up almost immediately. Gang members who had also seen the man go down told the police later that Veerappan's trusted aide held a wad of currency notes in a pouch braced tightly against his chest. The low-calibre 9 mm bullet had hit the pouch. Though he was bruised, Govindan escaped unhurt.

Govindan's narrow escape may seem straight out of a movie script, but history is replete with similar instances. Theodore Roosevelt survived an attempt on his life when the written speech in his pocket stopped the bullet. In 1915, a pocket watch saved Kamal Ataturk's life.

Veerappan's gang retreated into the forest, firing wildly as they fell back. The STF team responded with equal fervour. Within seconds, the scout had exhausted the bullets in his AK-47. Apart from Govindan's narrow escape, nobody on either side was seriously injured—remarkable, given the number of bullets that flew around in that brief span.

One by one, the STF's guns fell silent as they ran out of bullets. They paused to reload and take stock.

The gang had scattered like a herd of deer. After a few hundred metres or so, there was no clue for the pursuers. All they had left behind was some equipment, including a wireless set that had allowed Veerappan to eavesdrop on STF conversations and keep track of its movements. This critical piece of equipment was probably made available to him by someone with a vested interest to keep him free, though there is no tangible proof of it.

Veerappan's gang was known to always fix a rendezvous before splitting up. But the rather abrupt encounter had left little time, though Veerappan, Govindan and his cook Chandra Gowda managed to stay together.

After surveying the scene, Ramalingam said, 'We almost had them.'

Then he sighed and reached for the wireless. 'Sir, I am chasing the gang. But can't see them any more.'

•

Meanwhile, Veerappan shivered in the cold, but kept moving like a ghost. It had been a few days since the encounter with Ramalingam's team. Veerappan and the handful of men left with him had already dodged their way past several layers of the STF, but encountered more.

A faint sound reached Veerappan's ears. He paused and perched behind a huge rock. He turned slowly this way and that as he tried to decipher the origin of the sound.

A bunch of men in camouflage were stationed barely 30 metres away, their faces glowing in the light of a bonfire. Veerappan smiled grimly.

In the forest, a fire is a tactical blunder if one hopes to stay concealed, as even a glowing ember can reveal one's position to the enemy. But the strictest of rules can prove ineffective against human nature. It was a bitterly cold night and this team was far from the direct line of observation of its senior officers. Though there were strict orders against movement, noise or light, the chill of the nearby Silent Valley had slowly eroded their will. They probably believed that Veerappan was miles away.

As Veerappan and his men slipped through the cordon, he said, 'If

I had more men and weapons, I could have made them pay with their lives for this mistake.' Though the idea was tempting, he suppressed it. As morning dawned, Veerappan apparently said a silent prayer of thanks and swore never to return to the place that had given him such hellish experiences. He kept his word, though he sometimes pretended to be there, only to misguide the STF.

Later, non-STF police officers reached one of the slopes of Semmandhi in Kerala to conduct an investigation of the disastrous operation. They were armed only with lathis, their weapon of choice against one of the country's most dreaded outlaw!

A Mother's Wrath

July 2001

'How much longer before the rendezvous point?' I wondered as I silently cursed the heat and humidity and wiped away the sweat on my forehead.

Though I was quite fit for my age and had managed to keep pace with my men, the harsh terrain and unrelenting sun had taken a toll on the entire team.

Soon, I was part of a familiarization exercise with an STF team near a village on the easternmost part of our operational area. This trek was planned just a few months after I was recalled by the chief minister to take over the Tamil Nadu STF.

In all, there were five sections of ten men each. Each section had two veterans, whose movements were followed by the remaining eight. My section was at the head, with the other four following behind.

We had started at 6 a.m. When we paused briefly for a meal, half of the men ate swiftly and silently, while the others kept watch, some from treetops. Later, they reversed roles.

Some of the men crowded around a shallow pool, gulping liquid from green bottles. 'Where did you get Sprite from?' I called out.

Closer examination revealed that it was actually green-coloured water. There were elephant droppings all around the pool and in the water. Unlike big cats, which barely leave any trace, elephants are messy animals and litter indiscriminately. We always carried purifiers with us in the jungles, but the water remained green and muddy even after their use.

I knew I should have had the water to avoid dehydration for when it sets in one might not even feel the thirst. But I could manage only a couple of gulps before the gag reflex took over.

'One more hour to the vehicle point,' announced Inspector Rajarajan, the leader of the trek, rather suddenly, as if he had read my mind. Rajarajan, a seasoned STF veteran, knew the forest like the back of his hand.

The announcement sent a burst of energy through my exhausted body. 'Not much longer now,' I thought.

As we finished the climb, my buddy, Head Constable Sundaram, pointed to my right. On patrols, each person has a buddy who is responsible for his welfare—primarily security—and vice versa.

An elephant was feeding its calf. Rajarajan raised his finger to his lips. *Quiet.* Teams 2, 3 and 4 kept away from the mother. The first team had reached a flat grassy plateau.

'Take a break,' called out Rajarajan.

With a sigh of relief, I lay down and stretched my legs. They were beginning to cramp. I kept my boots on, but undid the laces to give some relief to my aching feet. My buddy passed me some dates and jaggery-coated peanuts. I munched away, gazing up at the blue sky. Little did I know that all hell was about to break loose!

One of the young constables, a greenhorn in the jungle, was in the last section. He was so fascinated by the sight of the mother elephant and her suckling calf that he approached them, camera in hand. The elephant immediately nudged the calf to its rear and faced the man.

Instead of recognizing the warning signs, he crept even closer. The elephant promptly raised its trunk and charged.

An elephant's trunk is capable of amazing dexterity. But it also contains 40,000-odd muscles. When it stiffens, it becomes harder than a steel bar. The mother brushed the constable's arm with her trunk. It was enough to snap three bones.

Rajarajan immediately fired in the air. The other men also raised a hue and cry and distracted the elephant from her primary target.

Hearing the noise, I turned and saw a trumpeting elephant only 20 metres away, charging towards me. At a speed of 25 km per hour, she

would be at my spot in three seconds!

I grabbed my AK-47 with such force that it caused a massive tear in my palm. I started rolling when a heavily built chap, face turned towards the elephant, crashed straight against my right knee. He must have weighed at least 90 kg. I heard a snapping sound and felt a wave of agony.

But I kept rolling towards a gradient. A second later, I found myself sliding down through stones and thorns, at almost 90 degrees.

After dropping about 10 feet, I came to a stop. Wincing, I drew myself to a sitting position. With all its human targets out of reach, the annoyed elephant stamped the ground and threw a dozen rucksacks helter-skelter. Then she marched towards the most obvious escape route from the clearing—the one I had just taken.

I still held my AK-47. I could see the pachyderm approaching. If the elephant attacked me, the bullets would not be of much help. But there was also no way I could outrun the charging animal, especially with my right knee screaming in protest at the treatment it had just received.

The elephant paused. I held my breath. It felt like eternity. Then the mother wheeled away abruptly and sped off, calf in tow.

Much to my relief, the STF men gave it a wide berth this time. I collapsed gratefully into the arms of my anxious buddy Sundaram, who had come scrambling down for me.

Rajarajan quickly calmed everyone's nerves and got them moving. The boys, keeping a sharp lookout in the fading light, carried the rookie constable and me on their shoulders to the waiting vehicles. I felt hugely embarrassed, but reminded myself that nature and bullets do not make any distinctions according to rank.

The constable ended up in Ganga Hospital, while I was taken to another. Dr Rajasekhar of Coimbatore's Ganga Hospital was always available to fix broken bones of STF troops. He was kept rather busy.

I went under anaesthesia for the only time in my life for a minor surgery on my injured palm. I had also snapped two ligaments in my right knee, but was able to avoid surgery, helped generously by the forced rest of three weeks in Chennai—the longest I ever had. Lying in bed at my home, I often worried about the operations ending in my absence. And

then, there was the agonizing thought of attending any award ceremony with a 'non-combat category injury'!

I missed the jungles terribly. I missed the kurunji flowers that bloom in Dhimbam Hills once in twelve years. I missed the simple meals stuffed in our rucksacks. Most importantly, I missed my boys.

In my mind, I prepared new plans to nab Veerappan. I was determined to see the mission through to a successful end.

I returned refreshed. But as luck would have it, a few months later in November the same year, I received orders to take over as commissioner of police, Chennai.

'But my task is incomplete,' I tried to protest feebly.

'Do you have a time frame for when you will catch him?' asked the CM.

I had to concede. I could not give a clear date, considering that the bandit had been elusive for close to twenty years now.

I moved to Chennai, wondering if I would ever return to the STF and finish the task. As it turned out, I would be back two years later under different circumstances and armed with a renewed resolve to accomplish my objective.

The Marina Beach Encounter

Year 2003

Soon after taking over as Chennai's police commissioner, I instituted a system under which all known gangsters were graded from A-plus to D, in descending order. Each one was kept under surveillance. While a head constable was responsible for nabbing or booking the D-grader, an inspector was in charge of a B-grader and so on. Both deputy and joint commissioners watched over the A and A-plus categories. There was also an A double-plus category, whose activities I closely monitored.

One of the more useful takeaways from my short and eventful tenure in Chennai was my first encounter with SI Velladurai, or Durai as he was nicknamed. The association with Durai materialized because of a well-known Chennai underworld gangster called Veeramani.

Veeramani had the dubious distinction of being a clear A double-plus. While he raked in the moolah by peddling brown sugar, he was dreaded throughout Chennai for his extortion business. Several major financiers, who had faced difficulties in getting their loans repaid, allegedly used Veeramani's help to cut delays in recovery. Rumour had it that some members of the film industry had appeared before him, either as supplicants or victims. Even some politicians had reportedly sought his help.

Veeramani was rumoured to conduct negotiations with trembling victims sitting under the moonlight on a catamaran a kilometre into the sea. The implication was that if they didn't pay up, the next time they

could end up as fish bait. Hardly surprising then that he boasted of a phenomenal recovery rate. His fearsome reputation ensured that issues in places as far off as Andhra Pradesh and Kerala were settled by merely invoking his name.

Veeramani was also known to have several girlfriends and safe houses, mostly along the beach. His favourite hiding hole was Ayodhya Kuppam, an erstwhile fisherman's hamlet, ironically only a stone's throw from the police headquarters on Marina Beach.

He also had a well-honed lookout system, which ensured that he got to know of any police movement in his area well in advance and promptly went underground.

'If we are to nab him, it will have to be a secret operation,' I told my joint commissioner, J.K. Tripathy.

'I think I may have just the man,' said Tripathy, who preferred to chew paan rather than speak too much.

Trippy—as I referred to him—had the sleep cycle of an owl. His sudden appearances in police stations were mostly nocturnal. In his previous posting, he had served as commissioner, Trichy, earning laurels for community policing.

It was here that he had met Durai. Once a history lecturer, Durai decided he would rather teach lessons to hardened criminals. He soon became known within the Trichy force for his daring encounters. But he was unknown in Chennai.

◆

July 2003

The bald, scruffy-looking mendicant scratched himself and stretched lazily in the sun. He squinted at the group of men strolling along the beach. Even from a distance, the alpha male was obvious—a big-built man with curly hair and heavy gold chains around his neck glinting in the sunlight.

The mendicant gathered his saffron rags around him and nodded. He had spent hours looking at pictures of the man and had memorized

every detail. He was indeed the person the mendicant had been looking for all along.

'Come to me, Veeramani. It's been a long wait,' thought Durai.

Upon being tasked with getting Veeramani, Durai had shaved his head and donned saffron robes. He spent the next few days and nights lying next to a croton plant on the beach opposite Veeramani's favourite slum stronghold, gazing at the sky and occasionally muttering to himself.

None of the policemen who patrolled the beach had any clue that this strange-looking fellow was one of them. His only backup was a buddy— another SI ready with a vehicle nearby.

That year, thousands of devotees of the Melmaruvathur Devi cult were scheduled to assemble at the beach in the afternoon of 27 July. Some had already arrived. Veeramani chose that day to brazenly take a walk on the beach, trailed by his acolytes, who were usually heavily armed.

As he neared Durai's location, the latter came to his feet in one smooth movement and whipped out the Browning 9 mm concealed within his rags. 'Police. Hands up. Surrender,' he yelled.

Everyone around froze for a split second, except Veeramani. Then there was a blur of movement.

When it was all over, Veeramani was incapacitated. His followers scattered in panic. Anticipating that they would regroup and return in force, Durai made his next move after buzzing for an ambulance.

A magisterial enquiry conducted subsequently ruled that Durai had followed standard operating procedure. He had made a reasonable attempt to arrest a fugitive of the law that was violently resisted. He had duly exercised the right of self-defence.

The effect of Veeramani's death on Chennai's underworld was immediate. Many surrendered; some even fled as far as Moreh near Myanmar border. I remember my batchmate Peter Ngahanyui, then ADG (Intel) Manipur, informing me of a sudden influx of Chennaiites in Moreh.

Rumour had it that several jailed criminals, who were due for bail, refused to exercise that option, instead preferring to stay within the safe confines of the prison. Some even protested to the court that they had never sought bail in the first place.

Though that particular episode was successful on the whole, another such op in Chennai landed me in hot soup. A team led by Deputy Commissioner Krishnamurthy had shot a don named Pannayaar in an encounter in the heart of the city. At a press conference, in response to a question on my views on such encounters, I had said, 'If you trust a policeman to carry a gun, then you must trust him to use it wisely and effectively under the law. We don't carry weapons around as ornaments.' This comment caused a furore in some sections of the media that accused me of being trigger-happy.

Even as the dust settled on this episode, another issue arose. An article on 'Intolerance of the Regime' was published in *The Hindu*. The Speaker of the Tamil Nadu legislative assembly issued a warrant for the arrest of N. Ravi, then editor of *The Hindu*, its publisher S. Rangarajan, its then executive editor Malini Parthasarthy and two senior journalists, V. Jayanth and Radha Venkatesan, for breach of privilege of the House. Since the warrant had come from the lawmaking body itself, it was sacrosanct. I had no choice but to get it executed. Eventually, the Supreme Court stayed the order. But the entire chain of events brought me into the frontline, especially with the media.

Within days I received orders once again, this time to leave Chennai and report back to the STF as Additional DGP.

Interestingly enough, over 100 journalists turned up for my farewell meet, including Jayanth of *The Hindu*. After all the brickbats, it was nice to receive some bouquets, both literal and verbal.

Inside Veerappan's Lair

Prior to my transfer to the STF and during my stint as commissioner, the STF had planned a brilliant strategy that nearly succeeded in eliminating Veerappan. It involved an elaborate ruse in which a suspected fundamentalist leader would reach out and gain Veerappan's sympathy.

The operation was carried out with remarkable secrecy—a fact that ironically worked against it. But one could hardly blame the planners for the utmost caution they exercised, considering the numerous occasions that operations had gone awry due to last-minute leaks.

◆

September 2003

Damani, the leader of a religious fundamentalist group, was being held in Coimbatore Central Jail on charges of involvement in a conspiracy to carry out blasts in several south Indian cities.

One day a slight, dark man entered his cell. The man wasn't a stranger to him because he had come earlier on several occasions as part of the team of physiotherapists that worked on Damani, who suffered from several ailments, including weak muscles and bones.

This time, however, his visitor was alone.

'What brings you here, Mr...?' Damani realized that he didn't even know the man's name.

'Kannan,' said the man, softly. 'I have a proposal for you. It might be mutually beneficial.'

'I'm listening,' said Damani, looking with new-found interest at the man.

'You've spent a good amount of time with Madhaiyan,' said Kannan.

Madhaiyan was Veerappan's elder brother and was in the same jail, just a few blocks away from Damani.

'I don't know what you're talking about,' muttered Damani.

'Please, don't waste your time and mine. We know it's true. We also know Madhaiyan is in touch with Veerappan. This can come in handy for both of us. Are you interested?'

Damani thought for a while. 'I might be,' he conceded. 'But what do I have to do, and what's in it for me?'

Kannan smiled. 'I'll get another person with me next time and we can thrash out the details.'

I had first heard of SP N.K. Senthamaraikannan or Kannan way back in 1991, when the SSG was set up for Jayalalithaa. I tried, in vain, to get him into the SSG. He had done a short stint with the STF from March 1999 to May 2000, after which he was moved to the Dairy Development Corporation as vigilance officer. I got him transferred back when I joined the STF after my stint with the BSF. After all, Kannan could do better than wield a lactometer to trap petty adulterators.

He impressed me, and the media, with his fluent Hindi, which he had mastered during his childhood travelling around India as the son of an Air Force officer. Unlike other senior STF officers, he was not fond of doing monkey crawls in the forest. A computer geek, he collated intelligence and employed cutting-edge technology to crack cases. He also had the habit of looking upbeat during troubling times and solemn when everything proceeded well. One was never overly excited or depressed with Kannan around. He was an invaluable asset to ADGP Nataraj, my batchmate who took over as head of the STF from me after my posting to Chennai.

With Damani taking his bait, Kannan made several more trips to the jail with Nataraj. The two men decided to implement the audacious plot. The STF learnt from its CIs that Veerappan urgently needed to add manpower to his dwindling band. It also learnt that Veerappan was in communication with Madhaiyan through a young relative, who regularly

visited him in jail.

The STF's plan was as simple as it was daring. Damani would tell Madhaiyan that he was willing to send some radicals to support Veerappan. But the men would actually be provided by the STF and would infiltrate Veerappan's gang.

Earlier, IG Mirji and ACP Bawa of the Karnataka STF had tried to implement the same plan and even shortlisted some denizens of Bangalore's underworld to infiltrate Veerappan's camp. These men were taken on a guided tour of the areas frequented by Veerappan. But after three days of seeing the jungle from a distance, the city slickers had quietly slipped away. The Karnataka STF then requested their counterparts in Tamil Nadu to implement the same plan. Nataraj and Kannan were only too happy to comply.

Damani had no clue that he was dealing with the STF. All he knew was that he had to offer to supply Veerappan some men. In turn, he was assured that his bail plea would be fast-tracked and that he could get his leg treated in the comfort of his own home.

Damani readily agreed and told Madhaiyan to inform his brother to expect some visitors soon.

Then came the tricky part.

The STF pulled some levers and ensured that Damani's access to Madhaiyan was cut off. Likewise, Madhaiyan's nephew was not allowed to visit him for the next few weeks. This ensured that Veerappan did not get to know that the men who had arrived in his camp were not sent by Damani.

Everything seemed to progress at a steady pace. But a news item in the Tamil daily *Dinamalar* almost derailed the plan. The news report speculated on the reasons for the frequent 'secret' visits to the Coimbatore jail by ADGP Nataraj. With a moustache that rivalled Veerappan's, Nataraj must have found it tough to outrun the media hounds. Though the story did not give the game away, it caused Nataraj and Kannan many sleepless nights.

But the bigger question was: Who would lead the infiltrators?

In keeping with the time-honoured dictum of setting a thief to catch a thief, Nataraj and Kannan identified a much-wanted don of the

Chennai underworld, who agreed to take on the assignment in exchange for clemency for some of his other crimes. He was powerfully built, but his face was a curious mix of the cruel and comic—his right eye had a scar above it and he had a squint, which made him resemble an old-world pirate.

The STF gave him the call sign 'One-eyed Jack'.

Negotiations proceeded without much trouble. An STF team arrived in Chennai to escort One-eyed Jack back for final parleys with Nataraj. But when the STF team was barely 100 metres away from the rendezvous point, they were stunned to see a team of the Chennai crime branch swoop down and arrest him.

The STF's dealings with Jack were conducted in such secrecy that the Chennai police had been unaware of the operation. I was then Chennai commissioner and rue the fact that I was not kept in the loop. Otherwise I would have ensured the mission's success.

But I don't blame the STF. Intelligence-sharing has always been the bane of agencies across the world, each keeping its undercover operations as well as other logistical details a closely guarded secret. This has, perhaps, allowed criminals and terrorists to literally get away with murder several times.

It was an extremely unfortunate coincidence that even as the Chennai police celebrated the arrest of a dreaded gangster, the STF regretted the loss of a potential major asset.

Nataraj and Kannan had to come up with another option on short notice. They settled on Hidayatullah, who was brought in hurriedly from Kanyakumari, along with some friends. While Hidayatullah had committed many crimes, his résumé was quite colourless, compared to Jack's. It was this lack of 'experience' that would prove to be a huge disadvantage much later. Contrary to suggestions in films, 'dead or alive' hunts are not easy, especially when the 'alive' option shrinks. But at that stage of the operation, the STF had little choice.

Hidayatullah and his men entered Veerappan's camp and were greeted warmly. They expected to be put through a gruelling routine. But to their surprise, their stay resembled a picnic.

The gang stayed mostly in the Tamil Nadu side of the Cauvery near

Hogenakkal Falls, where the forest cover was relatively thin.

Their stay was largely uneventful, but for one dramatic incident, when Govindan spotted some movement in the vicinity. He whipped out a pair of binoculars and gestured frantically. It was an STF party of eleven men. The gang hurriedly took cover.

Hidayatullah and his men were in a fix. Several thoughts raced through their minds—What if the STF attacked? Should they reveal their identities and surrender? Would they be believed? Only Nataraj and Kannan knew of the plan. Was fighting the STF an option? Could they risk getting killed in the bargain?

Even as the men tried to make up their minds, they saw the STF men settle down under a tree, barely a hundred yards away. They sat there for about an hour, ate and then walked away.

Hidayatullah and his men heaved a sigh of relief. The SI leading the team was hugely embarrassed later when it was brought to his notice that he and his men had been a few yards away from Veerappan, blissfully unaware that they were being watched by the very man they were tasked to nab.

Veerappan took a liking to Hidayatullah, who was always punctilious about praying five times a day and did all his chores meticulously. One day, he told Hidayatullah he had been cheated out of some money by the chief of a fringe political group that was later banned for being pro-LTTE.

'I gave him ₹2 lakh for an ambulance. I believed he was an ideologue. But no ambulance came. He ran away with the money,' said Veerappan through gritted teeth, his voice a mixture of anger, vendetta and helplessness.

'That's sad,' commiserated Hidayatullah, but pounced on the keywords. 'But why did you need an ambulance?'

'Oh, nothing,' said Veerappan hastily. As he got up and began to walk away, he seemed to stumble over a root. He hurriedly straightened up and looked around to check if anyone had noticed.

Hidayatullah saw it out of the corner of his eye, but pretended not to notice anything.

Over the next few days, Hidayatullah observed that Veerappan always walked behind everybody else whenever the party moved—which was

always at night. Initially, he thought this was just a security measure. But he also noticed that Veerappan always used a prop—often a tree branch—while walking. Many a times, he would walk into a bush or branch.

It soon became clear to Hidayatullah that Veerappan had a serious problem. This was confirmed when one day, he approached Veerappan to serve him some tea. He overheard him telling Govindan, 'Somehow, we should get a doctor.'

The conversation came to an abrupt end when Hidayatullah reached the scene.

Hidayatullah had gone into the forest expecting to meet a demon. But the Veerappan he saw was a far cry from the indestructible bloodthirsty image that was projected over the years. Instead, he met an ageing, fumbling fugitive. A megalomaniac overpowered by bouts of melancholy. A doting father, especially fond of his second daughter, whose photograph he showed all infiltrators. Late at night, he would fondly identify his birthplace, pointing out the village lights.

Hidayatullah realized that though Veerappan was in charge, his advancing age had compelled him to delegate many of his responsibilities to Govindan, who was every bit as wily and paranoid as Veerappan in his prime.

By now, Veerappan trusted Hidayatullah completely.

One day, when Govindan and the others went into the forest on a hunting trip, Hidayatullah and his men were left alone with Veerappan.

Though it was broad daylight, Veerappan lay down and pulled a sheet over his head. Within minutes he was fast asleep. His snores resounded through the clearing.

Hidayatullah walked up to Veerappan's prone form, his mind racing and heart pounding. There was a big stone nearby. 'I just have to pick it up and bring it down,' he thought. 'It will all come to an end and I will be a hero.'

His throat and mouth were totally dry. He swallowed, then bent down and picked up the stone.

A debate raged in his mind. He was faced with the unenviable choice of killing a sleeping defenceless man or sparing the life of somebody who had snuffed out hundreds of innocent lives. As Hidayatullah weighed his

options, Veerappan stirred in his sleep and turned to one side. A series of images flashed through Hidayatullah's mind—Veerappan showing his daughter's photo, pointing to his village with childish uninhibitedness.

Slowly, with trembling hands, he lowered the stone and walked back to his bed. His mate looked at him quizzically. Hidayatullah shook his head silently and gestured to the other man, asking if he wanted to perform the grim task instead. The man thought about it briefly and shook his head.

I have no doubt that One-eyed Jack's presence in the clearing that day would have brought Veerappan's story to an end right there. But Hidayatullah and his men had never committed murder and were unable to bring themselves to do so that day. One can hardly blame them for showing compassion, even though Veerappan had not done so for any of his victims.

Shortly after this incident, a tall young man came to meet Veerappan. The brigand was overjoyed and hugged him warmly, but paused when he saw a serious expression on the lad's face.

'Is something troubling you?' he asked.

The boy nodded. 'I met Madhaiyan mama in jail yesterday after a couple of weeks. He wanted to know why you hadn't replied to his recent letters.'

Veerappan raised an eyebrow.

'I went on visitors' day, both last week and the week before, but I was not allowed to see him. The jailor apparently told Madhaiyan mama that there were no visitors for him. Madhaiyan mama doubted these four, and wanted to confirm from his friend in jail. But he was unable to meet him.'

Veerappan was now on the verge of a panic attack.

Even as this interaction took place in the jungle, Madhaiyan had managed to get across to Damani. The latter informed Madhaiyan that the four boys with Veerappan had not been sent by him. But the nephew was unaware of this development. So Veerappan's dilemma about the identity of the four men continued. He was not willing to take any chances.

After a quick chat with Govindan, Veerappan walked up to Hidayatullah. In a measured tone, he said, 'Some urgent work has come up. We will have to split up. We'll meet again after a few days.'

He then mentioned a rendezvous point. Throughout the conversation, his demeanour was absolutely normal.

Govindan guided them west of the Cauvery, only 3 km away. As usual, Veerappan brought up the rear.

At the riverbank, Hidayatullah turned back and saw Veerappan still standing there, as if rooted. He waved warmly and left. He would never see the bandit again.

Veerappan and Govindan waited until the four men were out of sight and then exchanged glances. That had been close; too damn close.

'We should be more careful,' Govindan said.

Veerappan nodded bitterly. 'Agreed. We should get as far away from the rendezvous point as possible.' He crossed the Cauvery not far from the spot where he had ambushed SI Dinesh in April 1990.

Nataraj's attempt to infiltrate Veerappan's camp may appear to have failed at first glance, but it had yielded precious information to the STF. For the first and only time, the gangsters had offered refuge to their potential killers for twenty-one days. This chilling realization impelled them to tighten their inner circle. It now became that much tougher for the STF to plant a mole.

The STF also learnt that Veerappan desperately needed treatment for his eye—a priceless nugget of information that came in handy much later.

Upon his debriefing, Hidayatullah also mentioned that Veerappan had a weakness for country fowl and mutton, cooked and brought from villages in the MM Hills area.

Kannan's head shot up. 'Who brings the food?' he asked.

'Three–four people who visited the camp regularly. They always came around dusk, sometimes in pairs, but never all together,' Hidayatullah replied. 'Veerappan addressed them as mappilai (brother-in-law) or marumagan (nephew). One very fair guy was called Red (in villages, it was common to refer to a fair-complexioned man as ruddy or red). There was also a man whose face was always covered by a hood.'

The STF, who set out to track Veerappan's couriers, eventually traced down the nephew and the hooded man, whom they later code-named Blanket.

Since the nephew was just a boy, the STF hoped to bring him around

to their side. But he proved a tough nut to crack. He went through a lie-detector test but did not provide any new inputs to the STF. He was as wily as Veerappan and frustrated the best efforts of his questioners to trip him up.

The interrogators then turned to Blanket. After persistent questioning, they were finally able to crack him. 'I'm only working with Veerappan to provide for my son,' the man pleaded.

'Don't worry, we will take care of his needs,' he was assured. The love of one's child is a powerful motivating force. Blanket agreed to cooperate with the STF and managed to provide a crucial breakthrough later.

The Last Victim

August 2002

After Dr Rajkumar's abduction, Veerappan's war chest was full, but his ranks were empty. His followers from the TNLA, TNRF and other radical outfits had been arrested, one by one. Both Tamil Nadu and Karnataka had turned on the heat.

Tamil Nadu's 'Q' branch, which had once quelled Naxals and later kept Sri Lankan groups on a tight leash, under the leadership of S.P. Ravichandran, set their sights on Veerappan's radical friends—the TNLA and TNRA. But even as the noose tightened around him and his friends, Veerappan managed to stage one more daring operation. That would be his last.

◆

August 2002

Former Karnataka minister H. Nagappa's gunman Puttananja nodded at the lungi-clad stranger. The man had come earlier in the day as well, with a complaint that some people in his village were tormenting him over a land dispute. He was desperate to meet Nagappa, an extremely popular leader of the Lingayat caste.

Puttananja ushered the stranger into the portico of the farmhouse, located on the fringes of the forest. 'Sir is busy on the phone. Wait here.'

But the stranger scampered towards the gate and waved at somebody on the road. Within minutes, eight gun-wielding men in olive green fatigues stormed into the farmhouse. Sensing trouble, Puttananja bolted the front door, then took cover in the anteroom and fired.

But his resistance was futile. The men fired at the lock, smashing it and then bolted the anteroom from outside, trapping the gunman.

Veerappan smiled as he surveyed his captives. Apart from Nagappa, his wife Parimala, daughter Priyanka, grandson Sabaan, personal secretary Shivumurthy, driver Mahadevaswamy and an aide were present. He ignored them all and pointed his gun at Nagappa.

'Let's go,' he said.

Parimala began pleading for Nagappa, pointing out that he was diabetic and would not be able to survive in the forest.

Veerappan and his men ignored her and marched off with the sixty-six-year-old barefoot Nagappa. The family rushed to the neighbouring village to seek help. Soon, word got out.

A little over two years after the abduction of Rajkumar, Veerappan had once again taken a high-profile hostage.

About 2 km from the man's home, Veerappan stopped at the gate of another farmhouse. As the owner came out, he was shocked to find Nagappa sitting outside the gate, surrounded by armed men.

'Give him some slippers,' said Veerappan.

The man hastily removed his own slippers and handed them to Nagappa.

Veerappan then handed over a cassette. 'Give it to Mrs Nagappa. Tell her not to worry. I will release her husband after a few days,' he said.

The tape was for the Karnataka government and reiterated Veerappan's long-standing demands, which included the release of Tamil politicians Kolathur Mani and Pazha Nedumaran—both of whom had played a key role in Dr Rajkumar's release—from police custody and a reminder on the pending statue of the poet Thiruvalluvar in Bengaluru.

Veerappan signalled his men and they headed towards the Burude forest range.

Later that night at around 12.30 a.m., a few armed men stopped a private bus around 20 km from Kollegal. Two of them climbed onto the

bus and asked the weary passengers to disembark. As they stepped off, Veerappan and his remaining men emerged along with Nagappa from a field where they had been hiding.

While the women gawked, the male passengers rushed to shake hands with the notorious bandit. Some were terrified but Veerappan was quick to reassure, 'Don't worry. You won't be harmed. The bus will be sent back once my work is done.'

About half a kilometre from the spot of the hijack, the gang saw an approaching jeep. 'Could be the STF. Stop here,' Veerappan ordered the driver.

The bandits quickly got off the bus and melted into the forest.

After that ploy to throw off any pursuers, Veerappan headed for Kalmathur Hill, overlooking his stronghold Nallur.

As he escorted Nagappa through several villages, there was a spring in Veerappan's step. People lined up to greet him and Nagappa. It turned into a road show, as the combined mass appeal of the hostage and his captor proved irresistible for the village folk. Many folded their hands, some cheered and a few even shook hands with the bandit.

Veerappan moved on to areas that were full of his supporters. Many people had lost their jobs due to the closure of hundreds of quarries in the region in the 1990s after Veerappan unleashed his reign of terror. But people blamed the government for the loss of their livelihood instead of the bandit.

But why did Veerappan kidnap Nagappa? In all his subsequent interviews and statements, he was unable to provide a 'satisfactory' reply. One theory was that he nursed an old grouse against the man, who, as agricultural marketing minister between 1994 and 1999, had often spoken out against Veerappan. He had also led a steadfast crusade against sandalwood smuggling, and had urged villagers not to assist the bandit.

Also, when Nagappa finally defeated his political rival Raju Gowda in the local Assembly elections, Veerappan was convinced that Nagappa's victory was due to him and, as such, expected the minister's assistance. He believed that it was his support that had helped Gowda win the elections twice, a claim vehemently denied by Gowda. This time, he had not supported Gowda. When Veerappan's brother Arjunan and other

men died under suspicious circumstances in police custody in Karnataka, the brigand insisted that Nagappa's timely intervention could have saved their lives.

Veerappan's anger towards Nagappa may have been unjustified, but there was no doubt that he faced a severe logistics crunch as compared to the days of Rajkumar's kidnapping. He and Govindan had carefully buried cash in secret locations without the knowledge of other gang members. But the combined efforts of the STF in Karnataka and Tamil Nadu ensured his inability to retrieve the same.

Veerappan soon realized that he had committed a blunder by kidnapping Nagappa. The politician was extremely popular and had many supporters, even in villages regarded as Veerappan's stronghold. With this abduction, Veerappan lost public sympathy.

He was now trapped in a situation that he had created. He could not let Nagappa go free without extracting something in return. He dispatched more cassettes in which he repeated his demand for Kolathur Mani's release. He also demanded that Raju Gowda negotiate on the government's behalf.

Gowda flatly refused. However, a local Janata Dal leader and Nagappa's confidant is said to have taken some trips into the forest and met Veerappan. The leader reportedly established contact with the gang at a place called Odakkehalla. He was not allowed to meet Nagappa, but the gang accepted the clothes and medicines that he was carrying and ordered him to return, with 'instructions' for the Karnataka government to release ₹100 crore and speed up the release of Kolathur Mani.

The man returned and conveyed the message to Nagappa's family and Karnataka CM S.M. Krishna. It was supposed to be a closely guarded secret, but Mohan Nawaz, who had managed to win the confidence of Nagappa's family, got to know of it.

The Karnataka STF began combing operations in the Kalmathur forests. But the search became complicated when Nagappa's wife headed to the forest, accompanied by truckloads of tearful supporters, all demanding Nagappa's safe return.

The government initiated proceedings to secure bail for Mani, but it was a slow process. As the Karnataka STF closed in, Veerappan slipped

out of Kalmathur and headed towards Chengadi. But a walk that should have taken half a day took three days. With the forests teeming with STF moles and Nagappa sympathizers, Veerappan was forced to avoid many villages. He was also unable to push Nagappa due to the latter's ill-health. Usually, Veerappan's modus operandi was to cross into another state after staging a kidnapping. But this time he had to hole up in Karnataka, especially after Jayalalithaa made it patently clear that there was no question of any negotiations with him.

The CM's stand led to a visit by Parimala, who pleaded with her to withdraw the Tamil Nadu STF. The CM assured her that the STF would not cross the border, but remained firm that the cordon and search operations would continue in Tamil Nadu.

The impasse came to a sudden, unexpected end three months later.

In the early hours of 8 December, a dhoti was found tied like a banner between a pole and a tree, at a short distance from Nagappa's home. On it were written the words 'Nagappa-Veerappan', along with a microcassette in a pouch. It also had instructions in Tamil that Nagappa's household be informed about a new development.

Soon, word began filtering out that the tape contained bad news. For once, the rumours were true. Veerappan was heard stating that Nagappa had got separated from the gang and could be somewhere in the Chengadi forest.

In the tape, Veerappan recounted,

There was a bad omen. I told Govindan that bloodshed was likely. Let's get out of here. Suddenly, there was firing from AK-47s. Some people surrounded us. There was a lot of firing. I told the old man, 'Let's go.' He was petrified. He did not move. We shot down two cops. Then we ducked. There was heavy fire upon us. That's when I found Nagappa rolling on the ground. We left our bags and ran. We don't know if Nagappa's dead or alive. The blame will fall on me. But I have always kept my hostages happy. Rajkumar parted from us with tears in his eyes. I gave Nagappa copra and ghee. When he mentioned his family to us, we told him, 'We too are without our families because of cops. If you're now with us, it's because of the cops.'

Veerappan signed off by saying that he feared Nagappa was most likely dead, or else the Tamil Nadu STF would certainly have highlighted his rescue to the media. He swore five times in the name of God that he had not killed Nagappa.

That evening, Nagappa's body was found propped up against a boulder at a spot 25 km from his farmhouse. Autopsy and forensic evidence later revealed that he had been dead for almost three days.

People from neighbouring villages began gathering at Nagappa's farmhouse, shouting slogans against the government and police. Many held the Tamil Nadu STF responsible for the botched-up encounter. Though this was strongly refuted by the STF, the emotionally charged crowd was in no mood to listen.

Sensing trouble, Nawaz, who was at Nagappa's home when reports of his death began circulating, walked through the crowd to his vehicle parked some distance away. He asked the driver to leave the place quietly. Within minutes of his departure, the mob started pelting stones at vehicles. A Tamil Nadu State Corporation bus was attacked and burned. He soon received a call from a friend advising him to avoid the highway, as angry mobs were on the lookout for him.

That night, Nawaz hid in his friend's house. It was a tense few hours. Finally, at around 3 a.m., he left under cover of darkness and crossed over into Tamil Nadu.

Public fury continued for the next few days. Chaos prevailed at Nagappa's funeral as nearly 20,000 supporters gathered on the road to his house and stopped the cortege at will. Nagappa's family pleaded with his supporters to let them pass, even as the unruly mob abused ministers, political leaders, police personnel and journalists.

The post-mortem report stated that Nagappa had been killed by a single bullet fired from a distance of 20 feet (around 7 metres). He had been shot an hour or so after he had eaten a meal, probably on 4 or 5 December. The bullet had entered the left side of his chest and pierced his lungs and heart, and could have caused instant death.

But who fired that fatal bullet? It is a question that continues to remain unanswered. There are many conspiracy theories, though. One of them suggests that Nagappa was killed at the behest of some powerful

people who feared that he had learnt of their dealings with Veerappan during his captivity. Some maintain that Nagappa died during a shootout between Veerappan's men and a gang of poachers that the bandit's kinsmen mistook to be STF men.

The debate about the alleged role of the Tamil Nadu STF ended after Jayalalithaa wrote to her Karnataka counterpart Krishna, criticizing the remarks attributed to his home minister, Mallikarjun Kharge.

'The war against Veerappan must be fought in the forest where he lurks, not in the columns of the media,' she declared. Krishna, in turn, responded that Kharge had not commented on the Tamil Nadu STF's role.

Another theory maintained that the failed operation was actually mounted by some 'rogue' elements within the STF, who were determined to get Veerappan at any cost.

The truth has never been established beyond doubt. But one thing was certain—Veerappan's image took a severe beating. Just like the LTTE lost ground in Tamil Nadu after the assassination of Rajiv Gandhi, Veerappan's popularity among the villagers and tribals plummeted.

The former minister's death severely restricted Veerappan's manoeuvring space. He now became even more cautious about his sources of aid and assistance.

Nagappa was the first person abducted by Veerappan who failed to return safely. He was also the 124th person for whose death the bandit was responsible.

The presence of Nagappa's sympathizers in every village forced Veerappan to stay close to his home. Govindan, meanwhile, tightened all access control measures. Veerappan tried hard to mislead the STF about his whereabouts, but not for long.

If Rajkumar's abduction pulled Veerappan out of an eclipse, this hostage crisis pushed him into the final one.

Part 4

Operation Cocoon

Back with the STF

October 2003

In less than two decades, the Veerappan saga had assumed global dimensions. From *TIME* magazine to a Chinese daily that reported the incredible story of 'a law-breaker who managed to hide from the law for twenty years', Veerappan grabbed headlines all over. Some Indian dailies also placed him in the league of Osama bin Laden and Saddam Hussein, christening them the 'three most wanted'. But despite his global profile, Veerappan was like a general without a division. He desperately needed troops and an escape strategy.

A flurry of audio tapes was sent from his hideout. While in one tape he raved and ranted about a possible partnership with the Peoples War Group (PWG) of Andhra Pradesh, in another he talked about his dream of a car ride with his wife and two daughters. In yet another he spoke of his grand escape to Russia. The STF members laughed hysterically on hearing this.

His innate political aspirations came to the fore in a tape in which he expressed support for bandit-turned-politician Phoolan Devi, who was shot dead in New Delhi outside her MP's bungalow. 'Has she done more harm than the ruling political class?' he thundered.

But the most important tapes were reserved for two persons—CM Jayalalithaa and Walter Davaram. In the tape meant for the CM, he likened M. Karunanidhi to the demon Bhasmasura for launching the Semmandhi raid. In Walter's tape, Veerappan took back his earlier

unsavoury references. Both CM and Walter were clear that the ops against Veerappan would continue. Expert analysis of these tapes, however, proved futile.

Meanwhile, Nedumaran, Kalyani and Kolathur Mani raised their demand for the withdrawal of the STF. Posters condemning the past 'atrocities' of the STF appeared. The Tamil Nadu Police then arrested Kolathur Mani yet again (he had been out on bail following his previous arrest by the Karnataka STF).

Before I left Chennai to join the STF, I called on the CM. Despite all the media reports, she wished me luck and assured me of her full support. I knew she meant it. In my previous stint with the STF, I recall that all demands made by Walter Davaram, including satellite phones and Bolero jeeps, were approved immediately by the state administration. The CM ensured that red tape never hindered the STF. Just as it should be with any special force anywhere. Elite groups are typically created to handle crisis situations. They need mission-focused troops, rigorous training, inspiring leadership at all levels and the best possible gear. The last thing they need is to deal with bureaucratic queries about *why* special rations in place of standard rations, or '2,000 ammo 7.62 cal' when '2,500 ammo 9 mm' is in stock. It is for this reason that the 'tail' (quartermaster/storekeeper) must look at the 'teeth' (fighter in front).

Despite her generosity, the CM never put any pressure on us to deliver results. Only once during an election campaign in May 2004 near the STF headquarters in Sathy did she ask, 'How is it going?'

'We're doing our best. We should have some good news soon,' I assured her.

She nodded and left it at that.

The news of my posting to the STF provided fodder for the media. Some reported that I was being 'shunted to the jungles'. Many well-wishers in the media and police sympathized with me.

This show of sympathy stunned me. I knew it would not be easy to catch Veerappan, but it is precisely such challenges that make life worthwhile. After all, poring over musty files in an air-conditioned room wasn't exactly my USP.

My extremely supportive wife, Meena, shifted to Sathy to provide

me moral support, leaving our daughter behind in Chennai to pursue her master's. Luckily for us, some trusted friends agreed to take care of our daughter.

While we were packing our stuff for the move, Meena told me, 'You have eight years of service left. Even if it takes that long to get the job done, don't worry.'

'You think it will take me eight years to catch Veerappan? Thanks for your touching faith,' I teased.

'Well, considering that you can't even find your own slippers at home, it would be quite an achievement if you could actually nab Veerappan,' was her quick retort.

Touché!

But her witty reply belied the enormous faith she reposed in my abilities. For months, she refused to speak to a revered relative who insisted that Veerappan would never be apprehended.

◆

I stepped out of the bridegroom's chamber, my office at the wedding hall that now served as the STF's headquarters in Sathy, and smiled. Maps with pins of many colours dotted all the walls. It was good to be back.

'I can see many forty-plus bachelors waiting to enter the marriage market. When the happy day arrives, you may even consider this hall.'

My ice-breaker caused smiles all around. The men knew I was referring to the vows taken by many in the STF to remain single until Veerappan was nabbed.

'We have to get this done. How much terrain are we talking about logistically?'

It was Hussain who answered. 'Veerappan could be hiding in an area of almost 14,000 sq. km—about 6,000 sq. km each in Karnataka and Tamil Nadu and another 2,000 sq. km in Kerala. A lot of this terrain is under deciduous and semi-deciduous forest cover. The forest is full of thorns, rocks and shrubs. In some parts, like the Udutorai Halla gorge, you can hardly see 10 feet below. Plus, there are 400 small villages. It is impossible to keep an eye on all of them at once, but Veerappan can go to any of them for food and shelter, and often does.' The others in the

room murmured in agreement.

'Also, I think some of our SOPs (standard operating procedures) are wrong. We move in large teams, which can be spotted easily. Whenever a raid is planned, we buy rations in bulk from the market. Veerappan has a well-oiled network of informers, so he gets to know of our plans,' Hussain added.

'Let's take care of that issue immediately. Start buying rations in large quantities and store them here. Be ever ready with five days' rations issued directly from our stores,' I said. I then moved on to my next concern:

'How many men are there in Veerappan's gang now?'

The answer was prompt. 'Sir, four to six.'

Though Veerappan had many sympathizers and informers all over, his core group had dwindled to a handful.

'Why can't we have six-men teams too?' I questioned.

I wasn't being facetious, but was just drawing on the theory of Colonel John McCuen, a renowned American expert on counter-insurgency ops, who insisted that one should first mimic the foe, then go one better.

'Sir, if you recall, the STF had fifteen-men teams with LMGs when we first started patrolling,' someone said.

That was true, but the STF had since shrunk the patrol size, as it was hard to conceal big teams in the jungle.

I was instantly reminded of the tactics instituted by Brigadier Russell W. Volckmann, a founding member of the US Army Special Forces (Green Berets) and one of the leading authorities on counter-insurgency and guerrilla operations. As a young colonel, he had led a guerrilla resistance against the invading Japanese army in the Philippines.

The Japanese General Tomoyuki Yamashita later insisted that Volckmann's tiny bands of intrepid guerrillas gave him more trouble than the big armies he had faced in conventional battles. Volckmann's and his men's heroism earned him a place at the table when the Japanese finally surrendered, though he was quite low down in the food chain. Volckmann's exploits had convinced me about the power of small units.

I asked my boys if they could attain the standards set by Cuban military leader and insurgency guru General Alberto Bayo. 'Most of you have been in the jungle for a long time. Can you march for fifteen hours

with short breaks?'

Since the jungle's undergrowth, poor visibility and general disorientation made night and day virtually the same, I insisted that we train harder at night, using simple techniques. 'Just tie a handkerchief on your eyes right here in class and day turns into night. Walk on dry leaves to enhance the element of stealth,' I asserted. The idea was to bridge the forty-year head start that Veerappan had acquired over the STF, owing to his longer presence in the jungles. It could only be achieved by tougher training and more discipline.

'But first, we need to get smart and small,' I said.

My words sparked off an animated discussion. Finally, after much deliberation, it was decided that the STF would function in self-sufficient teams of six, equipped with the best possible gear, including night-vision devices. The decision boosted the men's sense of confidence and made them more close-knit, since they knew they had only each other to rely on.

Now that we had so many teams, the issue of leadership cropped up. Some teams were led by SIs, some by head constables, but in many teams all the members were of the same rank—constables.

Leadership cannot be imposed in a jungle fight. A nervous, unsure leader, unfamiliar with the strange sights and sounds of the jungles, will only spread panic in his columns. Since it would take too long to import platoon and section leaders, the cutting edge of such missions, we urged our boys to choose their own leaders. In some cases, one man from the team volunteered and the rest endorsed his leadership. But in other cases, the team unanimously chose its leader. I was often surprised to find that the man chosen was not a fiery orator, but someone with a cool head and steady nerves, blessed with the ability to bring the team home safely. It was a reiteration of an important management lesson: in stressful situations, people seek the same qualities from their leaders—calmness, faith and tenacity.

Another major concern was the morale of the officers and men. I was worried that the years of fruitless searches could have left them demotivated. But I was wrong. Officers like Hussain, Mohan Nawaz, Karuppusamy, Rajarajan, Ashok Kumar, Sampath and Ramalingam had

spent a significant part of their careers chasing Veerappan and remained just as enthusiastic as on their first day with the STF.

I even promised to ensure a speedy posting-out of officers and men unwilling to serve in the STF, as I wanted only committed officers. Nobody took my offer. But after discreet enquiries, it emerged that some officers would conduct patrols in the opposite direction of Veerappan's last-known location. Some would tell the men setting out, 'Go ahead, you won't even find Veerappan's shit.' Such elements were either eased out quietly, or moved laterally—just to retain institutional memory—to take care of supplies, where they would not interact with the men every day.

I was also inundated with requests from enthusiastic young officers wanting to join the STF. My screening procedure was simple. I would call up a few colleagues whose judgement I trusted and ask them to list out the best, bravest and brightest in the Tamil Nadu Police. If the same name appeared on two or more lists, I would ask for the officer to be transferred to the STF. We were able to induct quite a few valuable reinforcements in this way.

But I stopped the practice of SIs being rotated through the STF in three-month stints. Most of those who came on these short tours had no experience in jungle combat and needed intensive training. Just as they started to show promise, it was time for them to leave. I found this exercise a waste of time, energy and resources, and requested that it be scrapped, even at the risk of leaving the STF short-staffed. 'I'd rather have a few dedicated men that I can count on than lots of people marking time,' I said. I was delighted to get wholehearted support for my 'Miltonic fit-though-few' approach. The STF men more than lived up to my faith in them.

Getting Down to Brass Tacks

In preparation of our final mission, three issues stood out as urgent: coordination, intel and training.

First, I assessed our level of coordination with the Karnataka STF. I never got carried away by the terminology 'joint task force'. The word 'joint' may exude synergy and strength, but demolition manuals insist that the 'joint' is the best spot to fix a charge.

In the past, patrols of both teams had unwittingly walked into each other's ambush. Once, one of the STF team's LMG fire had roared just inches above the other STF team that was hiding in a floating ambush in a coracle midstream in the Cauvery. The boys dived into the river instantly, seeking a rather wet cover.

Issues like poaching of intel assets and Bidari's daring raids into Tamil Nadu had also caused occasional rifts between the two sides. Kolathur Mani's sudden arrest by Karnataka only exacerbated matters. It put an end to all hopes of the Tamil Nadu STF to harvest crucial intel from Mani, who had been under its discreet watch.

I was very clear that both the STFs needed to work more closely than ever before. I held over a dozen meetings with B.G. Jyothi Prakash Mirji, IG, Karnataka STF. Our mutual desire to develop a strong synergy led to several issues being ironed out and to a series of joint patrols and camps. The resulting pincer effect confined Veerappan to a restricted area.

The second issue I took up was intel and informers. We made sure all old dues were paid. Inspired by Carl von Clausewitz's 'blood-is-the-currency-of-war' quote, I created a new one: 'Currency (notes) is the blood of intelligence.'

Since constables constitute over 80 per cent of any police force, I also insisted on improving every constable's skills in cultivating intel and informers. Finally, it was a constable's personal informer who brought us our real breakthrough.

I also impressed upon all the men to try and win the hearts and minds of the local populace and build upon my predecessor Nataraj's work. 'If you can't befriend them, at least don't antagonize them,' I would emphasize repeatedly.

Veerappan could not survive without the people outside his gang who aided him either out of fear or greed. We needed to win these people over. To this end, we organized extensive programmes in villages, including medical camps. In many cases, it was the first time in years that the villagers were examined by a qualified doctor. Then, there were spiritual doctors like Inspector Dharmaraj, who wooed the villagers of Martelli—once the gang's stronghold—with a Bible in hand instead of an AK.

We also informed the poor villagers about the ₹5 crore reward on Veerappan's head. But such a large figure meant little to a man who barely had enough to survive the day.

'How much is that in goats?' one villager asked.

He was told that assuming each goat costed ₹2,500, it would amount to 20,000 of them.

'What would I do with so many? It's better to preserve one's life than run after an unmanageable reward, which you may not even live to see,' he blurted out. I couldn't help but laugh when I was told about the honest response. But it also demonstrated the odds against us.

The third issue I addressed was training. My stint at Rossie's school, the breathless climb up the Alps and my other postings enabled me to simulate conditions that were harder than anything the men were ever likely to encounter. I also sought the help of my old friend Colonel Britto of the 9 Parachute Regiment to pass on life-saving inputs in the Sathy jungles, based on the hits and misses both in Sri Lanka and J&K.

The men went through a gruelling regimen, including the notable innovation—the 'one-minute drill', inspired by the 'one-minute manager' series.

As a boy, I had watched the centenary parade of the Tamil Nadu Police in awe as the band stripped down from full ceremonial dress to shorts and vest even while they continued playing and ran 100 metres, all within a span of one minute. I modified that drill to pack in speed, perfection and stress management. The idea was to ensure that the STF was alert at all times. There were drills for both urban and jungle scenarios, while some were devised for pure fun. The message was clear: everything had to be done within a tight time frame, which was not always 60 seconds.

Some drills, like dismantling and assembling one's weapon, took less time. Other drills included running a certain distance while carrying one's buddy, going from deep sleep to full battle readiness, firing over twenty rounds from a .303 or an SLR—all within a minute. These drills broke the monotony of regular training. Though the boys sweated hard, nobody protested.

In the years since I have left the STF, I have noticed that the one-minute drills have gone viral, with several other police and paramilitary forces adopting and even improving on them (airports security and corporates for bonding-drills). Perhaps these tests were introduced by STF men deputed to these forces. Or maybe good ideas just take on a life of their own!

By the end of 2003, the men were fighting fit and in high spirits.

As 2004 dawned, many of us assembled at the STF memorial at Thattakarai and took a solemn oath that we would not rest till we accomplished our mission.

We didn't know it then, but our vow would be fulfilled even before the end of the new year.

Operation Boston

December 2003

'Sir, do you know what we've been doing wrong so far?' asked an officer of
the Karnataka STF, who had been posted out.

I was chatting with him at his farewell lunch at MM Hills and could
have thought of quite a few things to say, but it seemed that the man
had something on his mind. So I waited.

'For years, we've tried to get Veerappan inside the jungle, where he's
well entrenched like a crocodile in water. We should lure him out into
our area of strength. His wife is comfortably settled in Salem. Try moving
her out of there. She'll surely try to contact the gang, or vice versa,' he
recommended.

Luckily, the heavy lunch had not slowed down our thoughts. As
Kannan and I drove back to the Palar checkpost, we discussed the man's
suggestion. In the next few days, this idea developed into an operation
that, as per our plan, would culminate in a tea garden in Ooty. The
operation was code-named Boston, drawing inspiration from the famous
Boston Tea Party.

'We're spread thin. It would be good if Veerappan is drawn out of
the jungle.'

Kannan said cautiously, 'There's no doubt that our odds would greatly
improve if we got him out. Maybe after the Hidayatullah infiltration he
has raised his defences.'

'Veerappan has an eye problem. And he hasn't seen his family in

years. If Muthulakshmi were to send him a message, he might risk coming to meet her and getting treated as well,' I said.

'He won't come to Salem. It will have to be another location. We will have to make Muthulakshmi feel secure,' replied Kannan.

'Can't we get somebody to befriend her? Once she opens up to that person, we can plant the idea of calling Veerappan. How about an undercover policewoman?' I said.

'I know a civilian girl. She might be willing to help,' said Kannan.

A plan was beginning to take shape. Kannan and I were excited, but we knew that a lot of pieces would have to fall into place for it to succeed, especially as we were determined to make sure Muthulakshmi was not endangered.

While we had been busy chasing Veerappan, Muthulakshmi was first placed in the custody of the Karnataka STF, then within weeks, was transferred to the care of the Tamil Nadu STF. She was not under arrest but kept under watch. After the Rajkumar release she was put under the watch of DSP Ramalingam. For a while she stayed in Mettur, Mechery, then shifted to Salem.

The first step was to get her to move from Salem to a location of our choice. DSP Ramalingam was away on some work. But she also trusted DSP Ashok Kumar. Ashok Kumar was assigned the task of drawing her out.

As Muthulakshmi walked to a shop near her house to make a call, she spotted a jeep with a Karnataka licence plate. It had four passengers—all in civilian clothes, but with close-cropped hair. None of them looked older than forty years. She rushed home in panic.

Two days later, she spotted the same jeep parked in the street corner. Her brain went into overdrive. She figured in many FIRs as Veerappan's wife and accomplice. She had also read in Tamil dailies about a warrant issued against her by a court in Karnataka.

'They've come to get me,' she thought. 'I can't let them take me again.'

In desperation, she tried calling Ramalingam. But his phone was out of reach.

Just then, there was a knock on the door.

'Who is it?' she asked, trying to keep her voice from trembling.

'It's me, Ashok Kumar.'

It was a familiar voice. Muthulakshmi opened the door and pleaded, 'Please help me.'

'Don't worry. I'll move you to a safe location. But I can't reveal my identity. I'll pretend to be your brother, Shankar, who has just come back from the Gulf to help you find a place to stay. Now pack quickly; take only absolutely essential stuff. Let's leave at once,' said Ashok Kumar.

The duo went from Salem to Erode and then to Tiruppur—to houses already prepared by STF's intel branch. At each location, Ashok Kumar made a big show of pleading and negotiating, while Muthulakshmi watched from his jeep. At each place the 'owners', who were actually STF personnel in plain clothes, declined to rent their homes.

By the end of the day, Muthulakshmi was getting desperate. Finally, they reached Vadavalli, a quiet middle-class neighbourhood in Coimbatore.

'Let me try one last time,' suggested Ashok Kumar, pointing at a 'To Let' sign. Only women—a mother, daughter (our informer, Ramya) and grandmother—lived in the house. They said they could offer her a room with an attached bathroom and a small kitchen, with a separate entry.

Muthulakshmi leapt at the offer. She was delighted to find a place after a long harrowing day. Besides, the company of the young woman, Ramya, who seemed to be about ten years younger than her, was a welcome change after years of living alone.

Ashok Kumar made sure that Muthulakshmi had settled into her quarters and then bid her farewell. As he drove away, he called Kannan.

'First step of Operation Northern Star over,' Kannan reported to me. 'It went off rather smoothly.'

We had decided to name the operation Northern Star inspired by Vadavalli, where Veerappan's wife now stayed. In Tamil, 'vada' is north, while 'velli' means star.

'The hard part starts now,' I replied. 'I hope Ramya is up to it.'

◆

February 2004

Ramya exceeded our expectations. She soon became friends with Muthulakshmi, even convincing the latter to visit a beauty parlour for the first time in her life. After years of stress, Vadavalli must have seemed idyllic to Muthulakshmi. Soon, she would be chatting with Ramya all day.

At night, on the pretext of visiting the market, Ramya would meet Kannan and pass on updates on the day's developments.

An undercover STF man, who was designated as the family's driver and man Friday, monitored Muthulakshmi's activities. He observed her visitors closely and followed them. He was also supposed to protect the family, though the members were oblivious to his real identity. He had strict instructions not to intrude on Muthulakshmi's privacy.

With a strong friendship between the two women now in place, Kannan and I decided to take the operation to the next level. If we wanted to lure Veerappan to Muthulakshmi, we would have to take her to a remote location. There was no way he would take the risk of entering Coimbatore.

We located the perfect spot—a guest house of a tea garden some 20 km from Ooty. It offered a scenic view and, more importantly from our point of view, was completely isolated. This was the estate 'Boston'. We posted an STF man there, posing as the cook-cum-caretaker.

Ramya and Muthulakshmi drove there one day.

'It's so beautiful. Whom does it belong to?' asked Muthulakshmi.

Ramya made an expansive gesture. 'My family owns the house and the estates all around. We visit this place regularly.'

The cook took Muthulakshmi on a tour. Though the estate was barely 20 acres, he cheerfully enhanced its area, claiming that it extended right up to a waterfall some distance away.

Finally, they halted at a spot which lay across the Dhimbam Hills. Muthulakshmi could identify the location and her mind was flooded with memories. That's where she had been separated from her husband during the STF raid. She returned to the guest house in a pensive mood.

As Muthulakshmi grew closer to Ramya, the STF discreetly arranged for Muthulakshmi's second daughter, Prabha, to move in with them.

Shortly after her birth, her mother had left Prabha with her parents and had gone back into the forest. The STF had then handed her over to a Telugu couple who had raised her. The couple were deeply attached to Prabha and were reluctant to be parted from her, but Inspector Ramalingam persuaded them to allow the girl to be reunited with her mother. The first daughter, Vidya, was studying in a boarding school.

All this while, Muthulakshmi had not revealed her true identity to Ramya. But on 26 February, after a picnic on a pleasant day at the waterfall near the tea estate, she poured her heart out.

'You've become a dear friend. I want to tell you the truth about myself. But I want you to promise that you won't break our friendship,' she said hesitantly. 'I am the wife of a famous person. He is wanted by the police.'

'What are you saying!' exclaimed Ramya, looking suitably shocked.

'Don't judge me before hearing me out,' pleaded Muthulakshmi.

Then she narrated the complete story of her marriage to Veerappan and the events thereafter. After she concluded her tale, Ramya wiped her tears and embraced her. 'You've been through such a lot. Don't worry. You can stay with us as long as you like.'

Within minutes of the conversation, Ramya had passed on the details to Kannan, who, in turn, conveyed them to me.

It was time for the endgame to begin.

Ramya was quickly briefed. At this stage, she panicked. 'I don't want to be part of an encounter,' she said, her voice cracking on the last word.

'There will not be any extreme action. We intend to capture him alive,' Kannan was quick to reassure her.

The next day, when Muthulakshmi brought up the topic of Veerappan, Ramya was ready.

'I was up all night thinking. You told me your husband needs to get his eye treated. I know a doctor who can take care of it, no questions asked. Also, he hasn't seen Prabha since she was a baby. Why not ask him to come over? This way he can meet her too.'

Muthulakshmi got excited and said she would propose the idea to Veerappan.

Ramya got in touch with us, and we started preparations in right earnest.

Muthulakshmi and Ramya returned to Coimbatore for a few days. While away, Inspector Umapathy, known to the STF as Ultra, swung into action. A trained engineer and a wizard with electronics, Ultra quickly rigged up surveillance outside the house to keep an eye on any suspicious-looking people in the vicinity. He moved into a location close to the guest house to monitor the footage.

The inspector handling logistics hired a Mahindra jeep and an Indica. Kannan and I travelled in the jeep up to Kotagiri, and then to the guest house in the Indica. We were very careful not to use any official vehicles, as we didn't want word of police presence getting around.

We studied the area and all the access roads thoroughly. The guest room had a small attic, which could be accessed via a trapdoor in the roof. 'That could come in handy if Veerappan is in the room and we want to roll in a stun grenade and take him by surprise,' I noted.

While all these preparations were on, we hit a snag. The 'driver' assigned to Ramya's family wanted to quit. 'I've got three female bosses. The old hag is a pain. Cleaning the car is fine. But she expects me to mop the house and pick up the dog's poop as well. I did not join the STF for this,' he lamented.

Kannan stepped in to counsel him, quoting an old Tamil adage, 'This would be like breaking the pot when the butter is about to churn.'

The mollified driver went back to muck-raking, quite literally.

From Vadavalli, Muthulakshmi recorded an audio cassette in which she spoke about her past travails and hopes for the future. She listed all the ways in which Veerappan had failed in his duties as a husband and father, trying to inculcate a sense of guilt in him. At some places, she broke down. She shared some of the details with Ramya. By now, Muthulakshmi trusted Ramya so much that she even allowed her to fly with Prabha to Chennai for a few days.

Meanwhile, more tapes were sent by her to Veerappan, in which she informed him of the beautiful tea estate and guest house. The STF tried to follow the audio tapes to his den, but to no avail. Our men managed to follow a lanky youth, acting as the courier, till the Erode bus stand, but lost him there.

Whatever we could glean from Muthulakshmi's conversations with

Ramya indicated that Veerappan was likely to take the bait. Kannan rushed to Madurai and spoke to an eye specialist. He informed the latter that he would be needed on short notice to treat someone important, though he didn't give the name. A nurse, too, was put on standby. Fortunately, the doctor did not ask too many questions.

From Ramya's information, it seemed that Veerappan would emerge near Bannari. There were some hillocks below Dhimbam where he had kept Rajkumar hostage. It could be a possible route for him.

Kannan and I discussed the possibility of posting some women commandos posing as woodpickers in the area. We shortlisted some probables from the 3,000-odd women in the Tamil Nadu Special Police.

But then things took a turn for the worse.

On 23 March, Muthulakshmi noticed three missed calls on her mobile within a space of two minutes. She walked to a nearby phone booth and called back. When she returned, her demeanour had changed. She became nonchalant towards Ramya. But the two were scheduled to go on a picnic to Valparai Hills, so they went anyway. According to their plan, they would have a leisurely lunch and head back at around 4 p.m.

Around lunchtime, Ramya's mother rang up Kannan. 'Ramya just called. Muthulakshmi suspects she is under surveillance,' she said in an agitated voice.

'Don't worry, we'll take care of it,' said Kannan.

The moment he put the phone down, he called the driver. 'Pretend that the car has developed engine trouble. Whatever you do, make sure you don't start from there before 6 p.m.' Then he called Ultra. 'Pull out. Hide the street cam. She shouldn't find anything.'

By the time the two women returned, there was no trace of Ultra. But things were never the same between them again. Muthulakshmi even stopped letting Prabha spend time with Ramya.

A few days later, the surveillance camera recorded an image of someone hanging around early in the morning on a foggy day.

A long time was spent analysing the footage, but the person could not be identified. Taken in conjunction with the tip-off that Muthulakshmi had received over the phone, it was too much of a coincidence to ignore. The lab's effort to enhance the image came a cropper. It remained grainy.

'Who could it be?' I asked Kannan.

Could the mysterious visitor be a mole within the STF?

'It may be a rogue cop or a civilian,' said Kannan grimly, but didn't sound too convinced. Then he voiced the question that had been bothering me. 'Should we call it off?'

After much agonizing, we decided to persist with Operation Boston. Even if Muthulakshmi had an unknown visitor (we never found out who that was), it was unlikely that he would know about the op itself, as it was carried out on a strictly need-to-know basis. Only five people within the STF knew all the details—Kannan, driver Selvaraj, the cook, Ultra and me.

But one day, Veerappan abruptly called off his plan to visit Muthulakshmi.

There could have been many reasons for this. Apparently, an astrologer had warned him about the period being extremely inauspicious, which may have prompted him to lie low.

Also, Mohan Nawaz had launched a guerrilla force called Anjaneyas (after one of the many names of Lord Hanuman). The Anjaneya units were small, consisting of four to six men. At times, only a buddy pair would move, with the second pair keeping an eye from a distance. They lived on two meals of ragi balls every day. This was a step above Bidari's five-member civilian teams, called 'ragi squads'. They dressed like tribals and carried small bundles on their heads, which held their favoured weapons—sawed-off .303 rifles and shotguns.

There was only one way of differentiating an Anjaneya from a tribal—they did not have the spindly legs and splayed toes of the locals, who had spent their entire lives walking barefoot on hard terrain. But that would necessitate close scrutiny, by which time it would be too late, especially for a wanted man. Veerappan had come to hate and fear these hermit commandos. Their patrols in the crucial Dhimbam Hills had severely curtailed his movement.

In all, there were some ninety Anjaneyas. Realistically, they could only hold a maximum area of 10 by 10 kilometres. But their psychological effect was such that they had successfully sealed off an area almost fifty times larger.

Could the fear of crossing the Anjaneya-infested Dhimbam Hills have stopped Veerappan from visiting Muthulakshmi? If so, that was truly ironic. Perhaps Veerappan sensed that the STF was somehow involved. The mere thought was enough to scare him.

Whatever the reason, Operation Boston flopped. During the famous Boston Tea Party, chests of tea were dumped into the ocean. In this 'Boston', our hopes, plans and a lot of time and painstaking effort sank without a trace.

It was a demoralizing blow for those who had pinned so much hope on the operation. Fortunately, we got another crack at Veerappan soon.

Operation Inundation

August 2003

'All sources indicate that Veerappan is holed up within a 10-km radius of his village, Gopinatham,' I began, marking a circle on the map. 'Hidayatullah's debriefing has made it clear that Veerappan is getting fresh food whenever he crosses over to MM Hills. Can we choke his supply line? We can't dry up his civilian support, but how about flooding the area with multiple teams of our own...'

I broke off as I saw some of the STF officers trying to suppress their smiles.

'Is anything the matter, gentlemen?'

A brief silence, and then Hussain cleared his throat. 'I beg your pardon, sir, but there have been other big operations in the past that have achieved very little. The boys are a little sceptical.'

Their scepticism reminded me of the axiom: 'Tanks can't catch mice'. This was reinforced when the United States had carpet-bombed Tora Bora but Osama bin Laden had slipped away. In Kashmir, we would create huge cordons yet the target would manage to get away. We would then try to coax innocent men, women and kids with impromptu medical camps and subsidized canteens.

I knew Hussain was alluding to Operation Jungle Storm, a mammoth mobilization that the STF had carried out in June 2000. More than 1,000 men had churned the jungles for over two months under IG Balachandran, who had meticulously prepared the plan.

But Jungle Storm did not yield the desired outcome. Instead of actually scouring the dense forest, the teams got bogged down by the attempts to achieve daily targets for kilometres covered, villages visited and sources met. They stuck to beaten paths. Food was delivered by jeeps and vans. To collect it in time, the teams loitered near the pickup points, instead of performing in-depth patrolling. Most aspects of the operation were micromanaged and the local commanders' own tactics and initiative were mothballed.

There is an old adage that one should not confuse activity for progress. Unfortunately, despite the good intentions with which it was launched, there was hardly any progress. Within a month of Jungle Storm winding up, a far bigger storm had struck—Veerappan had abducted Rajkumar.

The previous year had seen huge sweeps by the Tamil Nadu Police to ferret out the bandit, be it Operation Vanamalai in 1989 or a decade later, Operation Tusker. But neither had been successful.

Despite a string of failures, I was convinced that if we persevered and changed the tactics, we would strike gold.

'I'm fully aware that so far it has seemed like a lot of sound and fury, but here is what I think we should do...' I said.

That was the launch of Operation Inundation. DSP Tirunavukkarasu, or Tiru, was its sheet anchor. This time, instead of sending large unwieldy patrols, we poured in fighting-fit, agile mini-teams equipped with GPS, night-vision devices and other gizmos. A significant part of the area covered fell under the Karnataka STF, but they were generous enough to allow us the tactical freedom to conduct the operation.

Though surprise, speed and simplicity were the buzzwords, there were two operational problems. First, the hills blocked the signals. We seldom received the signal, and when we did, it resonated from our walkie-talkies as garbled static. A weak signal is as bad as mangled code. Military legend has it that during World War II, 'camel ruptured' was read as 'Rommel captured'. The results speak for themselves.

Then a brainwave hit the police's whizkids—weak signals could be boosted by putting up unmanned repeaters atop the tallest and most inaccessible parts of MM Hills.

'What if the gang vandalizes the repeaters?' asked a sceptic.

'It will tell us for sure that they are in that area,' responded 'Ultra' Umapathy.

About 100 km away, overlooking Chennimalai (renowned for its cotton bed sheets), was a hillock atop which was a temple. Right next to it was a wireless station, part of a chain that provided the police network coverage. A portable repeater, the latest from Motorola's stable, quietly buzzed into life there. Suddenly, talking to a guy beyond the folds of MM Hills across the Cauvery felt like speaking to him next door. All my concerns were assuaged at that moment.

The next problem was graver. With so many small STF teams milling around in a small swathe, the odds of friendly fire had spiked radically, only aggravated by poor communication. The STF still recalled the tragic death of Ananjeya Kumar. The last thing we needed was another such episode.

This issue was resolved by extensive training and demarcation of responsibilities. The area was divided into 16 squares of 2 km by 2 km, with a kitchen for every six squares. Each square was allocated to two six-member teams—one on stand-to and the other on standby mode. In the STF's long history, teams had never had such small and well-defined turfs. Each team was in constant contact with the others. It was understood that if Veerappan attacked any team, the other thirty would rush in to its aid in overwhelming force.

Veerappan had a very cost-effective 'I-Com' wireless set—similar to the equipment employed by the LTTE, among others—that allowed him to tune into the STF's communications. His gang members had revealed in many a debriefing post-surrender that he could identify our personnel simply by listening to their voices. He particularly enjoyed the very chaste Tamil spoken by Karuppusamy. The bandit had apparently laughed heartily when an SP of the STF was nearly washed away in a flash flood.

But now Veerappan was flummoxed to hear only numbers and no words.

The STF had come up with a simple solution to counter Veerappan listening in. The over 60 sq. km that fell within these sixteen squares were divided into smaller squares. Then we superimposed an imaginary clock on the overall square for easy reference. We used clock positions

to refer to our locations, which were easily understood by our teams, but not by others listening in.

At a loss to understand the barrage of numbers, Veerappan now had to constantly worry about the direction of a possible attack by the STF. To add to his misery, the teams would sometimes deliberately lapse back into Tamil and pretend to have spotted his couriers, even when they hadn't. Veerappan was always on edge. After all, we were messing with his mind.

Another STF innovation was the use of Liquid Crystal Diode (LCD) on their caps during night patrols. LCDs, available in TV remotes, are invisible to the naked eye, but when seen through night-vision devices, they glow like stars. When the teams maintained strict radio silence at night, this innovation proved crucial in differentiating friend from foe.

Veerappan's spies, who tracked the movement of any man or beast in their neighbourhood, were rattled by our new tactics. They had never seen so many STF men per square inch. The six-member teams were too small to stage a massive raid, but were big enough to strike into the enemy's comfort zone and wreck his peace of mind.

In our attempt to employ the latest technology, we also engaged a tracker, meant to keep track of tigers, hoping that the sensor inside it would infiltrate Veerappan's camp. But this proved a disappointment. One time, a rifle that Veerappan's gang had sent out for repair reached the STF's armourer. The sensor was inserted in that rifle's butt, but the gang never managed to retrieve the gun.

However, our sustained efforts were boosted by some unexpected assistance.

One day, Karuppusamy came to me and said, 'Some victims of the gang want to help the STF.'

'How?' I asked

'By joining the hunt. They want six muzzle-loaders in return. Nothing more.'

We verified the antecedents of the six men. They were shepherds and hunters, village folk who had suffered at the hands of the gang. Soon, they were serving as irregular scouts for the STF. Their knowledge of the terrain and local customs was invaluable.

We also tried to draft dogs, mostly seized from hunters, into the STF

ranks. For a few days they outperformed the STF's trained Dobermanns and German Shepherds. But once they acquired a permanent government job, they became lazy and ineffective. We then decided to demobilize them and send them back to their masters. Ironically, their efficiency levels shot up again!

Initially, Veerappan had hoped that this was a brief exercise that he would be able to wait out. But as days went by, he realized that this was something else altogether. As the noose tightened around him, he retreated deeper and deeper into his lair. He and his men were forced to stop hunting, as they could not risk their gunshots being heard. He also stopped ordering hot curries from his village's popular non-veg eatery, which was now doing brisk business thanks to the STF boys.

On several occasions, the STF teams came within striking distance of his hideout, but years of living in the forest enabled Veerappan to evade contact. He was well aware that he was living dangerously and that the STF was closing in. It was just a matter of time.

We also reached out to boatmen, as we feared that Veerappan might try to cross the Cauvery back into Tamil Nadu.

Based on this hunch, the STF laid a series of ambushes on likely crossing points along the Cauvery's bank on the Tamil Nadu side. Sometimes, there were unforeseen consequences. Once, one of the boys lying in an ambush suddenly got up screaming after being bitten by a snake. Fortunately, he survived, though the ambush had to be aborted.

While Operation Inundation was in full swing, I was called in for a meeting to New Delhi. There, I requested helicopter support to supplement our efforts to flush out Veerappan. Though they agreed to make a helicopter available the very next day, nothing materialized. The STF chugged along in infantry mode.

But I wasn't dejected for very long. Mirji, the head of the Karnataka STF, called to tell me that his boys had managed to find a den that Veerappan seemed to have left just days ago.

'Want to have a look?' he asked.

The den was not far from the epicentre of Operation Inundation. It was extremely well concealed and offered a formidable defensive position. It lay 50 feet below a sheer rock at the peak of Mylamalai, one of the

MM Hills. On the other side was a precipice dropping almost 2,000 feet, directly to a huge flat rock.

All this while, we must have been visible to the gang! A barrack joke came to my mind, 'If the enemy is in range, so are you.'

To reach the den, one had to climb to the peak and then go down 50 feet. The descent had to be on all fours. With strong winds greedily trying to pry away one's precarious finger holds, it was not a place for the faint-hearted. As I gingerly made my way down, I thanked the police academy for teaching me the rudiments of rock climbing.

After the ordeal, I reached what looked like a natural cave. There was a small, shallow pool of sweet cool water. With enough rations, a small team could survive here for weeks. There were plenty of eggshells under stones, but no signs of regular cooking. The gang seemed to have been living on an enforced high-protein diet. I had seen some pretty impregnable hideouts in Kashmir, but this one would rank among the most sinister.

Why did Veerappan abandon this stronghold? The only conclusion was that he must have become either very restive or desperate, or both. This was heartening but also threw up a fresh worry. Would he stage another high-value kidnapping for leverage?

The STF's intel branch promptly listed five places in Veerappan's turf, all of which attracted several potential abductees.

In the east, Galibore near Sangam on the Cauvery topped the list. It was a famous fishing spot, known to offer the occasional 200-pound mahseer—providing excellent photo ops for avid anglers who often left the local fishermen guides richer with tips of at least ₹1,000. Thankfully, the gaming season was from November to March, so there would be no tourists there, as it was only August.

In the west was the Bandipur Sanctuary, home to the bison and the royal Bengal tiger, and hence, a big draw for foreigners. Just next door were the forest resorts of Masinagudi, nestled in the heart of the Mudumalai Forest. Popular Bollywood star Mithun Chakraborty owned a hotel and some land in the area and often visited it. Further west, close to our old beat, was the Isha Yoga Centre, which drew flocks of visitors. And lying cheek by jowl along the same foothills was the Salim Ali Centre—a

magnet for avid ornithologists from across the globe. Snatching someone from any of these places would be a cakewalk for Veerappan.

We debated about warning potential targets. But we were unable to narrow them down, considering their number. Finally, we decided against it, as we didn't want to spark panic. As a precautionary measure, though, we hand-picked some boys to watch each spot. But I constantly worried that a sudden strike by Veerappan could catch us flat-footed.

It was a nerve-racking time.

Fortunately for us, Veerappan himself was too exhausted to mount a counter-attack. His wishful thinking circled around a mutt leader near Mysore, but Mirji had subtly kidnap-proofed that target. With poor vision and low spirits, the bandit's first priority was to somehow get out of the STF's suffocating cordon.

On a quiet, starry night, he boarded a coracle and crossed the Cauvery into Tamil Nadu near Hogenakkal Falls. As he stepped out of his coracle into Tamil Nadu, Veerappan gazed at the grandeur of the Cauvery. Then he sighed and turned away. He would never again enjoy such a glorious view of the river.

In the early 1970s, communist revolutionary Charu Mazumdar had held a secret conclave near Hogenakkal Falls. According to murmurs in our secret service, Mazumdar, along with Kanu Sanyal, planned to take the Naxalbari movement across West Bengal and other parts of the country. As regards south India, two tri-junctions—Tamil Nadu-Karnataka-Andhra Pradesh in the east and Tamil Nadu-Karnataka-Kerala in the west—were identified as the areas for the potential development of this movement. Ironically, Veerappan too thrived between these two tri-junctions.

But we were unsure of the gang's landing spot or eventual destination—the sparse jungle along the dry Chinnar River. Across the river, our boys scoured the piece of turf that he had just vacated, checking every bush and rock, seeking a foe who had fled the scene just hours ago. Unknown to all, except a handful in the STF, we were running another operation in parallel. It featured a man code-named Trader.

And it was about to yield a handsome reward.

Planting a Mole

The phone buzzed once, and then stopped ringing.

'A missed call', wondered SP Shanmughavel, peering at the screen.

Tall, lean, slightly dark, a little shy and extremely focused, Shanmughavel held the fort at Mettur, the STF's original headquarters before it was moved to Sathy. An STF veteran, his call sign was SP-2 (Kannan being SP-1). Popular with his subordinates because of his habit of deflecting credit for his good ideas, he had learned not to get too excited or depressed by the constant twists and turns of the Veerappan saga.

Still, when SP-2 saw the caller's identity, he felt a jolt of excitement. A few minutes later, he reached the pre-fixed rendezvous point.

Two men waited there. One was a mason, who had been working on a school building in MM Hills for some months. It was hard work and the food, mostly gruel, wasn't appetizing. But he never complained. An industrious man, he was well liked by his fellow workers, none of whom were aware that he was an undercover STF constable.

'Pandikannan,' said SP-2. Then, he turned to the second man. 'And this is…?'

The stranger was burly, with thick curly hair. After he was introduced, SP-2 gave him the code name Trader, since he had once aspired to be a businessman. That nom de guerre would be used throughout Operation Cocoon.

He listened to Trader intently, and then gave me a call.

'Sir, I need to see you with a friend,' he said, deliberately keeping the conversation vague. 'Alone,' he added, with a slight emphasis on the word.

Shanmughavel was normally an unflappable character. But that day, there was a note of excitement in his voice, even though he tried his best to sound businesslike.

'The den, after dark,' I replied. Over phone, it's best not to be too specific.

That night, at 10 p.m., there was a knock on the door of my house in Sathy. SP-2, Pandikannan and Trader hurried in.

'Did anyone see you?' I asked.

SP-2 shook his head. 'I don't think so. I kept checking. But I'll do one more check before we leave.'

I nodded and turned to Trader. 'You have information?'

'I have met Veerappan and his gang in Kombutukki (near MM Hills),' he replied. 'It's the truth, promissa'. That expression meant that he swore on his life.

'How did you find them when the STF hasn't?' I asked, appearing sceptical.

'I didn't, sir, they found me,' he replied. 'I was riding my mobike along the (MM Hills) Ghat Road when Govindan stopped me. I feared he would attack and steal whatever I had, but the gang knew me because I am from the same clan as Veerappan. But promissa, I have never had dealings with him till now. However, Govindan knew all about me and my family—he enquired about my uncle and wife. Then he ordered me to follow him. What could I do? I obeyed.'

'So you saw Veerappan?' I prodded.

'I could only make out his silhouette,' replied Trader. 'It was dark. He was seated above me on a rock. But it was him. There's no mistaking that moustache.'

I spent the next two hours talking to Trader, using all sorts of tactics to test his information. Trader was an interesting character. He had studied till Class 12 and used a smattering of English words while speaking.

Finally, I concluded that his information conformed to our own intelligence.

'So where are they now?' I asked.

'I'm not sure of the current location, but they asked me to expect their call. Our next meeting would be across the river,' he said.

A mole either amongst cops or robbers is not unusual. But a mole inside the gang, that was a first. Trader, I hoped, would soon trade some inside information.

'I'm going to give you ₹1 lakh from our funds. I want you to help us,' I told him.

It was a princely sum for the man. Though it was six times the salary of Constable Pandikannan, it was an investment that would pay off if things worked out.

After a long show of protest, Trader finally accepted the money. He had an asthmatic wife and small children and the cash would come in handy. As he left flush with funds, his parting words were, 'Sir, I'm scared. My wife doesn't know. I'm risking my life because of Pandikannan.'

Shanmughavel and I attempted to understand the reasons that prompted Trader to spy on such a dangerous man. It was definitely not MICE—money, ideology, coercion and excitement-revenge. Shanmughavel insisted that it was 'just friendship'.

'Then why was he sweating so profusely?' I enquired.

'Sir, he was excited to meet you.'

'Well, that's exactly the same thing he said about his interaction with our *friend*. I hope he won't piss his pants at the crucial time,' I said.

I prayed fervently for him to keep his nerve during the decisive encounter with Veerappan. I was concerned about Trader's safety, though from my long bitter experience, I knew I could not guarantee it. But I was determined to try my best to protect him.

However, I was more anxious about my men's safety, considering that Veerappan had the ability to turn our source into a double agent. I had confronted a similar reality in Kashmir. Security forces were often deceived by the enticing baits provided by a 'sole source', many times with fatal consequences.

Over the next few weeks, the operation reached a critical stage. I asked Trader to report exclusively to Kannan. SP-2, who had brought him to me, was no longer part of this operation. A lesser man might have resented this, but he displayed true professionalism by accepting my decision without any fuss. He was aware that a puppeteer needed to ensure that the strings did not tangle. Pandikannan was also cut out of

the dealings with Trader. But he, too, accepted it with tremendous grace, despite the hard work put into the operation.

A few days later, Kannan called, 'Sir, we have contact. Trader has been summoned.'

Trader was escorted to the gang's new den by a fellow villager, nicknamed Red, the same Red who had access to Veerappan's camp. After taking Trader on a bus ride, Red got off at the next stop and handed him over to another guide.

Trader switched several more buses and guides before he was finally escorted to his destination by a short, hirsute fellow, unusually muscular for a man of the hills. Trader realized that he was near Hogenakkal Falls, barely 20 km from his starting point. But he was made to go through such a convoluted route that he had travelled over 200 km. The intention was clear—to shake off any pursuers.

Upon arrival, Trader mustered up the courage to take a close look at the gangsters' faces. He was shocked to see Veerappan looking utterly dehydrated and listless.

Govindan, almost a decade younger than the brigand, looked in far better shape. Though medium-built, he had strong shoulders and his eyes were constantly roving. There were only two others—Chandra Gowda and Sethukuli. The latter stood at a slight distance from the group. Quite clearly, he was treated as a sort of general handyman by the others. Even if he resented it, he kept it well concealed.

Trader's sly eyes swept the jungle palace of the famous bandit. He noticed a few plastic sheets, bed sheets and blankets and some aluminium and stainless steel vessels. They were mostly brewing tea. The aroma of dals or masalas from the open kitchen was conspicuous by its absence. The smell of some incense sticks wafted through the air. He saw some flowers, portraits and small idols of gods under a rock.

There were some fringe members and villagers who provided logistical support, but Veerappan now stayed in close proximity of these three, who had been with him for years. Even these four men never slept in the same spot. They would typically split up into two pairs and sleep at some distance from each other.

Trader greeted Veerappan respectfully.

Veerappan grunted, and then asked, '*Ean STF naiynga numma usiyerai edukarangoe*? (Why are the STF dogs making our lives hell?)'

Trader's heart almost stopped. He struggled to look calm, but his mind was racing. 'Does he know? Anything I say could backfire.'

He decided not to say anything unless he was forced. It proved to be a wise decision.

Veerappan did not suspect Trader. He just felt bitter and launched into a long tirade, concluding, 'MGR's nephew is coming here too often!'

He was referring to me. When I had served as SP in Salem district from 1983–85, a rumour had spread that I was related to the then chief minister M.G. Ramachandran. The closest link we shared was that my paternal grandfather and the CM's father hailed from neighbouring villages in Kerala, with no known record of any interaction. But the rumour refused to die down, despite my constant denials.

But it also revealed that Veerappan had done his homework on his enemies. It seemed that while I was tracking him, he was engaged in pretty much the same task.

Trader kept silent throughout the monologue, wondering when he would be given his instructions. But Veerappan dismissed him with a flick of his hand. 'Go. I'll call you again.'

Puzzled, Trader returned home. After waiting for a discreet period, he sent word to Kannan and briefed him.

'What do you make of it?' I asked Kannan.

'I guess they're trying to see if they can trust him,' said Kannan. 'But one thought is worrying me. Only a handful of us are aware of Trader's exact role. The STF is very active in that area. What if Trader is captured by one of our own?'

With Boston still fresh in my mind, I knew secrecy was paramount in this situation. 'We can't let too many people know about Trader.'

After much fretting, Kannan and I decided that whenever Trader visited Veerappan, we would direct the STF to conduct patrols at other locations.

But I felt a little concerned about Trader's safety whenever he went into the jungle. After all the risks he took, it would have been truly ironic—not to mention tragic—if he ended up on the wrong side of an

STF gun. Fortunately, that never happened.

After a few days, Trader was summoned for a second meeting. Again, he went through a circuitous route. The short muscular man was again present to guide him to the den, which was in the same vicinity, but at a different location. After a while, we began referring to the man who took Trader over the last part of the journey as Guide.

Trader and Guide stopped at a tea shop and picked up supplies before visiting the gang. Again, it was a short visit.

Govindan, who spent most of the time twiddling a needle, asked Trader if he could arrange for some new clothes for him, as his old outfit was rather threadbare. Veerappan handed an audio tape, full of misleading information, and asked him to make sure that it reached the authorities. On the tape, Veerappan claimed that he had long since left the MM Hills area and was now in Andhra Pradesh. Two years back, his tape had a reference to the PWG or the People's War Group—the Maoists of Andhra Pradesh.

Kannan and I glanced at each other when we heard the tape. 'At least he has admitted he was in the MM Hills area till recently,' I remarked.

But Trader confirmed that he was still around MM Hills, only across the river in Tamil Nadu.

Kannan and I briefly debated the prospect of staging a raid, based on Trader's inputs. But Veerappan never met Trader twice in the same location. He shifted camp constantly. After studying all the near-misses of the past, we decided not to proceed on intelligence that was not foolproof.

'We're still not getting any actionable intel from Trader. But the gang seems to be warming up to him. Let's give it some time,' Kannan nodded.

In any case, Trader seemed to be making headway, so we decided to be patient.

Sure enough, the third meeting provided a breakthrough. Trader spent a whole day and night with the gang and was able to observe them in some detail.

He noticed that Veerappan's eye problem was more acute and he often stumbled around. He was able to get close enough to overhear snatches of a conversation between Veerappan and Govindan. Though he couldn't get much, he did register words like 'eye problem', 'doctor' and 'guns'.

Then the two men noticed him and fell silent. Unsure of his next actions, Trader began to walk away, when Veerappan beckoned him. Trader walked up to the duo, his heart pounding painfully.

Veerappan looked him in the eye. 'You're of my own clan. Will you help me?'

Trader immediately folded his hands. 'Anna, don't embarrass me. Consider it done. Tell me what it is.'

Veerappan smiled and patted his shoulder. 'I want to get some guns. I have one friend in jail and another in town who might be able to help. I think you should meet the man in jail. His name is...'

Before Veerappan could finish, Govindan interrupted. 'First we should find out what happened to the last consignment, no?'

Trader looked at Veerappan to gauge his reaction. But Veerappan just nodded. 'Yes, you have a point.'

It was an eye-opener for Trader. He realized that Veerappan had become so dependent on Govindan that it was the younger man who increasingly called the shots. This was what Hidayatullah had also told us in his debriefing. Veerappan explained that he had paid ₹5 lakh to someone as an advance for a large consignment of guns, but the man had run away.

'The bastard bore a hole in my ears,' said Veerappan, using the local idiom for being stabbed in the back. His voice was throbbing with emotion. He was furious at being defrauded, but what hurt him even more was his helplessness to retaliate.

Trader made sympathetic noises. 'What can I do to help?'

'There's a periyavar (elderly man) who lives near Trichy. He knows everything going on in the underworld. He might be able to shed some light on where that traitor went with our money,' said Govindan.

That night, Veerappan was in a chatty mood. He conveyed to Trader that he missed his family terribly. He said that he had planned to meet his wife and daughter at a location near Ooty, but it had to be cancelled at the last minute.

It was a clear reference to Boston. When Trader told us about it, we knew he had received the information straight from the horse's mouth. One more jigsaw piece fell into place!

Before Trader set off to meet the periyavar—christened Old Man Woz by the Phantom-comic-crazy members of the STF, Kannan and I met him at a rendezvous point in an unmarked vehicle.

Kannan produced a listening device. Trader recoiled as though stung by a real bug.

'What's that?' he asked, his voice quivering.

'It will help us listen in on everything,' said Kannan in a soothing tone.

Trader's sweat glands went into overdrive. I patted him on the shoulder and said, 'For me, you're no less than any brave policeman. Think of yourself that way.'

Trader gave a wan smile, but continued to perspire profusely. I gestured to Kannan and we stepped a little distance away.

'Are you sure?' I asked in a low voice. 'What if he's searched? They'll kill him if they find it, provided he doesn't die of a heart attack first. He seems really scared.'

'Even if they don't search him, he's so terrified he might blurt it out himself,' acknowledged Kannan. 'Let's drop it.'

We went back and told Trader that he didn't have to take the device along. He looked visibly relieved.

Trader duly met Old Man Woz, who turned out to be blind, though extremely sharp. But the trip failed to unearth any information of interest to either Veerappan or the STF. Kannan and I were hopeful that when Trader returned from his next trip he would mention the name of the contact that Veerappan wanted him to meet in jail.

Instead, Trader returned with a bombshell. Apparently, Veerappan wanted him to meet a certain gentleman—let's call him Mr X—who lived in a large city.

According to Veerappan, Mr X had links with certain Sri Lanka-based Tamil radicals, and could use them to procure guns. Veerappan also wanted him to pull some strings and arrange a cataract surgery.

When Trader mentioned Mr X's name, my eyes widened in shock. Trader hadn't heard of Mr X before, but Kannan and I had. He was a prosperous man with a reputation for being an honourable citizen. If he had a seamier side, he had masked it for years. News that he had links

with both a dangerous criminal as well as anti-India elements was quite a revelation.

Kannan and I quickly hatched a plan.

It was based on the new developments—Veerappan's keenness to meet an influential man across the straits, the deteriorating condition of his eye that had to be examined by a doctor outside the jungle and his failed attempt at acquiring guns and possibly even foot soldiers. We had to refit the pieces into a new puzzle.

Trader called up Mr X, briefly introduced himself as a friend and asked for a meeting. Mr X asked for the password, which Trader had been told by Veerappan. After confirming that Trader was indeed Veerappan's emissary, Mr X called him to a guest house in another town.

This time we wired up Trader, with the assurance that a crack STF team would be on hand to immediately step in if something went wrong.

'What news of Anna?' asked Mr X, the moment Trader stepped into the room.

'He's well, but he needs help. Can you get him to an eye doctor and arrange for weapons from your contacts in Sri Lanka?' asked Trader.

'I need a few days. Tell him I will send a message through one of my men,' said Mr X.

The moment Trader left the guest house, a team of tough-looking men in plain clothes burst in. One of them introduced himself as an STF officer.

As soon as Mr X saw them, he turned ashen. He sat down heavily upon a couch and began sweating profusely. It was a wonder that he managed to hide his underworld dealings for so long. He would have made a lousy undercover operative.

'What are you going to do to me?' he whimpered.

He was told he only had one hope—if he helped the STF nab Veerappan, perhaps a favourable deal could be negotiated for him.

Mr X pounced at this opportunity like a drowning man at a straw. 'Anything. Just say it. I'll do it. But spare me, please.'

'Good, now listen,' the STF officer told him. 'After a few days, send one of your men to Veerappan. This will give credibility to your message. Tell him you have made contact with your friends in Lanka. They will

be sending a man who will escort him to Trichy or Madurai to get his eye operated, after which he will be taken to Lanka. Once the arms deal is done, he will be brought back to India.'

'Who is this man who will be the escort?' queried Mr X.

'Not your concern,' the officer replied. 'Send this message and your task is done. And no tricks. I doubt a court will be lenient if it chances upon your CV.'

Mr X's eyes darted around the room, but he had little choice. 'You won't kill him, will you?'

'We will make every possible effort to capture him alive,' the officer assured.

Mr X buried his head in his hands and his shoulders shook. After a while, his words came out, muffled but irrevocable.

'Fine, I'll do it.'

A few hours later, Kannan and I were discussing our next action.

'If we're planting a mole, it will have to be someone not only unknown to Veerappan, but even to most of the STF. In addition, this person will have to be discreet, courageous, resourceful and a skilled marksman. Quite a tall order,' fretted Kannan.

I wracked my brains for a suitable candidate. Then, I remembered Durai—who had been imported from Trichy to tackle Veeramani when I was Chennai Police Commissioner—and his dramatic encounter with the gangster at Marina Beach.

'I have just the man,' I smiled.

Enter Hitman

July 2004

Durai sat perfectly still, but his eyes darted constantly. Left to right, then the other way around and back again. He struggled to see through the near-total darkness of the moonless night.

'What am I doing here?' fretted Durai.

He had never seen a jungle in his life, at least not in such a daring role. Now he was sitting on the fringe of a forest with only Trader for company, waiting to rendezvous with Veerappan's gang. In a few short days, he had become the pointsman of a complex, twenty-year hunt for a man who knew the terrain very well.

The weight of the responsibility pressed down on Durai and, for a moment, he felt like he was choking. He hadn't bargained for this when he had got a call asking him to join the STF the very next day.

An unmarked car had picked up Durai from the Sathy bus stand and had taken him to the STF firing range. There he found himself to be the sole trainee, polishing his long-honed skills against a dozen targets, mostly cardboard caricatures of Veerappan—a standard practice—under the supervision of a retired Tamil Nadu Special Police inspector, Swaminathan.

There was an array of weapons, but he focused on the 9 mm Browning and a Heckler & Koch sub-machine gun of the same calibre.

The brief training he received on jungle survival felt pathetically inadequate.

'I can't do this,' he thought, panic stirring. But then he steeled himself, remembering my briefing. 'It's a tough and risky assignment. It's not that we don't have guys in the STF. But you're unflappable. That's why I chose you,' I had told him.

Squatting on his haunches, he spat out sputum and blood. His wife had called me to complain that he was neglecting his health. And even though I urged him to take better care of himself, we both knew that that was impossible in the midst of such a tense operation.

Sitting next to Durai, Trader was startled. Guide emerged noiselessly from the darkness. 'This is the one?' he asked, pointing at Durai.

Trader nodded. 'Yes, he's an arms dealer. He can be useful to Anna.'

Guide stared at Durai from head to toe. Durai looked back, unflinching. After a while, Guide signalled for the men to follow him. Durai and Trader exchanged glances. Then Trader nodded, and the two men set off into the forest after their guide.

About a kilometre behind Durai, two teams of the STF followed, one led by Rajarajan, the other by me. We walked cautiously, taking care not to make any sudden noises or trip on rocks, shrubs and slippery pebbles that littered the path.

Durai dropped 'glow sticks' every 100 metres or so. Seen through night-vision goggles, they lit up the trail, pretty much like Hansel's pebbles from the fairy tale 'Hansel and Gretel'.

After a while, the sticks disappeared. Durai had obviously made contact. Our tension levels began to rise. The experienced trackers came forward and began to follow the foot trail left by Durai and the others.

Meanwhile, the three men reached a dried-up stream. Guide gestured them to wait.

Durai tapped his wrist and turned both palms upwards, as if to ask, 'How long?'

Guide shrugged and turned away.

It turned out to be a long wait.

At around 3 a.m., Trader lost patience and knocked a small stone against a boulder thrice, at intervals of half a minute. The answer was supposed to be three firm knocks by a wooden stick on a tree. The men strained their ears to detect any sound. There was none.

Durai peered into his water bottle. All that remained was a few drops and some green leaves, which the STF believed would reduce the sloshing sound of water. There were also some biscuits, but he did not eat, as there was no water to wash down the crumbs.

As if reading his mind, Guide pointed to a puddle of yellow water nearby. Durai shuddered and turned away. Guide grinned thinly.

Minutes ticked by with agonizing slowness. Suddenly, Durai retched and threw up. He put the last few precious drops of water on a cloth and dabbed at his lips, trying to wipe away the bitter taste. Bone-deep exhaustion settled over him as the darkness faded away to be replaced by the glorious colours of dawn. Guide signalled that it was time to leave. Durai stood up, wincing. He felt as if his feet had turned to lead. He was not sure if he was frustrated or relieved that the gang had failed to appear. Guide bared his teeth in a smile. His teeth, sharp and yellow, reminded Durai of a predator. He spoke the first words in many hours. 'Be patient. We'll meet again.'

Over the years, the STF had got used to Veerappan's sudden changes of plan. So it didn't surprise us that he had not kept his appointment. He had probably watched the three men to see if there was any suspicious activity on their part. Our hunch was confirmed much later.

Durai left for Chennai the next day for the long-delayed medical examination. Within two days, Trader hinted that the gang had asked him to bring the arms dealer back to the jungle with him the following week.

Durai's treatment was put on hold once again as he rushed back to Sathy.

On 27 July, Trader, Guide and Durai made one more foray into the forest. It was exactly one year since the encounter in Chennai that killed Veeramani. Durai took that as a good omen. The rendezvous point was between the Chinnar River and the small town of Pennagaram.

The jungle did not pose as many challenges to Durai this time, but he felt like he was being watched. They waited in the shadows of a huge tamarind tree.

Suddenly, two shadows moved. Two human beings. Reflexively, Durai's palm caressed his gun—his inanimate buddy and reservoir of reassurance. He looked at Guide to check if he knew the men. Guide

looked blank, while the two men shrank back and beat a hasty retreat, clearly unnerved by the sight of three strangers in the forest.

In that moment, Durai missed the babble of city life. 'Anything is better than this eternal waiting,' he thought. 'I'd even welcome a gun battle to break this monotony.'

His wish wasn't granted. Again, the whole night went by without contact.

Finally, Durai looked wearily towards Guide and raised his eyebrow. Guide gave a resigned nod. Durai stifled a groan and rose to his feet.

'My day will come,' he consoled himself as he walked away.

Contact, at Last

October 2004

Kannan burst into my room, ecstatic.

'Sir, good news. The gang has reached out to Mr X again. They've asked him to meet their emissary at a tea shop in Dharmapuri.'

I looked up sharply. It had been over two months since Durai's last failed attempt to meet Veerappan. The trail had gone completely cold thereafter.

In that period, Mr X proved his utility in another clandestine op. This time, we used Kannan's father as our courier, since we didn't want to send someone who looked even remotely like a serving STF personnel. Well into his sixties, but fit and alert, Kannan's father, retired Indian Air Force officer Navaneetha Krishnan, did an excellent job. He collected the package, took all necessary precautions to ensure that he was not being followed and completed the mission successfully with the aplomb of a trained agent.

The news of fresh contact with Mr X ended the agonizing wait for both Kannan and me.

'How did they get in touch?' I asked.

'Remember Blanket?' asked Kannan. 'He had agreed to become our informer if we took care of his child's education. By a stroke of luck, the gang picked Blanket as the courier to deliver the message to Mr X. He told us. But Mr X told us without any prompting as well. So, we have the same news from two different sources and neither is aware that the

other has informed us. It doesn't get more reliable than this.'

'It seems like they've decided to cut Trader out of the loop,' I said. 'Let's keep an eye on Mr X in Dharmapuri. Have a few guys in plain clothes take turns to shadow him. Only one person should not be seen hanging around him for too long.'

On 16 October, Mr X turned up at the tea shop at the assigned time. He took care to avoid flaunting his wealth. A little later, Red sidled up and asked if the bench opposite him was taken. When assured that it wasn't, Red sat down and ordered a glass of tea, ignoring Mr X all the while. After a few minutes, the tea arrived. Red took a couple of sips, and then asked Mr X to pass the sugar lying in front of him in a small bowl. Mr X passed it across.

'You're new to this town, aren't you?' said Red.

Mr X played along. 'Yes, I'm just passing through on some work.'

To an onlooker, it appeared like two strangers were making polite conversation.

After a while, Red dropped the charade, leaned closer to Mr X and spoke in a low tone. 'Anna is ready to come out.'

'Where the hell has he been?' demanded Mr X. 'Why didn't he meet the man I sent?'

Red shrugged. 'You know Anna. He likes to double- and triple-check. He wanted to make sure this fellow could be trusted. He observed him from afar and he's quite satisfied about your man's credentials. But there was too much STF activity in the area. Things are slightly better now.'

'And where's that fellow who brought his message to me initially?' Mr X enquired, referring to Trader.

'His job is done. There's no need for him to know anything more about Anna's plans,' said Red curtly. 'Now, if you're done with your questions, can I give you Anna's message?'

'Of course,' backtracked Mr X hastily. 'What is it?'

'Anna will come out on 18 October. Your man should wait at the junction near Papparapatti Police Station at 10 p.m. If he doesn't hear from us that day, he should come again on 20 October, and then on 22 October. Your man will be taken to Anna.'

Then, Red looked around to ensure that nobody was watching and

took out a lottery ticket. He showed the ticket to Mr X. It was numbered 007710. He tore the ticket in half with a dramatic flourish and handed over one piece to Mr X. The numbers on it were, rather appropriately, '007'! He retained the other half, with the numbers '710'.

'This will serve as Anna's travel ticket. When your man meets ours, they should match the edges. Arrange for a vehicle to bring out four people.'

'There will also be my man and possibly a driver. So, that's six. It will have to be a large vehicle,' said Mr X. 'An ambulance? It can move at high speeds without arousing suspicion and cops are less likely to stop it.'

That suggestion was the result of discussions between Kannan and me. Anticipating Veerappan's necessity for a getaway vehicle, we thought of various options, including a car, jeep and SUV. We even discussed the possibility of sticking a label like 'Govt' or 'Press' on the vehicle, or putting a political party's flag on it, since cops tend to be wary of inspecting such vehicles. Finally, after much deliberation, we decided that an ambulance would be ideal. We code-named it Cocoon—with the fervent hope that Veerappan would be cocooned in it and unable to fly away. Mr X was then briefed that he should propose an ambulance in the event of any discussions on a possible evacuation plan. Red nodded. 'That's a good idea. Just make sure both the vehicle and your man are there on the assigned date and time.'

The two men noted the full lottery ticket number on separate scraps of paper. Then Red drained the rest of his tea and left just as abruptly as he had arrived.

Mr X drove out of Dharmapuri in his personal vehicle. An STF team followed him in a civilian Omni van. After he had travelled a fair distance, the van overtook him at an isolated spot and signalled him to pull over.

Kannan emerged from the van and walked up to Mr X. 'How did it go?'

Mr X quickly debriefed him and handed over the torn ticket. 'I've done my part. Now please leave me alone,' he begged Kannan with folded hands.

Kannan smiled as he saw the ticket stub with '007' on it. When he

observed that the last two digits on the stub were '07', he asked, 'What are the first two numbers on the other half?'

'71,' replied a puzzled Mr X, referring to his scrap of paper. 'Why?'

Kannan's smile grew wider, but he didn't say anything. Later, he told me, 'My father's first car had the number 0771. It served us faithfully for many years and never broke down. I have a good feeling about this.'

The Longest Day

18 October 2004

I'm normally a sound sleeper. At home, with my default alarm Meena around, I usually sleep like a log.

'I hope it's not the same in the jungle. Don't let Veerappan carry you off while sleeping,' she would often tease me.

'Not an issue. My buddy in the next bivouac has sharp ears,' was my weak riposte.

But the previous night was different.

I peered bleary-eyed at my bedside clock. It was 4 a.m. I shut my eyes and willed myself to go back to sleep, but realized that I was wasting time. At least the little sleep I had managed to get had been restful. I swung out of bed, trying to make as little noise as possible so that I wouldn't disturb Meena. I needn't have bothered. She was up a few seconds later.

'Everything okay?' she asked, displaying the kind of telepathy that most wives, but very few husbands, seem to develop with their spouses. I nodded.

She looked at me, unconvinced, but said, 'I'll get you some filter coffee.'

I began my morning routine with the rather noisy ritual of gargling with 10 ml of gingelly oil for 20 minutes. It is done first thing in the morning before brushing one's teeth and is believed to detoxify the system. I can certainly vouch for the fact that it acts as a great mouth freshener.

Today, though, I abandoned that process halfway. There was just too much going on in my mind.

I sat at the dining table as Meena brought the coffee and sat with me—a quiet, reassuring presence. As I sipped the coffee, I felt an immense sense of gratitude to her. Our daughter Ashwini was in Chennai, devastated by the premature death of our Golden Retriever. But my wife had left her alone in her grief to provide me support in Sathy.

I owed her a lot, but I couldn't find the words.

As I finished the filter coffee, I simply said, 'Thank you.'

It wasn't just for the beverage. She smiled, 'All the best.'

I had not discussed Operation Cocoon with her, but she knew me well enough to understand that something big was underway.

By 6.30 a.m., I left for Kannan's. A series of meetings were lined up for the next two hours. First up were Saravanan and Durai, who were introduced to each other and briefed thoroughly.

Then Nawaz, Rajarajan and Hussain came in separately and were briefed. Over the phone, I also spoke to SP-2, DSP Tiru, Sampath and Inspectors Kandaswamy and Karuppusamy.

At this stage, my orders to the team, except Kannan, Durai and Saravanan, were clear—everyone needed to gear up for an intense training exercise. By now, they knew my endless harangue about training being a bloodless war. I knew they would excel.

By 10 a.m., I was at my office like any other day. I browsed through the sitreps or situation reports, which mentioned details of some medical camps and unconfirmed reports of the gang's movements. Luckily, there was nothing happening around our rendezvous point. Any kind of action there might have led to police presence, which would have impeded our mission.

I went through the video I shot the previous day of the probable scene of action. It was a habit I had picked up while in the SPG. I viewed everything clearly—Kannan driving the Maruti and the tinted windows slightly pulled down, the one-room school, the big trees and the traffic.

There was a horse and monkey Feng Shui charm on my desk. 'It's for those in the armed forces and police,' a Chinese vendor in Kuala Lumpur had told my son Arjun, who had gifted it to me.

'Let's see if it works,' I thought. 'After all these years, the STF could do with some luck.'

For operational secrecy to be maintained, it had to appear like any other day at the office. The STF had organized a huge medical camp the previous day. I met the doctors to thank them. Then I left for the firearms range.

Just as I was leaving, Kannan came up to me and whispered sotto voce, 'Bunker is GO. Sweet box is loaded with sugarcane.'

I nodded and got into the jeep. At the range, three teams were engaged in firing from the sandbag redoubts they had just erected. I commended them for the phenomenal hits they managed to achieve. Later that day, I stopped at the Bannari Temple.

In the afternoon, I tried to catnap for thirty minutes. A lifetime of police work had taught me the importance of a good siesta and I could usually fall asleep the moment I shut my eyes. But not that afternoon.

By 5 that evening, I was out of Sathy.

It was dark as I neared Mettur. I thought of Walter Davaram, who had launched the STF right there eleven years ago.

I wore my favourite jeans and green tee and constantly touched an Ayyappa medallion in my wallet. There may have been times when I didn't have any cash in it, but the medallion has been a constant since 1993, when I first wore it on a beaded chain during my pilgrimage to Sabarimala. The medallion has seen me through all ups and downs, providing solace during failures and urging me to express gratitude to God for my triumphs.

I was in a Tata Sumo—the same one that Walter had used—with the driver, who should have rightfully been in the Formula-1 ranks. I signalled him to take it easy. I didn't have to reach too early. The Sumo's windshield had a sticker that said 'Guruvayurappan Travels' in bold black and gold letters. My AK rested on my lap, while the 9 mm was tucked into my jeans.

Kannan had left Sathy much before me in a red Omni; part of the STF's hidden fleet. Other vehicles packed with men and materials converged towards our rendezvous point—an inspection bungalow in Dharmapuri. The most important vehicle, however, was on its way from

Coimbatore—the modified 'ambulance' code-named Cocoon.

Clad in a crisp white shirt and trousers, Saravanan sighed in relief as he finally exited the congested streets of Coimbatore. Cocoon's drive from Coimbatore to Dharmapuri was about four hours. He was at the wheel of his favourite Tempo Traveller, which belonged to the STF's Intel wing.

Saravanan had driven the vehicle numerous times. But over the last five days, it had been transformed beyond recognition. 'Ultra' Umapathy, our resident gadgets' expert and Saravanan kept a close watch as numerous modifications were made to the vehicle.

The vehicle was remodelled at a nondescript workshop in north Coimbatore. The only distinctive feature of the place was its name— Kannan Workshop.

We took that as a good sign. The mechanics had ticked each box of a long checklist without asking questions. Saravanan stuck to the vehicle like a limpet, living mostly on tea and samosas and even spending his nights in the van.

A huge revolving front seat—resembling the VIP seat of an executive jet—which had been used by several senior STF officers, was removed. The rear seat was realigned. A plywood partition was put in to separate the front from the rear, but with a peephole. A stretcher was added, as were three portraits of deities. Lord Venkateswara in the middle had a camera fixed on his forehead, to pass on real-time information to us. A revolving blue lamp was fixed on top of the vehicle, and extra fog lamps were installed.

As Saravanan drove contentedly, his eyes briefly rested on his fellow passenger, sitting as still as a statue, his bulging biceps resting on the window.

The two men had met in Kannan's room that morning. Kannan and I had called in Saravanan first. As per the original plan, Saravanan was not supposed to drive the vehicle. His role was to end with overseeing the makeover, after which he was to hand over to another driver.

Saravanan was smart and quick-witted, but there was a softness to him that worried me—the reason I believed he wasn't the right man for the job.

However, when Saravanan realized that there was a very real possibility of him being separated from his beloved van, he politely but

adamantly indicated to me that the separation would happen over his dead body!

It was a matter of honour for him. He swore he would not let his STF comrades down, no matter how dangerous the mission. I relented, though I must confess, I continued to doubt my decision during the tense hours that followed.

Once it was settled that Saravanan would drive, Durai was called into the room and the two men were introduced. They were told about the pickup point and Cocoon's ultimate destination. This was the most crucial part of the briefing, so we were deliberate. There was absolutely no room for any margin of error.

Kannan and I addressed all the queries. There weren't too many. The questions were asked and answered mostly in monosyllables.

Durai and Saravanan only knew that some dangerous people were to be escorted in the vehicle. But the identity of those people was not revealed. I thought I saw a glimmer in Durai's eyes. Fresh from two recent forays, has he caught on?

By 8 a.m., Durai and Saravanan slipped out of Kannan's room and were taken to the workshop. Last-minute changes were still being carried out. There was a latch on the rear door to lock it from the outside, but we decided to remove it as it could make the gangsters suspicious.

Once the latch was removed, the two men inspected the vehicle closely, running through their respective checklists. It was time to eat— their first and, as it turned out, only meal of the day.

They managed with curd rice from a rundown joint opposite the workshop and returned to see to the final touches of the makeover.

Paint was being sprayed over a stencil. When cleaned up, the words stood out boldly on both sides in bright colour: SKS Hospital, Selam.

Durai smiled, turned away and then whipped around. 'Oh hell!'

'What?' asked Saravanan, anxious.

'Salem has been misspelt,' pointed out Durai. 'Our target may not spot the mistake, but we don't want to attract anyone's attention en route.'

The two men huddled with the mechanics. Could it be fixed? Yes, but it would take a while.

'We don't have much time. We'll take our chances,' Durai took the call.

Saravanan scrubbed Cocoon clean one last time, quickly bathed and put on a fresh set of clothes. He carefully applied kumkum (vermillion) to his forehead and said a quick prayer. The two men then set off.

It was already 5 p.m.

Saravanan did a quick calculation. He could reach Dharmapuri well in time even if he cruised along at 60 kmph.

Occasionally, he tried to talk to his passenger, but soon realized that despite his toughness and quiet competence, conversation was not his forte. Saravanan shrugged and shifted his focus back on the road.

'I just hope we don't get stopped by a police party,' he thought.

In the worst-case scenario, he could always call me or Kannan, but that would completely jeopardize our operational secrecy.

Meanwhile, Durai went through his calming ritual. He tapped his shoulder, hip, thighs and heels again and again, obsessively, in a perpetual loop. To break the monotony, he started checking his wireless set, earpiece and stun grenades. The maximum attention was reserved for his MP-5 Heckler & Koch sub-machine gun and his 9 mm Browning. Right at the end, he tilted his head to look at a slot in the partition beneath his seat and nodded. Perfect to slip in a stun grenade that would leave the targets disoriented.

Satisfied, Durai leaned back and settled into a meditative trance. It was disturbed only as the vehicle crossed Thoppur Ghats, when his phone buzzed. He listened intently, but only grunted a couple of times in reply.

Saravanan waited to be told about the details of the call. No information was forthcoming. He shrugged and kept driving, without taking any break, either to pee or for tea.

A little while later, they reached the outskirts of Dharmapuri.

Saravanan, a native of the place, knew the road would soon fork into two—one towards Bangalore, and the other towards Chennai. Just before the vehicle reached the fork, Durai signalled Saravanan to stop.

They parked Cocoon in the shadow of a massive tamarind tree and boarded a red Omni that had been waiting for them. The vehicle took them to the rendezvous point—Dharmapuri Traveller's Bungalow—where all of us had already reached. This was the base camp from which we would launch the final assault.

The Longest Night

I was at the Traveller's Bungalow in Dharmapuri. All cell phones were switched off, as a call from home could paralyse an otherwise combat-ready operative. Later, we were informed of a call that had left Sub-Inspector Rajesh Khanna 'tele-paralysed'. His wife had got her mangalsutra entangled in a nail on the bed and was worried about his safety.

I looked around. It was time for the final briefing, which assumes critical importance, since every mission has a definite target. But I was faced with the onerous task of conducting the briefing without disclosing the target in an attempt to ensure ops secrecy.

I was suddenly overcome by a sense of guilt. Was I not pitting the Cocoon team of the STF against the rest? Was I not endangering the lives of Durai and Saravanan? What if any team member made a wrong move? Things could spiral out of control with the mere twitch of a finger, a slight shuffle or even a wink.

Even before I could unveil the op plan, Hussain and Rajarajan realized that this was anything but a routine exercise.

Hussain had been in Chennai, on leave for the holy month of Ramadan, when he was recalled. Though he had reported back immediately, the thought of his leave being cancelled for a mere training exercise must have rankled him.

But his qualms, if any, disappeared when I revealed that some gangsters or smugglers would be travelling in that vehicle that night.

A smile lit up his face. Clearly, he was happier being here than with guests at home, tucking into succulent Iftar dishes. 'Hussain, ensure fire

No. 1, Church Street, Bengaluru - 560 001.
Mobile : 98450 76757, 99647 46222
E-mail : kris.bookworm@gmail.com

To

No. 21562

Date :

Sl. #	Particulars	Qty.	Rate	Amount Rs. Ps.
	Veerappan			320
	Total			320

Rupees.....................................

For The Bookworm

restraint, if it comes to that,' was all I said to him. After all, if even one chap pulled the trigger too early, it would be disastrous for Durai and Saravanan. They would be facing a firing squad at point-blank range.

Rajarajan too seemed to be bubbling with energy all of a sudden. He moved around, talking to his men, and putting some of them through the 'jump test'—which you fail if any object on you clinks or rattles when you leap.

SP Chinnaswamy was busy handling all logistics.

As I observed the men, Kannan whispered into my ear, 'Cocoon has arrived.'

I nodded to him to go ahead. He slipped away towards the rear compound wall. Durai and Saravanan stepped out of the shadows and greeted him. They declined Kannan's offer of a quick meal of bread and apple. Kannan passed the torn scrap of paper with the incomplete lottery number on it. Durai nodded and tucked it into his pocket. He also wore a green tee.

I came out to have a quick chat with the two men. Their demeanour indicated that they were determined to do their best. Kannan looked at me enquiringly. The moment of truth had finally arrived.

'Go ahead,' I said.

Kannan then finally revealed the identity of the people they would escort.

Durai's visage remained expressionless. But there was a burst of feverish excitement, mingled with considerable anxiety, on Saravanan's face. He quickly composed himself and looked me in the eye. No words were exchanged, but the message he conveyed was loud and clear: 'I won't let you down.'

I nodded, mentally taking the driver's seat in Cocoon.

The duo boarded the Omni, now suffused with the fragrance of biryani packed in vessels. In addition were bottles of buttermilk and containers carrying fruits and dry fruit. All the stuff was quickly transferred to Cocoon.

Saravanan and Durai then left for their next stop near Papparapatti Police Station. It's unlikely that Veerappan would have read Edgar Allan Poe's *The Purloined Letter*, but he followed the same principle—letting

his conduit and the getaway van hide in plain sight, as that was the last place anyone would expect to find him.

The driver wasn't too sure about the wisdom of this strategy, and his apprehension rose as he saw four cops hurriedly cycling out of the station. Two of them headed towards Cocoon. Saravanan anxiously turned towards Durai, who remained deadpan as usual.

'Relax,' muttered Durai. 'They will not use bicycles if they want to nab someone barely a stone's throw away.'

Saravanan bit his lip. The cops cycled past. He realized that he was holding his breath. He exhaled gently and said a silent prayer.

Durai got down and stood by the van. In his peripheral vision, he detected a movement—a man emerged from the shadows to the left and advanced towards him. At first, Durai thought that it was Guide, who had escorted him on his abortive attempts to contact the gang. On closer inspection, it was somebody else, but Durai guessed that like Guide, this man too was probably a local tribal, perhaps even related to him.

The man approached Durai and cleared his throat. He proffered the torn lottery ticket. Durai rummaged through his pockets and produced his own scrap. The two pieces were placed together to form the number '007710'. The stranger smiled thinly.

'Hope it proves to be the winning number tonight,' thought Durai, careful not to let his feelings show on his face.

Durai and the stranger entered Cocoon. Saravanan revved it up and drove about 4 km. As the vehicle neared a water tank at the fringe of the village, the stranger motioned 'stop' and jumped out while the vehicle was still in motion.

Durai and Saravanan stood by the van. 'It's up to us now,' thought Durai. 'Would the target come out tonight?'

He had been given three possible dates: 18, 20 and 22 October.

'Just come out now and get it over with,' Durai prayed. The thought of possibly having to do this twice more was unbearable and also increased the risk of failure.

As they waited, two figures emerged from the bushes nearby. First was Sethumani, followed by Chandra Gowda. Both peeped into Cocoon and inhaled deeply, savouring the rich aromas emanating from the vehicle.

Durai observed them out of the corner of his eye, but his attention was focused on the bushes.

Then Sethumani and Gowda signalled towards the bushes.

Time seemed to stop for Saravanan and Durai as a tall, wiry figure emerged. His handlebar moustache had been trimmed, but there was no mistaking his identity. Saravanan felt the strength going out of his limbs. He glanced nervously at Durai, who studiously ignored him. Instead, Durai looked at Veerappan and joined his palms together in the traditional vanakkam (namaste).

Checking his rising panic, Saravanan mimicked Durai. Then, he held the side of the van and literally dragged himself to his seat. Once in the seat, he gripped the wheel firmly and stared straight ahead. He felt some strength return to his limbs.

A couple of minutes went by, but none of the passengers got on board. They seemed to be waiting for something.

'Are they getting suspicious?' wondered Saravanan, his blood pressure rising rapidly at the thought. Desperately trying to conceal his anxiety, he prayed for divine intervention.

Luckily, the gangsters did not notice Saravanan's state of mind. Even if they did, they would have perhaps attributed it to the understandable awe anyone would feel in Veerappan's presence.

Just then, Govindan emerged. He stayed behind to make sure nothing went wrong when the three men boarded the vehicle. He was followed by some other unarmed men. 'Take Anna safely,' said one of them.

Durai's right eyebrow arched ever so slightly. None of us had factored in a see-off team. While the core gang may have been reduced to four men, there were still sympathizers providing cover. 'I hope there are no other surprises tonight,' thought Durai sourly.

It emerged later that our mole, Blanket, was also part of the group. Of course, neither he nor Durai knew of each other. Blanket asked if he could get a lift and be dropped off along the way.

'No,' said Durai. 'I was told four men. I'm not making any changes.'

Govindan nodded. 'I agree,' he said.

Blanket didn't know it then, but Durai's decision may well have saved his life. What if he had been on the vehicle when we intercepted it? A

'yes' or a 'no' can often separate life from death.

The four men scrambled on board and took their seats. There were two rows facing forward, and in the last row, one seat faced sideways. The seat opposite that had been removed, creating space for a stretcher and some food packets. Govindan sat in the seat facing sideways, AK-47 in position, while the others occupied the two rows in front. Sethumani and Chandra Gowda sat to the left and right in the middle row, while Veerappan sat alone in the front one.

Durai closed the door firmly and turned on his heel concealing the excitement that suddenly flooded through him. It was an indulgence he seldom permitted himself.

Then, with the sudden release of the clutch, Cocoon set off with a jerk.

Shootout at Padi

18 October 2004, 10 p.m.

T minus 60 minutes

It was the fourth night after the new moon. Poor visibility was worsened by the four massive tamarind trees near the location. If this bothered the well-drilled commandos, they certainly didn't show it. Waiting in the dark for long hours in the hope of getting a single shot to be taken within seconds was part of their expertise. In the past, they had lain in ambush in far worse conditions.

I surveyed the trap zone one more time. God certainly seemed to be on our side. He had provided an almost perfect site. Kannan and I had identified it just the day before, after videographing the entire road incognito from a Maruti 800. But I chose to believe that divine forces were also at play. Somehow, everything seemed right.

Kannan and I stood next to the one-room school in Padi, around 12 km from Dharmapuri. The school overlooked the road. Its roof provided a perfect field of fire.

Six of my crack commandos were squeezed together on the school's roof, weapons at the ready. 'They look like a bunch of cards held together,' I thought. The concept of selfies didn't exist then, but the men were crammed so tightly together that it was almost like they were posing for one.

Six Kalashnikovs pointed unflinchingly at the road, as if they had a mind of their own. The limbs of the men holding them were mere extensions of their weapons.

An undercover police vehicle, masquerading as a sugarcane-laden lorry, was parked in the middle of the road. It was named 'Sweet Box', as it was full of sugarcane supposedly heading towards the sugar mill nearby. The lorry was actually meant to block the path of the oncoming Cocoon. It also housed three tech experts, who would receive signals from the surveillance camera concealed inside the ambulance. It was their job to confirm that the target was inside the vehicle before we intercepted it.

Another lorry—code-named 'Mobile Bunker'—packed with sandbags and armed STF commandos, was parked on the other side of the road, at an angle of about 45 degrees to the school, partially concealed by a tree.

Inspector Charles—our logistics man, not unlike James Bond's 'Q'— had dug into his eclectic inventory, which included over 100 items like a loud hailer, inflatable lamp etc. He first pulled out a selfie-stick-like contraption with a lamp at its end, which would be used to light up the spot. Next, he grabbed some luminously painted orange-coloured cones, the kind used by traffic cops. He stacked eight of these against a tree.

A team led by DSP Tiru was on standby in a civilian vehicle some distance down the road. Once the ambulance was spotted, they would move behind it, cutting off any chance of reversing and making a getaway. This would also ensure that no other vehicle would come between the ambulance and the police.

If all went off well, the ambulance would be trapped, hemmed in from all sides by the Sweet Box, Mobile Bunker, the school and Tiru's team. Another DSP waited in the east towards Dharmapuri town. His job was to cut out all incoming traffic. We needed a sterile zone to ensure no collateral damage.

Unusually for him, Veerappan was not very alert that day. In fact, his mind seemed preoccupied with memories and regrets. But his natural optimism seemed to resurface despite these dark thoughts.

As his mind hatched plans, his gaze fell on the 7.62 mm SLR lying near his feet. Many of his comrades had moved on to the deadlier AK-

47, but he still liked to carry the weapon, which he had personally taken from a policeman killed during the ambush with SP Gopal Hosur.

Veerappan smiled at the memory and glanced out of the ambulance. He noticed the vehicle was passing by Papparapatti Police Station. The sight reminded him of his two daring raids on police stations. He wrinkled his brow as he tried to recall them. *Ah, yes, one in Karnataka, and the other in Tamil Nadu.*

A few metres down the road, Kumaresan, a seemingly nondescript STF old-timer, sat in a shack. He half-heartedly picked at some food, trying to make sure he was well within the shadows. Except for the driver, Durai, Kannan and I, he was the only other person who was aware of the target's identity.

As the ambulance passed by, Durai nonchalantly stretched his arm out of the window, flattened his hand against the side of the vehicle and moved his thumb very slightly. The target, lost in his reverie, didn't notice.

But Kumaresan did so instantly. He also spotted two other things—the blue revolving light of the ambulance was on, which meant that the entire gang was inside. So was the fog light, which meant that all the gang members were armed.

T minus 10 minutes

Kannan's cell phone buzzed. He walked away a few steps and took the call.

'*Tapal anuppiyaachu* (The mail has been sent),' said Kumaresan tersely.

Kannan glanced at me and gave a thumbs-up.

Just then, we heard a slight clicking sound on our muffled wireless set. It was a signal from Tiru that our prey had come into view.

Kannan uttered the words, 'Cocoon in ten minutes.'

But that was assuming he came this way. He still had other options. 'What if he had turned to the right at the Papparapatti T junction? What if he had rolled some cowrie shells or heard a lizard's call?' I thought.

'Kannan, that rules out the road where Nawaz is positioned. But let's alert Shanmughavel on Hogenakkal Road; you never know,' I said in a hushed tone.

Kannan nodded. Like me, he knew that every minor detail could make the difference between celebration and censure.

T minus 5 minutes

I scanned the troops one last time. Each one knew his place. I had indicated their perches, chosen during my recce a day ago.

I caught Chandramohan's Cobras doing a quick dress rehearsal next to a tamarind tree northwest of the school. Prasanna's Angels seemed smug in their bunker and Rajesh Khanna's Rocky team had occupied the school terrace, in the selfie-like strategic cram.

Every passing second felt like eternity. 'Why was Cocoon taking so long to fetch up?' I wondered.

'Calm down, calm down,' my mind sternly ordered my racing heart.

We began signalling the men to get ready. Suddenly, we heard the sound of a rickety vehicle approaching.

'How did they get here so fast?' I wondered, bewildered.

The teams reacted instantaneously, as if responding to an invisible signal. The Cobras—tactically the most exposed—were the fastest to seek cover. Some hugged the trees; others slithered behind bushes. The rest hit the road and lay there motionless.

I strained my eyes and ears to spot the vehicle. It was too faint to be a four-wheeler. Gradually, an old motorcycle sputtered into view. A couple was sitting on it, apparently involved in a heated argument. In the still night, their voices carried clearly.

The motorcycle moved at its own pace.

'Come on,' I muttered furiously under my breath. The last thing we needed was the couple to be around when the ambulance turned up. Thankfully, they gradually faded from sight.

I heaved a sigh of relief.

The Cobras had placed sandbags on the ground, hoping to erect a bastion. Under the eagle eye of their leader, Chandramohan, they had spent the last week practising relentlessly. They could raise 144 bags into a 5-foot-high U-shaped wall and take cover behind it, all within a span of three minutes. But the arrival of the motorcycle forced them to

abandon their drill. Luckily for us, the couple were too immersed in their conversation to notice the sandbags lying on the road.

Sweet Box too felt the impact of the interlopers. The sensitive gadgets inside the lorry were turned off, as their glow would have been a dead giveaway. Ultra stifled a pained sigh. Rebooting all the devices would take a while.

As soon as the motorcycle moved out of sight, the teams swung back into action.

Charles leapt out of the darkness and neatly placed the cones—four each on either side, marking out the final parking slot for Cocoon. With such measured gaps, the cones, in that dim light, looked like stiff sentries keeping a grim vigil for any unlucky intruder.

My AK was dangling on its sling from my shoulder. With all the teams watching, I stretched both my arms, turned 360 degrees and chopped the air to mark the exact arcs of fire for all three teams. Every inch of space, fenced by the cones, would be swept by a bunch of guns, from every conceivable angle.

Hussain would cover the entire northern flank and Rajarajan the southern, I gestured.

T minus 120 seconds

'Activate the tech guys,' I whispered to Kannan.

He nodded and headed over to the Sweet Box.

A few seconds later, he came back sprinting. He looked alarmed.

'The tech team has confirmed four people in the back of Cocoon. But the picture from the camera is blurred, can't make out their faces. Sorry, sir,' he blurted.

I swore under my breath. 'Should we still proceed with the ambush?' I wondered. I would be held entirely responsible in the event of a misadventure. They say, 'When the going gets tough, the tough get going.' In my case, though, the tough got praying!

The lights of the ambulance appeared to come closer and closer. I tried to consider all options frantically. I just had a few seconds left to make a decision. Then providence stepped in and took the decision out

of my hands.

The darkness was pierced by four powerful beams of light. Two were from Cocoon's normal headlamps; the other two yellowish lights emerged from the fog lamps.

I nodded. Kannan raised a hand, like the conductor of an orchestra. Hussain and Rajarajan mimicked him. The teams froze.

Time seemed to have come to a standstill.

The mild breeze had suddenly died out. There were no sounds— either from the jungle or from the nearby villages. Only the rumble of the fast-approaching Cocoon. The sound and light emanating from it provided an almost surreal contrast to the dark stillness that shrouded us.

'Would they stop at the designated spot?' I asked myself. It was crucial that they did, since a moving target is much harder to hit than a stationary one.

Bullets fired from an AK-47 move at 2,500 kmph. In comparison, a van's 60 kmph may seem very modest, but it can severely complicate matters for the ambush party. Of the 140 bullets fired, only seven hit French President De Gaulle's Citroën car, a staggering 1 out of 20!

T minus 60 seconds

Saravanan's heart fluttered as he spotted the glowing cones. He could barely locate the school. On their way in, Kumaresan had slowed down his two-wheeler and pointed it out to him.

'Brake hard. Switch on the rear cabin lights. The passengers must not catch sight of anything, but must be seen,' Saravanan recited the instructions to himself one more time.

Then, with fumbling fingers, he flicked on a switch and Cocoon's three cabin lights came on. He simultaneously stepped on the brakes with all the force his right leg could muster. Cocoon lurched hard and screeched to a dead stop right in the middle of the designated slot. The smell of burning tyres filled the air.

Even as Cocoon shuddered to a halt, a vehicle came up rapidly from behind. Tiru had been trailing Cocoon discreetly, keeping out of sight to ensure he didn't arouse any suspicion. But with Cocoon trapped, he

moved quickly into position to block the exit. The lights from his vehicle beamed straight at the rear of Cocoon and illuminated it. Four guns were already trained on its exit doors—two from the school roof, and two from the Bunker.

All eyes were on the halted ambulance. Thumbs eased the safety levers, index fingers twitched, slipping in beyond the trigger guards.

T minus 5 seconds

In the heat of the moment, Saravanan had forgotten to douse the headlamps and the revolving blue lamp on the roof. The burning lights engulfed Cocoon's front in a soft halo. It stood there in the middle of the road in all its majesty, still rocking like a boat tossed by waves, its double beam of lights bobbing up and down.

Two men shot out of Cocoon with the speed of discharged bullets— the captain and the navigator had abandoned their ship.

Saravanan's voice carried clearly, his left hand pointing backwards. 'Gang yulla irukaangoe (The gangsters are inside).'

Even in that moment, I could make out that he was eager to catch my eye, as if seeking approval for delivering the goods. I nodded appreciatively and hurriedly patted him as he brushed past me.

Rajarajan grabbed Saravanan and shoved him behind a huge tree near my position. Meanwhile, Durai—identifiable from the shine of his shaven pate—turned back abruptly towards Cocoon. He had pulled the safety pin of his stun grenade and rolled it into the rear of Cocoon from the secret slot under his seat. 'What had happened to the damn thing?' he thought. It took him a moment to realize that the damned thing had a four-second fuse to blow up. It finally did.

Cocoon rocked on its wheels. Durai had 4 metres to reach the relative safety of Hussain's flank, just opposite my position. He headed for it like Usain Bolt taking off from the blocks. After all, the firefight could begin any time, and he had no intention of getting caught in the core battle zone. I raised my right palm.

Kannan's warning rang out over the megaphone, 'Surrender. You've been surrounded.'

A few moments went by.

Then, the unmistakable sound of an AK-47 emerged from the rear of the vehicle.

There was a sudden flutter of birds from the tamarind trees. Far away, a lone dog barked. Soon, many joined the chorus.

Shattered glass flew out of the rear of Cocoon. With the others fumbling to retrieve their guns, Govindan must have been the first to react, we later concluded.

If the four men had come out of the vehicle with their weapons raised, we would have accepted their surrender. But the moment they opened fire, they closed that window for themselves. I could not risk losing any of my men.

A total of forty-four cops and foresters had already died at the hands of these men. At least eighty more civilians, known to the police, had been killed by them. There may have been more deaths that were never reported. Those people were probably killed in multiple brutal ways. It would end tonight, one way or the other.

Our response was instant and overwhelming. Brass hosed down on Cocoon from every direction. Bullets zipped all around along with the rhythmic flashes of guns.

I felt something hot on my neck. Empty shells were spewing from my buddy Sundaram's AK. Since we were standing close together, some of them scalded my neck.

I shuffled to my left, flicked my gun to burst fire mode, and let go.

After a few bullets, I paused briefly, as did the others. Another couple of reports of a self-loading rifle and a shotgun came from Cocoon.

Kannan reiterated the terms for surrender.

There were a few more shots, followed by a volley of the STF's response. I signalled the teams to stop.

Another pause. This time, there was no return fire.

The mayhem of the encounter faded to a dull murmur. Some birds had returned to their nests, but were still chirping restively. Dogs were still barking in the distance. Cocoon was engulfed in smoke and dust.

I signalled to Rajarajan and Hussain.

Another stun grenade was lobbed into Cocoon. There was a flash

and a bang. Rajarajan flashed on a torch, which he held below his gun's barrel, as did Hussain. The two beams of light converged.

The two men approached Cocoon warily. They heard a gurgle, followed by a hiss—like air escaping from a cycle tube. It is a sound typically made by air trapped between the lung tissue and the chest. Someone wounded was trying to suck in air.

Then, silence.

The stillness was finally broken by the cry of 'All clear'.

The encounter had started at around 10.50 p.m. and was over in twenty minutes—a rapid climax to a twenty-year wait!

Hussain and Rajarajan saw blood and bodily fluids splashed all over—the walls, floor and seats, food packets and the stretcher. They picked up two AKs, a 12-bore Remington pump-action gun and the infamous 7.62 mm SLR.

Three persons were huddled together—their final conclave before going down. Men in their death throes, clutching each other! One, later identified as Govindan, was a little distance away.

The four men were speedily removed from Cocoon and laid on the ground. I beckoned to Kannan and, ignoring a cramped muscle, hobbled over to where they lay.

It was my only face-to-face moment with Veerappan, if it could be described as such. He was unable to speak and was clearly dying. I noticed that a bullet had gone through his left eye, just as it had with Senthil in Sorgam Valley almost ten years ago. With his moustache trimmed and in civilian clothes, rather than his trademark green dress and brown belt, he seemed a stripped-down version of his former self.

He had been a wily and worthy foe, with a mastery over both strategy and tactics. Even at fifty-two, he was sinewy and extremely fit. Forensic specialist Dr Vallinayagam, who later examined his body, told me he was in the shape of a twenty-five-year-old, apart from the problem with his eyes.

Rumour has it that he had damaged his eyes while applying dye to his famed moustache, which often filled him with pride. It was an irony worthy of an O'Henry tale. The famous moustachioed bandit eventually trimmed his whiskers to get his eyes treated, only to end up losing both—

his eyes as well as his life.

I took stock of the encounter. There were no casualties or serious injuries among my boys. I sent up a quick prayer of thanks. It was one more thing to be grateful for on a night when fortune had been exceedingly gracious. I was not the only one to be scalded by a buddy's empty shell. It's not so unusual when people are firing while packed in close proximity to each other.

A total of 338 bullets were fired by us. Later, seven were found in Govindan's body; two had pierced Veerappan's body and exited from the other side, while one stayed inside.

It is impossible to predict the number of bullets that could hit a target during a firefight. Two people close by may not receive the same number of bullets or wounds. In 1980, when the SAS had stormed the Iranian embassy in London to rescue twenty-six hostages, eighty-two bullets had hit one terrorist alone. The bullet count for his other five comrades was in single digits.

An early casualty of the firefight was the lamp at the tip of the selfie-stick, which had been shot out. The shreds of its shattered bulb nearly got SI Rajesh Khanna in the eye. Thankfully, he did not sustain any serious injury. In any case, the illumination from the lamp had not really been used as Cocoon glowed in the radiance of its own light.

Charles, like a conjurer, pulled out a black cloth the size of a bed sheet. He was supposed to have cut the cloth into strips to be used as bandanas. But in the excitement, everyone had forgotten about it. Now, it served to cover the four men.

Gradually, I sensed a growing murmur from the boys.

Since the identity of the men inside the vehicle had not been revealed to them initially, they began to mutter in disbelief when they recognized the fallen men.

'Could it really be him?' 'Is it just someone who looks like him?' 'No, it's actually Veerappan!' they wondered aloud.

I then signalled that we needed to rush the four men to the nearest hospital. They were loaded onto an Omni and dashed away.

Suddenly, cries of 'Long live the STF' resounded through the clearing. There was a spontaneous eruption of delight and high-fiving. I was

hoisted on the shoulders of my men and effortlessly passed around. I noticed that Kannan had been similarly hefted. We exchanged broad grins and shook hands. No words were needed.

Next, it was the turn of Hussain, Rajarajan, Tiru, Sampath and Saravanan.

All the officers and team leaders present were tossed around, as were the head constables, who had spent years haranguing and tongue-lashing the men to finally make this moment possible.

There was a brief pause as the boys looked in puzzlement at Durai, standing calmly at a distance, scratching his shaven head. Nobody knew him, but they clearly understood that he was one of them and had played a pivotal role in the operation. Up went Durai, too.

As soon as the boys brought me to the ground, I bounded up the school's steps, two at a time. Sitting on the parapet with my feet dangling on the dangerous side, I made the call.

'The CM has retired for the night. Is it urgent?' asked Sheela Balakrishnan, Jayalalithaa's secretary.

'I think she will like what I have to say,' I replied.

An instant later, I heard her voice on the phone.

'We got him, ma'am,' I said. Then I quickly recounted the operation and informed the CM that Veerappan was on his way to hospital, but survival seemed unlikely. I replied in the affirmative to her brief query on the STF's safety. Though she was her usual dignified self, the elation in her voice was unmistakable. 'Congratulations to you and the STF, Mr Vijay Kumar. This is the best news I've ever had as CM,' she said, before hanging up.

I looked up to the sky and touched my lucky medallion. Some of the boys were pocketing souvenirs to show their unborn grandchildren. The ballistics guys would go ballistic at the missing empties, I thought wryly. But the men would surely take immense pride and great delight in narrating the story of this unforgettable night. Then I felt something lodged in my vest. It was the empty shell fired by my buddy, now wet with my sweat. I twirled it on my fingers for a moment and decided to keep it as a souvenir for my unborn grandchildren.

It was now time to drive straight to the Bannari Temple and stand

before Bannari Devi with my tonsured head bowed in gratitude. That would complete a vow made when I had felt very lonely and was filled with a sense of despair about this mission.

I began walking towards my jeep. As I was about to enter it, I turned back for one last look at Cocoon.

The rooftop blue lamp had found its own rhythm as it revolved during the entire firefight. Incredibly, it had not been hit by a single bullet. Now, it finally ground to a halt, as if to say 'Mission Accomplished'.

All cell phones continued to be on switch-off mode. I tried to call Meena to inform her about the operation's success, something she had always prayed for fervently. But the news flash on BBC, CNN and their Indian counterparts ensured that the element of surprise was lost. Later, when I reached our home in Sathy, a huge crowd greeted me with a traditional aarti. Meena stood behind, an unmistakable look of pride and adulation in her eyes. It would be a while before I could pat and hug her, but sadly, I could never convey my true feelings to her.

The media frenzy also gave rise to persistent rumours that Veerappan had been captured, tortured and executed and that the encounter was entirely fake and stage-managed. Such rumours are an insult to the ethics and calibre of a force like the STF. Veerappan's wife had approached the Madras High Court seeking a CBI probe into the encounter, but the court not only turned down the plea, but complimented the force.

Some people insisted that Veerappan's fingertips were blackened, which showed his fingers had been burned. Actually, ink was applied during the inquest to take his fingerprints for the first time.

There were also rumours about an ambulance moving around in the area a few days before the encounter, which proved the bandit's alleged capture before the officially recorded date. The ambulance in the area was part of our 'hearts and minds' programme, which provided medical aid to the local population. The truth is that Veerappan died due to bullet wounds sustained during the shootout at Padi.

18 October 2004, Monday, 11.10 p.m.

File on Koose Muniswamy Veerappan closed.

Epilogue

The priest's hands fumbled as he cleaned up films of cobwebs and layers of dirt. With a wet cloth, he slowly wiped the doors of the sanctum sanctorum of the village's temple. He was bathed in sweat by the time he pushed open the doors. As they creaked open, long-accumulated dust showered down upon him. He shut his eyes and received it like a benediction.

The sanctum sanctorum, which was only 6 feet by 4 feet, housed Shiva—the powerful God of Destruction. Almost every family in the village had at least one member who bore his name, Jadeyan.

The priest washed the deity's feet as his body trembled. 'Forgive us, O Lord,' he prayed silently. 'How could we have turned our back on you? You are everything to us.'

It had been ten years and ten days since Veerappan and his men unleashed their sheer brutality on Geddasal. Their bloodthirsty search for Jadeyan, the village headman who had tipped off the STF about his camp, ended with five dead bodies near the temple. 'God did not stand by us when we needed him. What is the point of our daily prayers?' the villagers had remarked. The temple doors were then slammed shut.

Today was different. Veerappan was dead. Justice had finally been delivered to the victims of Geddasal.

The priest shuffled the plate of flowers closer and began ringing the prayer bell. He heard villagers gather outside in full strength. Slowly, their voices joined in chorus as they began singing.

The priest smiled. 'It's just a matter of time. You'll forgive us,' he thought, as he bowed to the Lord.

On 30 October, the CM hosted a state ceremony and banquet in Chennai, wherein Walter, Nataraj, Kannan and I were awarded medals. Each member of the STF was given a house plot and ₹3 lakh in cash. Accelerated promotions were announced for all, up to the rank of DSP.

Later, we all got back to our lives and everyone is doing well, wherever they are today. Walter Davaram continues to be the head of the Tamil Nadu Amateur Athletic Federation. Shankar Bidari, R. Nataraj and others chose to shed their fatigues and don political colours. Kempiah, who was brought into the STF after the Rajkumar episode on the specific request of the actor's family, is now advisor to the Karnataka CM. Gopal Hosur is retired and lives in Bangalore, as does Ashok Kumar. Sanjay Arora, Kannan, Shanmughavel and Nawaz still continue to be in the force. Hussain now runs a farm, not far from the 'dosa point' where he narrowly missed Veerappan. Rambo, who recovered from the Good Friday blast, continued in the Tamil Nadu police for fifteen years. He passed away on 9 November 2016. Jedayan died in a car accident four years back.

Mr X has apparently stopped his nefarious activities but, I'm told, keeps looking over his shoulder!

Appendix 1

The Fault in Veerappan's Stars

Towards the end of 2001, one of our intelligence sources provided a copy of a document resembling a birth chart along with a horoscope at STF headquarters. The chart identified the child's father as Muniswamy and mother as Ponnuthaiammal. The date of birth was 18 January 1952. It was the horoscope of Koose Muniswamy Veerappan.

We were stunned, but doubts quickly arose. Was this horoscope genuine or fake? Some senior citizens of his native village Gopinatham, who were consulted, confirmed its authenticity. Members of the Valluvan community, who specialized in preparing horoscopes, would join a family within days of a child's birth and stay with them for the next two-three weeks to prepare the chart. Apparently, this chart was prepared by a particular Valluvan who was trusted by the people of Gopinatham in the 1950s and 1960s.

Like some men who lead hazardous lives, some members of the STF were deep believers in astrology. Experts were summoned and asked to decipher what the stars apparently foretold for our adversary. The horoscope stated the subject would be particularly vulnerable at the ages of fourteen, nineteen, thirty-two, forty-five and fifty-five (he died at the age of fifty-two). If he survived his sixty-fifth year, he would go on to be seventy-eight.

Some of his predispositions were also mentioned. He would be efficient and complete any task undertaken. But it also said that he would be 'red-eyed, less educated, ungrateful, egoistical, fond of women, petty-minded, and short-tempered'. The chart also added that 'big people would seek him out, but he would be an enemy of the government'.

VEERAPPAN ASTRO CHART

2 Ju	3	4		5
1 ASC RA		**Veerappan** Date of Birth–18/01/1952 Place–Gopinatham		6
12 Su			Ke	7
11 Me	Ve 10	Ma 9	Mo 8 Sa	

Date of Birth–18/01/1952, Place–Gopinatham

As readers flipped through the 125-page document, several interesting predictions tumbled out. The horoscope said he would run away from home and spend a lot of time living outside his home state. There was also a mention of a prolonged period of 'vanavasam' (life in the forest). There was a clear reference to his receiving a rajadandanai (punishment by the state).

For believers, that last prediction was a huge source of hope, which kept them going during dark times. Sceptics will probably scoff at that, but when you live a dangerous life with an uncertain future, every little bit of optimism helps.

Acknowledgements

I would especially like to acknowledge the lion-hearted efforts of Walter Davaram and Shankar Bidari. Between them, they reduced the Veerappan gang's numbers to single digits. I enjoyed working with the Karnataka STF: Kempiah was bold and risk-taking. K.N. Mirji, my Karnataka counterpart, cheerful and focused, was a great partner. His full cooperation led to the success of the operation. The Karnataka STF veterans 'Tiger' Ashok Kumar, Poonacha, Bawa, Saudagar and Prasad, who had many run-ins with Veerappan's gang, deserve a book of their own.

I thank the Tamil Nadu Intelligence and Q branches for backing us to the hilt. My DG, I.K. Govind, totally trusted me. Home Secretary Sheela Rani Chunkanth and her predecessor Syed Munir Hoda were a great help. So was Chief Secretary Mr Narayan. The Forest, Revenue and PWD officers put up with the STF, although it was actually poaching their turf and occupying their sparse accommodation. The district collectors and SPs of Ooty, Coimbatore, Erode, Salem and Dharmapuri stood by us. I would like to thank them all. A big thank you goes out to the STF's Sorimuthu, Pugalmaran and photographers Ravi and Surjeet. My buddy Sundaram inside the jungle and Janardhan outside the jungle helped me no end.

I also thank Dr Udaya Kumar of Sathy—the STF's unofficial doctor, Dr Murthy and the other doctors for conducting medical camps.

V. Vaikunth, former DGP who wrote the first commendation of Operation Cocoon in *The Hindu*, deserves a special mention. Thanks are due to Balasubramanian and Saravanan of Bannary Sugars—many STF officers were their near-permanent guests. The 'sweet box' of the last day was courtesy these two.

To the media, a big thanks. It fully cooperated when I reduced the

STF's media presence, which helped us keep the various operations under wraps.

If nearly four decades in police service has convinced me 'it's mostly team work', one decade's attempt to be a writer only firmed up that belief. It has been a wonderful journey with so many carrying me on their shoulders.

The following were my sources of strength:

My batchmate, late Jagdish Saligram, the first to prompt me to write.

My wife, Meena, for putting up with my protracted struggle to turn into a writer; my mother Kausalya who, at over ninety years, keenly read my draft; my son Arjun and daughter Ashwini and their spouses—Dr Gita Arjun and Deepak Menon—for their constant queries.

My sisters Malini, Usha and Latha; brothers Sivu and Rajan and brothers-in-law Dr Gangadharan and Mohan Menon were of great support.

Thank you, Meera and Dr E.K. Ramdas of Calicut, for letting me stay at your Wayanad coffee estate where I wrote my first draft. Ravi, Ubaiyadullah, Saravanan, Javed, Ayyappan, Dhiman, Nandanan and Hari Kumar for typing reams of stuff. For the map, Satheesh Edwin and Sajeem.

My trainees, Rohan from the IPS and Abu, now in the IFS, who went through the manuscript many a time and gave useful suggestions.

I also want to thank my erstwhile SPG colleague Shantanu Mukherjee for his very incisive comments, Satyamurthy, formerly of *The Hindu*, and *The Hindu*'s Sudharshan for their suggestions.

Author Amish Tripathi, thanks for putting me through to Anuj Bahri of Red Ink Literary Agency. That's how I met Vikas Singh. Thank you, Vikas, for helping organize and structure hundreds of pages of research material, collected over several years, into a tight, gripping, reader-friendly narrative from the first word to the last.

I wanted this book to read like a thriller. I thank Sharvani Pandit, editor, Red Ink Literary Agency who made a vital contribution in helping me towards that end.

Special thanks to Rupa Publications' Kapish Mehra who, in the first meeting itself, made a dozen very useful suggestions followed by many more later, and also for getting this book fast-tracked. So also Rupa's

editors Yamini Chowdhury and Amrita Mukerji who led my final charge. I thank both of them for their polite but firm interventions and hard work, especially around New Year's Eve, and for tolerating my eleventh-hour alterations.

Finally, my thanks to the Karnataka STF who, as I have said before, deserve as much credit as their Tamil Nadu counterparts for the success of Operation Cocoon, from where the journey of this book began.